2478 The Impressionists
This edition published in 1999 by CLB

Copyright © 1990 Quadrillion Publishing Ltd,
Godalming, Surrey, England GU7 1XW

Distributed in the USA
by Quadrillion Publishing Inc.
230 Fifth Avenue, New York, NY 10001

Printed and bound in Italy

ISBN 1-85833-671-6

the impressionists

Corinne Graber and Jean-François Guillou

the impressionists

CLB

CONTENTS

On 2 December 1852, the anniversary of the coronation of Napoleon I, Louis-Napoleon Bonaparte exchanged his odd title of Prince-President for the more desirable one of Emperor. He took the name of Napoleon III, to perpetuate the great Napoleonic legend in a second empire. This heritage was a certain embarrassment, since the days of heroic conquest were long over. However, if Napoleon III could not bestow the brilliance of Austerlitz on his French subjects, he would dazzle them with military parades, grand receptions and splendid festivities. These were the days of imperial display.

Paris thus became the new Babylon, addicted to pleasure and vanity, in which the demi-mondaine triumphed. It was the era of La vie parisienne, as immortalised by Offenbach and summarised in the following words by Meilhac and Halévy:

Du plaisir à perdre haleine, *Breath-taking pleasure*
Oui, voilà la vie parisienne *That's Parisian life and leisure*

What did the French public make of these extravaganzas? They hesitated, puzzled. The old aristocracy was suspicious and stayed in the background since, after all, the Emperor was merely a nephew of the Usurper. The middle classes were enthusiastic supporters, admiring the spectacle from afar, secure in their havens of calm and tranquility built on a life of hard work and thrift. Their defenders claimed them to be industrious, but Labiche thought them ridiculous and Flaubert concluded in Madame Bovary that they were stupid. This harsh judgement indicated the ambiguous position of the arts and the artist in society during the Second Empire.

Some of the Empire's detractors, disappointed in the people who had preferred having an emperor to a republic or, like Victor Hugo, overtly hostile to the ruler France had just granted itself, withdrew into their "ivory towers". They included Leconte de Lisle who went into exile in Jersey. Others took refuge in "art for art's sake" like the poets of Parnassus. However, for those who wanted to succeed and forge a brilliant career there was no alternative but to serve the regime. This is what the conventional painters of the time did, those contemptuously designated in French as les pompiers.

Winterhalter painted the portraits of courtiers. Meissonier specialised in battle scenes to exhalt the glorious memory of Napoleon Bonaparte and Cabanel; in less martial vein, he inflamed the imaginations of the virtuous with his pristine Venus. This type of art aspired to be exemplary. It educated, it edified, it delighted the superficial eye. Its glories were recognized, given the official and court seal of approval, thus ensuring that it reigned supreme in the Salon.

The entire success of a painter's work hinged on his being admitted to the Salon, because at the time there were no private galleries to speak of or, at any rate, there were so few that young painters were forced to submit their works to the cold eye of official inspection. They did so with hope and enthusiasm until the year 1863. In that year, the jury rejected 4,000 paintings a judgement which was possibly severe but was most definitely blind. This refusal gave birth to a movement which a decade later an unknown journalist would baptise, despite himself – Impressionism.

Yet, without the aggressive intransigence of officialdom, this movement might never have been born. A few of the younger artists who grouped themselves around Manet organized a collective retort which inadvertently gave rise to the whole movement of Modern Art.

the Refusés

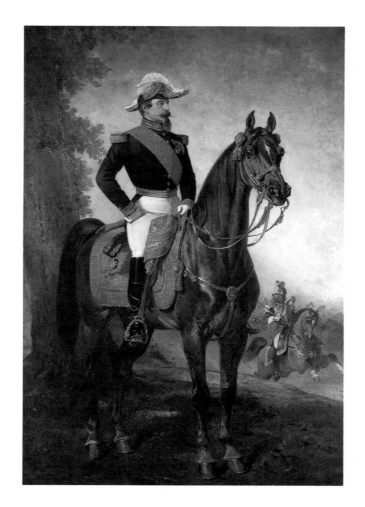

Alfred de Dreux
Napoleon III
oil on canvas
Paris Musée de l'Armée

During the reign of Napoleon III – and to an even greater extent under the Third Republic – it was vital for any artist who aspired to see his paintings hung in the Salon to take a course of study at the Ecole des Beaux-Arts in Paris. Nearly all the Impressionists submitted to this rule. Students drew from life models three times a week; for the rest of the time, they had to make do with plaster casts or visit the Louvre to copy the masters. They were supposed to be learning about Beauty. Academic Beauty, of course, reduced to a few simple, intangible rules which must be applied zealously, submissively – and monotonously. In a retreat of this nature, talent was suspect and originality despised. Viollet-le-Duc wrote in 1862 that a student was expected "merely to possess the ideas accepted by the academicians and above all not to have any pretentions to possessing any of his own".

Yet this same atmosphere was pervaded with vulgar, scatological jokes which were orchestrated by the senior students and tacitly tolerated by the professors in the name of tradition. The students in question were the penniless failures, voluble and drink-sodden, who were thus able to revenge themselves for the mediocrity of their existence by creating an ambience worthy of their own status.

Any prestige possessed by such a school was mere illusion. Consequently, some students, whether to gain a measure of freedom or from an interest in their vocation which can be readily understood, sought to complete their studies in a private academy or the studio of a teacher at the school. The latter method was a good way of ensuring such a teacher's protection during the examinations.

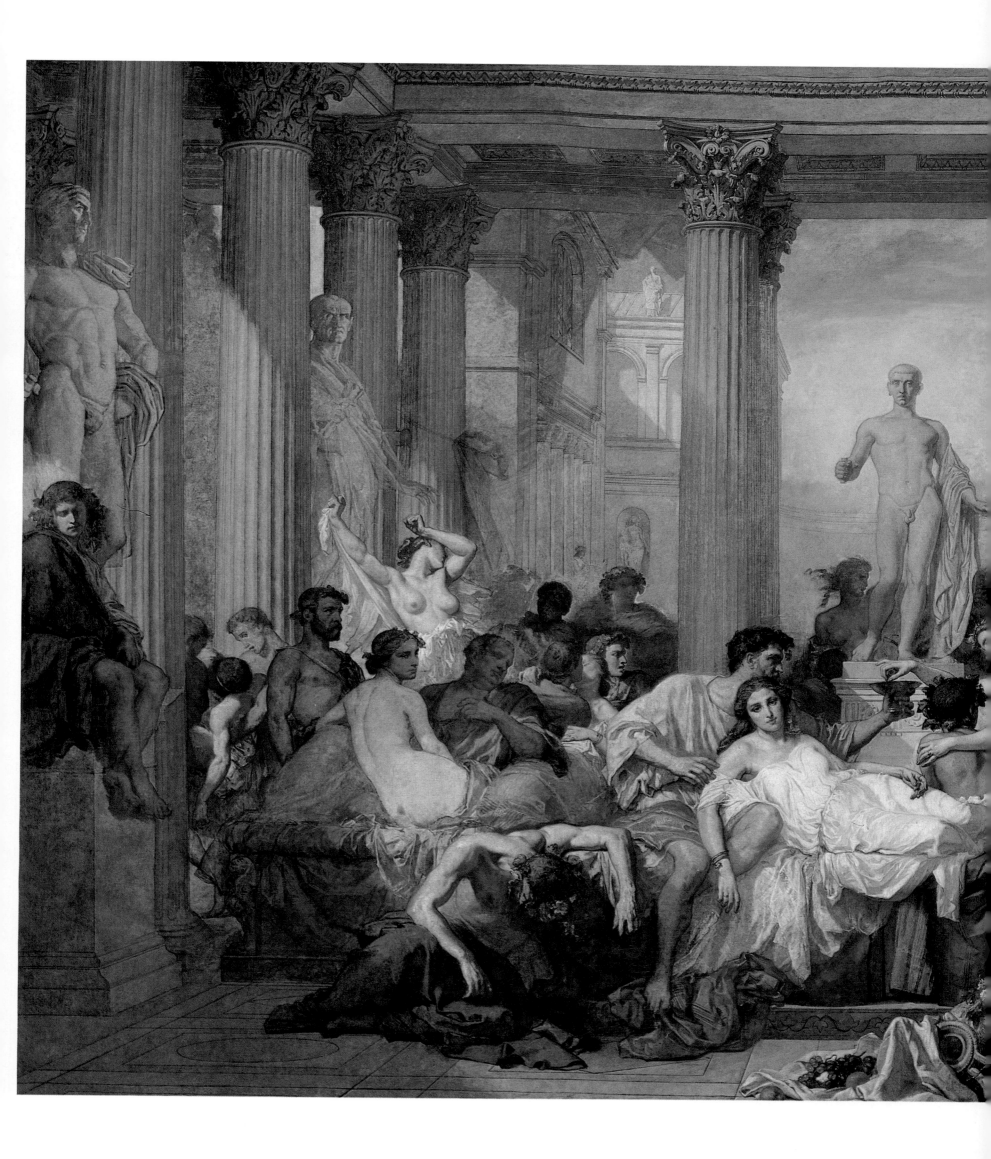

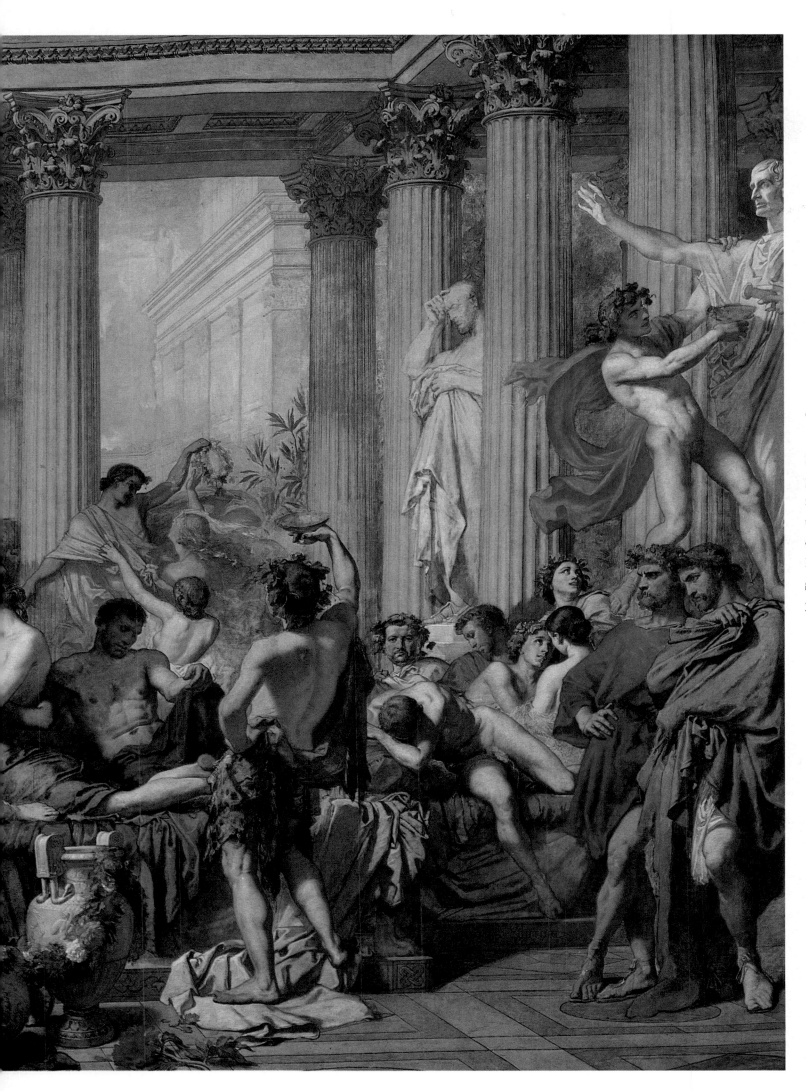

15

Thomas Couture 1815-79

Famous painter of his day,
pioneer of the eclectic
movement. He had a studio
until 1863, then he stopped
exhibiting his paintings.
Manet thought he was a
good teacher and spent six
years in his studio.

Thomas Couture
The Romans of Decadence
1847
oil on canvas 466 x 775
Paris Musée d'Orsay

16 *Gleyre's Studio*

Gleyre 1808-1874 was a Swiss painter from the Vaud canton and author of *Illusions perdues*, whose studio has passed into posterity merely because from 1862 onwards his pupils included such famous names such as Monet, Bazille, Sisley and Renoir. Gleyre was a good-natured man who was often laughed at by his students but to his credit, despite his strong attachment to academic rules, he granted his painters a measure of free- dom. Renoir liked him. One day, when Gleyre reproached him for enjoying himself when he painted, Renoir answered ironically that he would not paint if this were not the case. Later in his life, when Renoir was reminiscing to his son, Jean Renoir, he recalled that at least, "If Gleyre didn't teach the future Impressionists anything, at least he left them in peace."

Monet, on the other hand, was less appreciative of the master's attempts at correction. During one such session, Gleyre examined his work and said reproachfully, "Not bad, not bad at all, (...but...) you have a stocky man here. He has huge feet; you've painted them just as they are. That's all very ugly. Remember, young man, when one draws a figure, one must think of antiquity. Nature, my friend, is all very well as an object of study but is of no interest in itself. Style, you see, is everything!"

Easter was approaching. Monet left for Chailly-en-Bière with his friends and never crossed Gleyre's threshhold again. The others were less touchy; they returned to the studio after the holidays and emerged from it none the worse for their experience.

Charles Gleyre
Lost Illusions or *The Evening*
1843
oil on canvas 156.5 x 238
Paris Musée d'Orsay

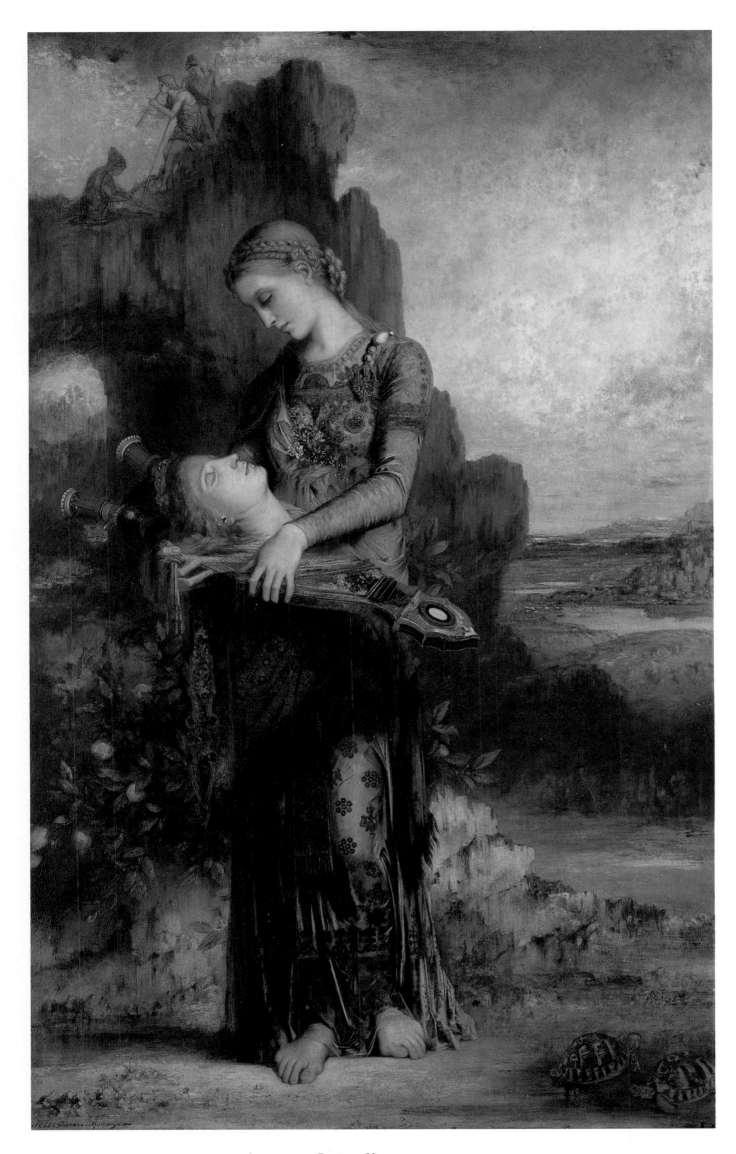

Gustave Moreau
Orpheus
1866
oil on panel 154 x 99.5
Paris Musée d'Orsay

18 *The Suisse Academy*

The studio was at the end of a dilapidated old building. You had to cross two stinking courtyards to reach a third, across which stood a sort of closed shed, a huge hall of wooden boards and plasterboard. (....)

In a corner, the stove (...) was rusting. (...) The walls were particularly noticeable (...) soiled with graffiti and drawings (...) as in the margin of an ever-open book.

Zola
L'Œuvre
A Studio During France's
Second Empire Period

In addition to the studios, young artists could complete their apprenticeship at the "academies," a pretentious name for places that were often squalid. These establishments lacked teachers and examinations but gave their students complete freedom. For a token payment, students could work from live models every day except Sundays.

Père Suisse, a former model and pupil of the painter David, had opened such an establishment on the Quai des Orfèvres in the Ile de la Cité in Paris. Bonington, Delacroix and Courbet had all passed through its portals. It was here, in 1859, that Pissarro, then aged 29, met Monet, 10 years his junior, and Guillaumin made the acquaintance of Cézanne who had come up from Aix-en-Provence in April, 1861. Cézanne befriended Guillaumin who introduced him to Francisco Oller and Oller completed the circle by introducing Cézanne to Pissarro and Monet. Thus the nucleus of the Impressionists group was formed.

Cézanne has left two important paintings from his stay at the Suisse Academy, *Scipio The Negro* 1866-68, now in Saõ Paulo, a portrait of one of Suisse's models, and *Portrait of Achille Emperaire* c 1868, now in the Musée d'Orsay, Paris. The latter painting was rejected for the Salon of 1870. Emperaire was a painter, a cripple who craved fame and fortune. Like Cézanne, he came from Aix-en-Provence where his paintings are now preserved. It is an irony of fate that any fame he may still enjoy is almost entirely due to the existence of this unflattering portrait which is almost a caricature.

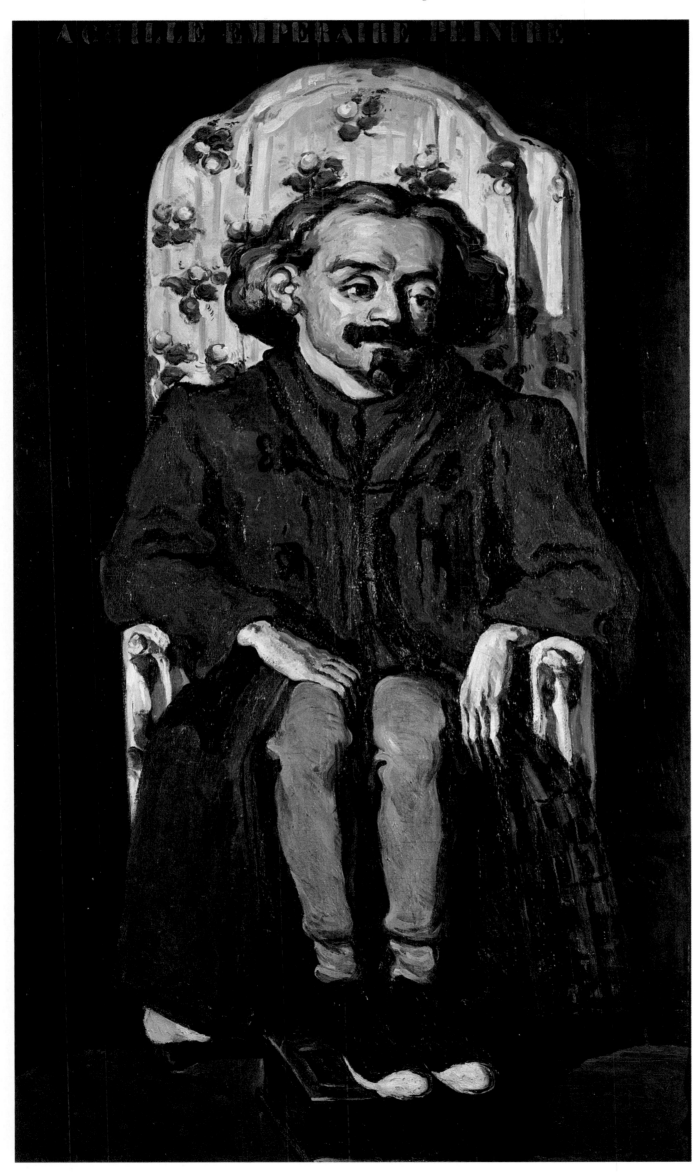

Paul Cézanne
Achille Emperaire, a Painter
1868
oil on canvas 200 x 120
Paris Musée d'Orsay

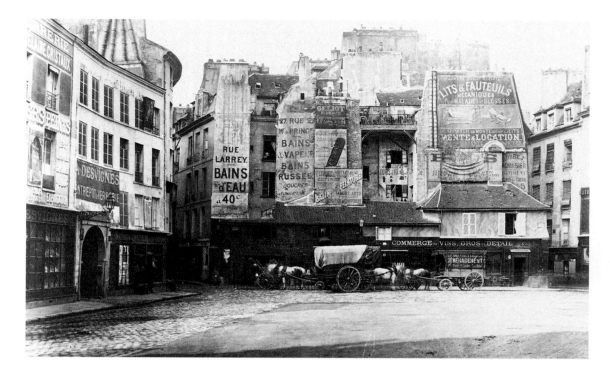

20 *The Café Guerbois*

*The café was situated
on the Boulevard des
Batignolles. (...) For
some unknown-reason,
the group had chosen
to meet there (...) on
Sunday evenings; then
on Thursdays at around
five o'clock (...). The
little tables under the
awning outside the café
were all occupied by a
double row of customers
who obstructed the
pavement. Yet they hated
this close proximity,
this public promiscuity,
so they jostled everyone
to get inside the cool,
empty room.*

Zola
L'Œuvre
A Description
of the Café Guerbois

The studio was not the only school. When an artist laid down his paintbrushes at 6.00 p.m., another day began, one in which he repaired to the café to continue discussions started at the easel. Manet "discovered" the Café Guerbois in 1863. Its address at 11 Grand-rue des Batignolles (near the avenue de Clichy) gave it the singular advantage of being the closest café to the artists' materials shop which Manet patronized.

Renoir, Sisley and Degas were regulars at the café but Monet and Pissarro, who had already moved to the fringes of the group and often stayed in the suburbs, were less frequent visitors. As for Cézanne, his occasional appearances were always of a provocative nature. Cézanne was the son of a banker but his relationship with his father was unhappy and he could not bear material success at any price, "All those people are swine", he used to say, "They doll themselves up like lawyers". If the truth be known, he was a little jealous of Manet who had become quite well-known while Cézanne remained a nonentity. "I shan't shake hands with you, Monsieur Manet", Cézanne grunted at him one day as he arrived at the Café Guerbois, "I haven't washed for a week".

Manet himself was often left speechless by Degas' sarcasm. Degas was quick at repartee and could be quite treacherous. Yet Manet dared to challenge his old friend Duranty, a critic, to a duel one evening in February, 1870 over an unfavourable mention he had received in the *Paris-Journal*. The fight duly took place and did not end until the two swords had been turned into corkscrews. Two hours later, the opponents were clinking glasses together!

Place Saint-André des Arts
photography
c. 1860
Paris Musée Carnavalet

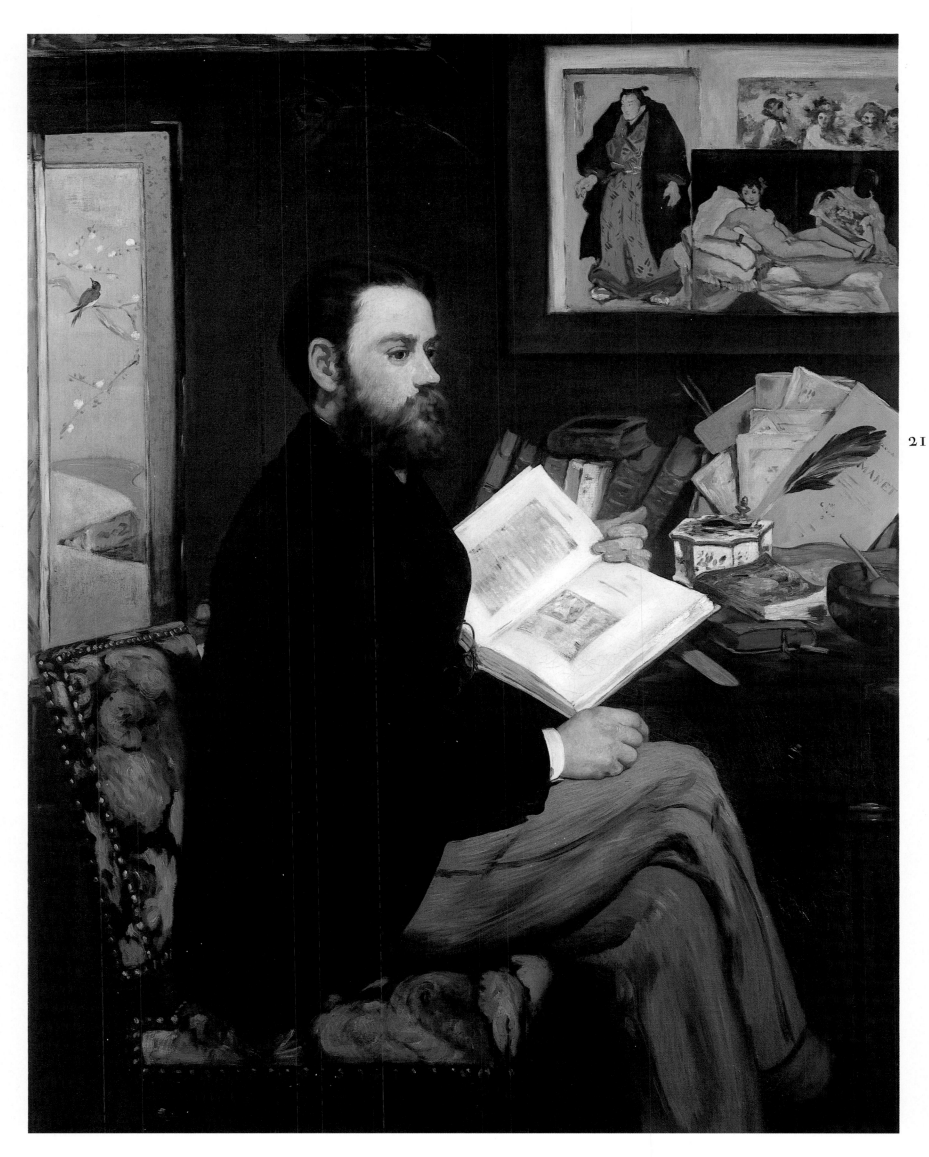

Edouard Manet
Portrait of Emile Zola
1868
oil on canvas 146.3 x 114
Paris Musée d'Orsay

Otto Schölderer

Manet

22

Renoir

Zacharie Astruc

Bazille

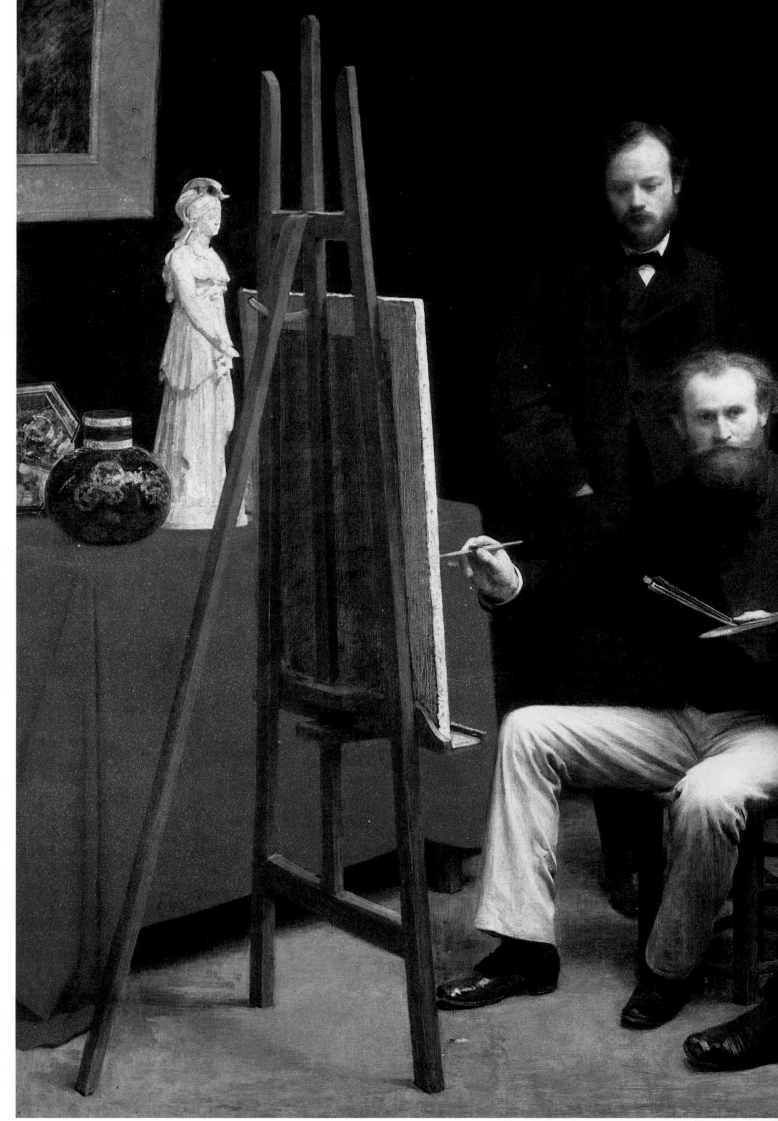

Henri Fantin-Latour
A Studio in the Batignolles
1870
oil on canvas 240 x 273.5
Paris Musée d'Orsay

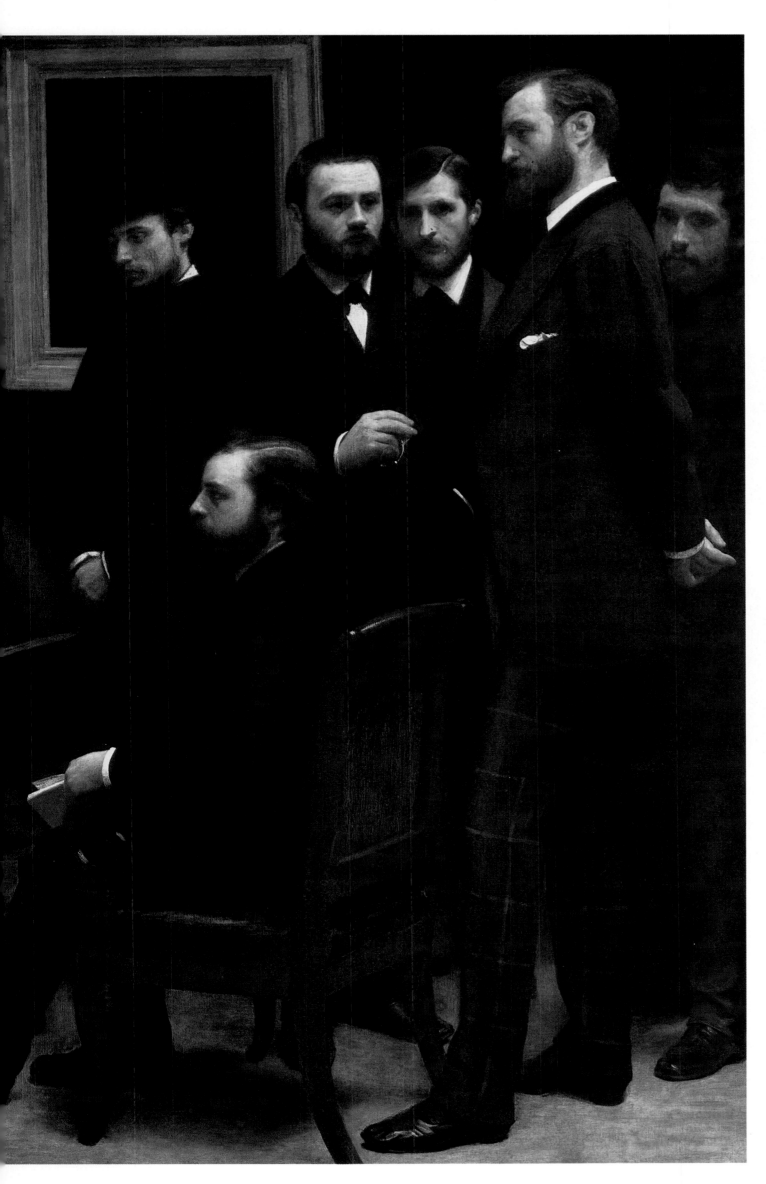

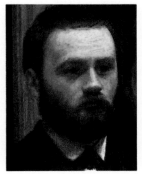

Emile Zola

23

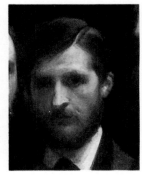

Edmond Maître

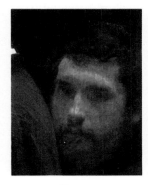

Monet

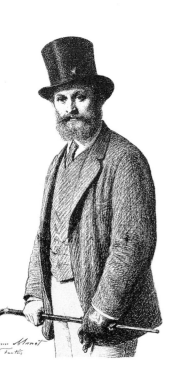

Friends

In addition to Duranty (who was erroneously believed to be Prosper Mérimée's son), a few men of letters were occasional visitors to the Guerbois. Some were well-known, others on the ladder to fame, such as Théophile Gautier, Paul Alexis or Emile Zola. Zola had an ambiguous relationship with the Impressionists. He did not really understand them, but he used them a lot. Degas reproached him for doing so. Yet by using them, he helped them, in a way, because of his enthusiasm and his passionate defence of them, at least in their early days. Zola probably confused his humanitarian views with the considerably more aesthetically-inclined views of the Impressionists, which were, in fact, quite at variance with his own. Thus he wrote about Claude Monet: "Like a truly Parisian painter, he takes Paris into the countryside, he can't paint a landscape without inserting elegantly-dressed ladies and gentlemen". Knowing what Monet's work was to become, one cannot help but smile.

Other celebrities came into contact with the Impressionists, at the Guerbois or elsewhere. These included Zacharie Astruc, who appears in *A Studio in les Batignolles* by Fantin-Latour and who indirectly suggested *Olympia* as the title for Manet's famous painting, and Marcellin Desboutins, a Bohemian writer and painter, who is depicted in *Absinthe* by Degas. *Cabaner was a musician who had befriended the bad-tempered Cézanne,*

at a time when even his friends reproached him for laying on paint with a trowel, and always being so unwashed! Manet even refused to have his work exhibited alongside Cézanne's.

Of this motley crew, perhaps the most extraordinary was Félix Tournachon, known as Nadar, a brilliant jack-of-all-trades, who was simultaneously a painter, journalist, caricaturist, flyer and photographer. The first Impressionist exhibition would be held in his studio in 1874. This will be mentioned again later.

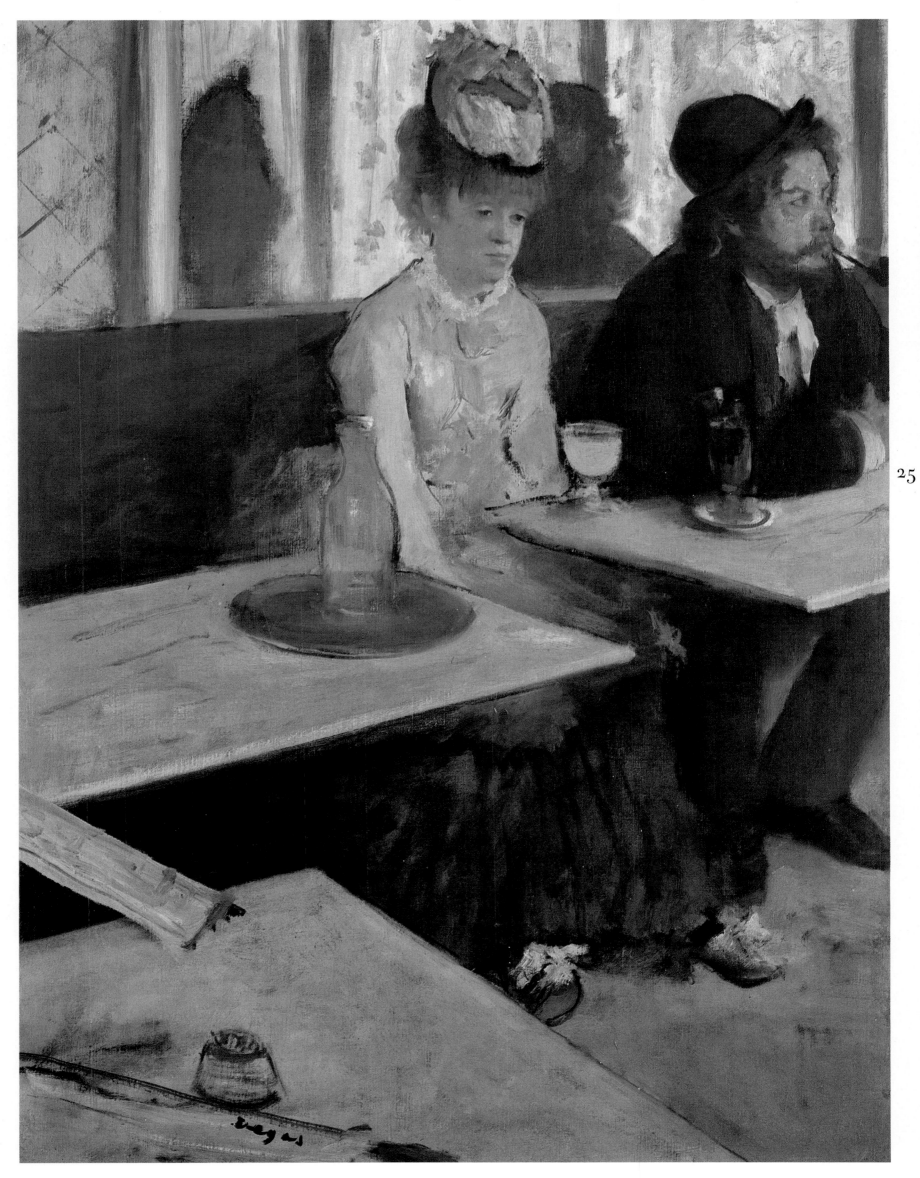

Edgar Degas
The Absinthe Drinkers
1876
oil on canvas 92 x 68
Paris Musée d'Orsay

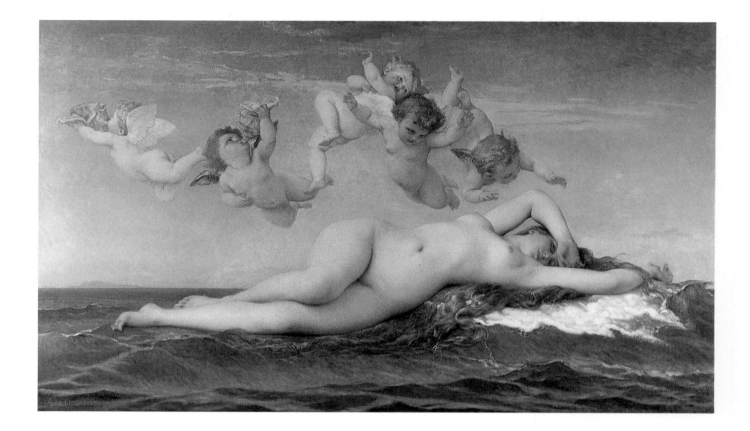

Alexandre Cabanel
The Birth of Venus
1863
oil on canvas 73 x 60
Paris Musée d'Orsay

While these artists were deep in their private discussions at the Café Guerbois, a few streets away in the fashionable xviith arrondissement, the official painters, the "Pompiers", entertained Paris society in their mansions. These painters lived well under the Empire, and did even better under the Third Republic whose rulers, in their aspirations to establish their legitimacy, instigated a vast and lengthy programme of official commissions.

The elect included Jean Benjamin-Constant, who decorated the ceiling of the Opéra-Comique 1898, Alphonse de Neuville, Meissonier, Gervex and Bonnat. By no means all were rabid foes of the Impressionists and Degas, who occasionally played the man-about-town, was on friendly terms with Gervex and Bonnat. However, this was an exception. Cabanel, the Emperor's favourite, and Gérôme, who painted the Czar of Russia and Queen Victoria, spent their lives trying to prevent the Impressionists from triumphing.

The success of the "Pompiers" was due mainly to the fact that their work was a true reflection of the prevailing ideals, which were those of the bourgeoisie. The moral ideals were those of love, virtue and courage, and the political ideals were those of the defence of and devotion to one's homeland. The social ideals were respect for labour and thrift. The poor were expected to bear their fate with resignation. The ultimate ideal was religion, the promotion of faith and Christian charity. None of these themes was omitted from fashionable painting and the public was thus delighted and flattered to behold itself reflected in an idyllic image.

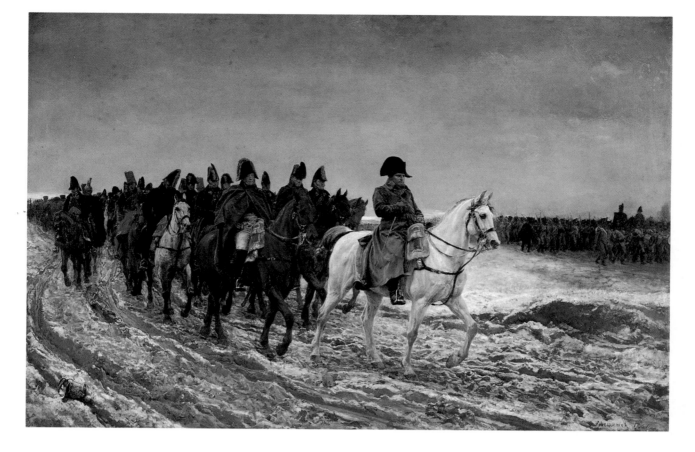

28

Between 1856 and 1868, Edgar Degas lived in Italy where he had family. It was here that he met Gustave Moreau. In 1858, he stayed in Florence at the home of Baron Bellelli, his uncle, and painted this family portrait. On the left, Baroness Bellelli, née Laure de Gas, the artist's aunt, stands near her two daughters, Jeanne and Julie. On the right, Baron Bellelli, is seen in the background and in profile, ensconced in his armchair.

The influences that can be detected in this painting are varied. There are traces of Holbein, Van Dyck, Raphael, Bronzino, as well as Ingres whom Degas considered as his mentor. Degas' technique, though classical, is a fore-taste of his later works, especially in its penetrating psychological study, the play of perspectives and delicate shades of colour.

Naturally, in this context, the painting counted for less than the subject matter. The artist had other concerns. His task was to tell a story, to illustrate, demonstrate, explain and, where appropriate, to glorify his subject. The "Pompiers" were particularly adept at this last task. They were absolutely clear in their own minds about what they were doing; they were serving the regime (whether it was the Empire or the Republic mattered little) as a general serves his country. In fact, there was some similarity in both these careers.

The road to success began at the Ecole des Beaux-Arts. Then the pupil would wangle his way into the Villa Medici, where he would study the Renaissance masters and submit a painting to the Salon. His canvas would be chosen, he would win a medal and would soon thereafter become a tea-cher at the Ecole des Beaux-Arts, the very place where he had studied. Some time later, he would be admitted to the Institute and his reputation would be established. These laureates died happy. The walls of the Sorbonne and the Palais de Jus-tice of Paris are still adorned with traces of their passage.

In short, everything began and ended with the Salon. Without it, there were no medals and no medals meant no commissions. This de facto dictatorship imposed by the Salon had been denounced by such eminent artists as the Romantic, Delacroix, the Realist, Courbet, and even by the extremely respectable Ingres. Yet in 1863 their criticisms were largely ignored.

Ernest Meissonier
The French Campaign
1814 1864
oil on canvas 51.5 x 76.5
Paris Musée d'Orsay

Paris, the first day of the Salon
at the Palais de l'Industrie
1869
Paris Musée Carnavalet

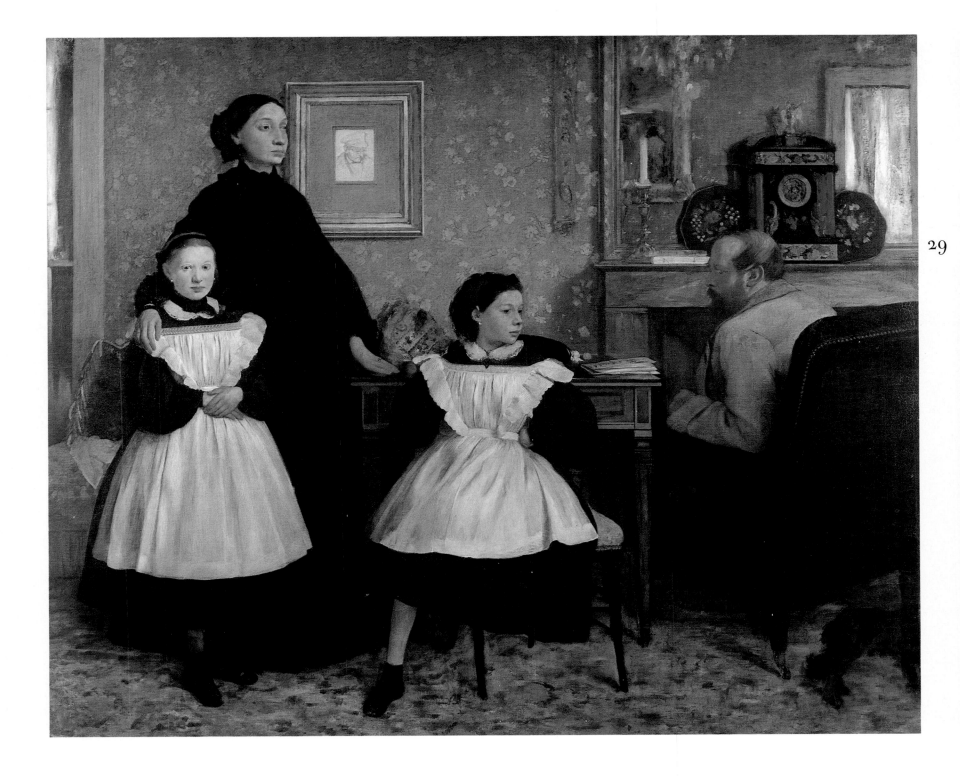

Edgar Degas
The Belelli Family
1858–1860
oil on canvas 200 x 250
Paris Musée d'Orsay

The Palais de l'Industrie built on the avenue des Champs-Elysées for the Universal Exhibition of 1855 demolished for the 1900 Exhibition and replaced by the "Grand Palais" and the "Petit Palais"

engraving by Asselineau
Bulloz

30

The Peregrinations of the Hanging Committee

(The hanging committee held) only one session, from one o'clock until seven, for six hours of which there was a frantic rush through this labyrinth! (...) By four o'clock they were an army in retreat. (...) Haphazardly, (...) they grabbed at anything to make up the numbers (...) What about this one? No, that one! Whatever (...) At last, they had done it, they limped away, safe and free!

Zola
L'Œuvre
A Second Chance

The Salon of the Académie des Beaux-Arts was an event whose influence extended far beyond restricted artistic circles. It was held in early spring and opened the Parisian season, so that thousands of people thronged there to see or to be seen. After 1855, the Salon was held in the Palais de l'Industrie, a huge construction of iron and glass which was demolished in 1900 to be replaced by the Petit and the Grand Palais on the Champs Elysées.

The selection ceremony was rather extraordinary. First, all the artists brought in their works which were packed into the 35 galleries of the building. The next step was the election of the 40-member Hanging Committee, which was always chaired by the Superintendant of Fine Arts, the Count de Nieuwerkerk, the self-declared enemy of freedom, whether in politics or in the arts. The Hanging Committee would then proceed on a lengthy peregrination through the packed galleries which could last for weeks. Jacques-Emile Blanche described the scene thus, "One could observe these gentlemen proceeding from one gallery to another, preceded by the attendants, and when the curtains of a room had been drawn behind them the chairman would ring a hand-bell. It was a very formal procedure and hundreds of artists would desperately try to discover their fate from some petty official of the Ministry of Fine Arts; they hung about (...) waiting for a medal or an honourable mention which might ensure that they enjoyed a prosperous year".

At the end of this tedious selection process, only half of the 6000 works exhibited were selected. The others were removed on pallets and returned to their unfortunate creators. The fortunate elect merely had to prepare themselves for the great day of the opening.

The Impressionists dreamed of becoming the heroes of the hour just like any other painter. Degas, for instance, used a technique at the time which was still influenced by the teaching of the Flemish and Italian masters, and it is difficult to understand how his work could bewilder the Academy. That is why these painters, who never intended to shock anyone, found the mass rejection of 4000 paintings in 1863 so appalling.

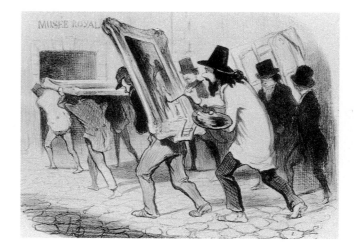

Honoré Daumier
The Last Day of the Reception of Paintings
lithograph plate No. 122 2nd version
in Le Charivari "Actualités" February 20 1846
21 x 27.2
Paris Bibliothèque Nationale Cabinet des Estampes

Henri Gervex

A Hanging Committee

1885

oil on canvas 299 x 419

Paris Musée d'Orsay

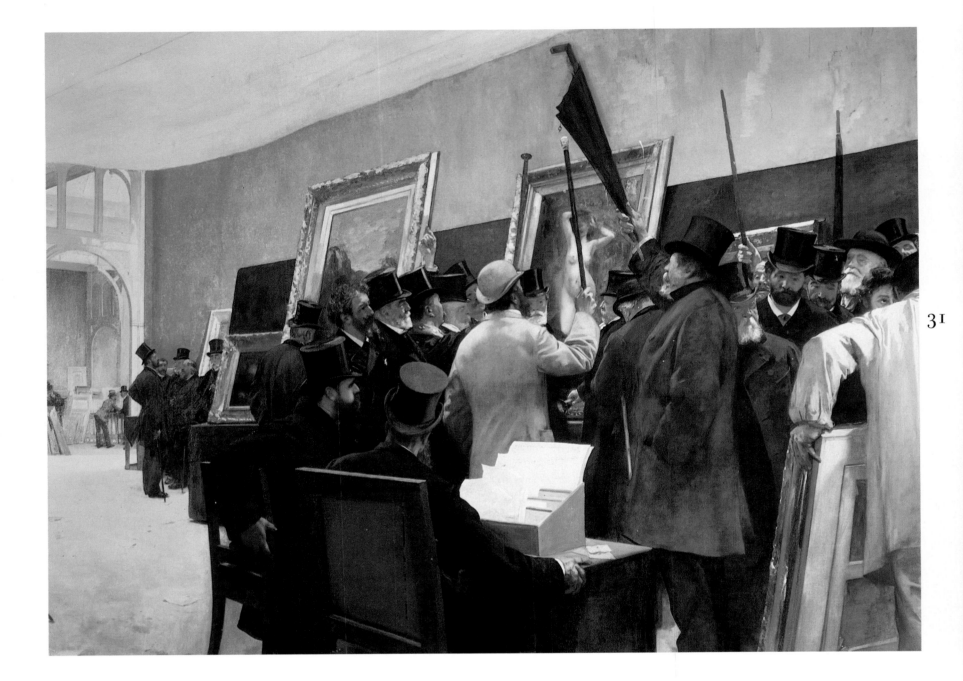

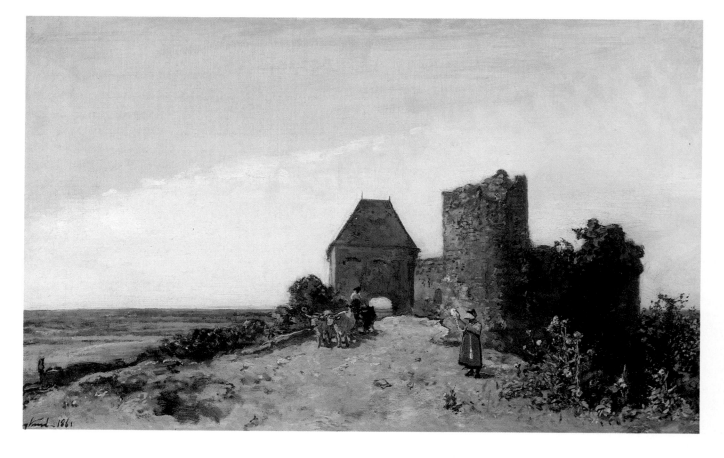

32 *Vulgar daubers*

When the news of this intransigent attitude spread through the studios of Paris, there was an instant reaction. For the first time, it reached right into conformist circles. Even a painter as conventional as Harpignies had been rejected. This was a clear example of an excess. At the time, Napoleon III was encountering some political difficulties which he was attempting to overcome by pandering to the liberals in order to win them over. On hearing of the general disquiet at this event, he realized that he had been presented with an opportunity. He unceremoniously ordered to be taken to the Palais de l'Industrie, where he ran his eye over no more than 40 of the condemned paintings and left, giving orders for all of them to be exhibited. The Hanging Committee, thus deprived of its prerogative, disapproved but obeyed. Manet and his friends thought they had won, but they had forgotten the sheep-like nature of the Paris public.

In any case, the rejected artists were by no means united. Six hundred among them declined the Emperor's offer, preferring to withdraw rather than exhibit next to someone like Cézanne. Like the Hanging Committee, they regarded these "independents" as vulgar daubers. The others were allotted a suite of seven rooms hastily arranged in an annex. Undoubtedly, this "Salon des Refusés" was an enormous success, but it was a success that the future Impressionists would have preferred to forego. On the very first day, 15 May 1863, 7000 visitors jostled with each other to view the canvases. The atmosphere was frenzied, the public could hardly contain itself. They expressed themselves in a confusion of laughter, mockery and insults. Thus it was that the public, who were even more conservative than the jury, turned this exhibition into an irresistible comic attraction. Even the critics, who might have been considered to be more enlightened, were particularly harsh. "There is something cruel about this display," wrote Maxime du Camp, "It reminds one of a farce at the Palais-Royal".

The painting which drew the most criticism of those thus exposed to public censure and scorn, was *Luncheon on the Grass* by Manet. By the following day, everyone in Paris was talking of nothing else . "You've become as notorious as Garibaldi", Degas is supposed to have said to Manet, expressing a mixture of sympathy and jealousy.

Johann Barthold Jongkind
The Ruins of the Château de Rosemont
1861
oil on canvas
Salon des Refusés 1863 donated by Moreau-Nélaton 1906
Paris Musée d'Orsay

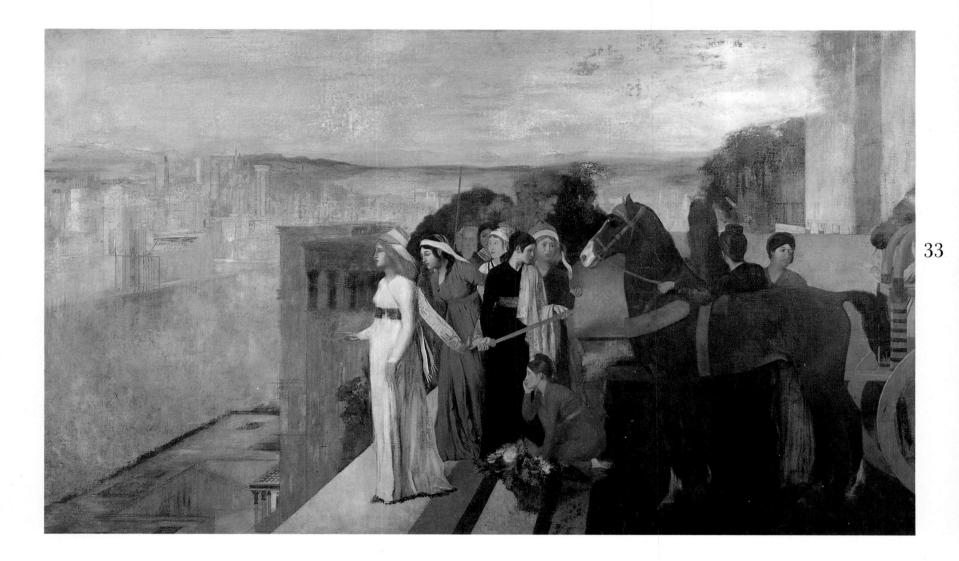

When a young painter wanted to be noticed at the Salon he could not confine his offerings to portraits, but had to present an historical subject. Semiramis, an unfinished painting, reveals to what extent the young man was fascinated by quattrocento Italian painting. In spite of the hieratic attitudes of the figures and the rigorously strict composition, the whole painting is endowed with an airy and fluid quality.

According to Lillian Browse, wrote François Fosca, this Semiramis is not in the standard repertoire of subjects from antiquity, but from a play on the subject, performed at the Opera. The painting may thus have marked the first occasion on which Degas found the subject for a painting on the stage.

Edgar Degas
Semiramis Founding Babylon
1861
oil on canvas 151 x 258
Paris Musée d'Orsay

34

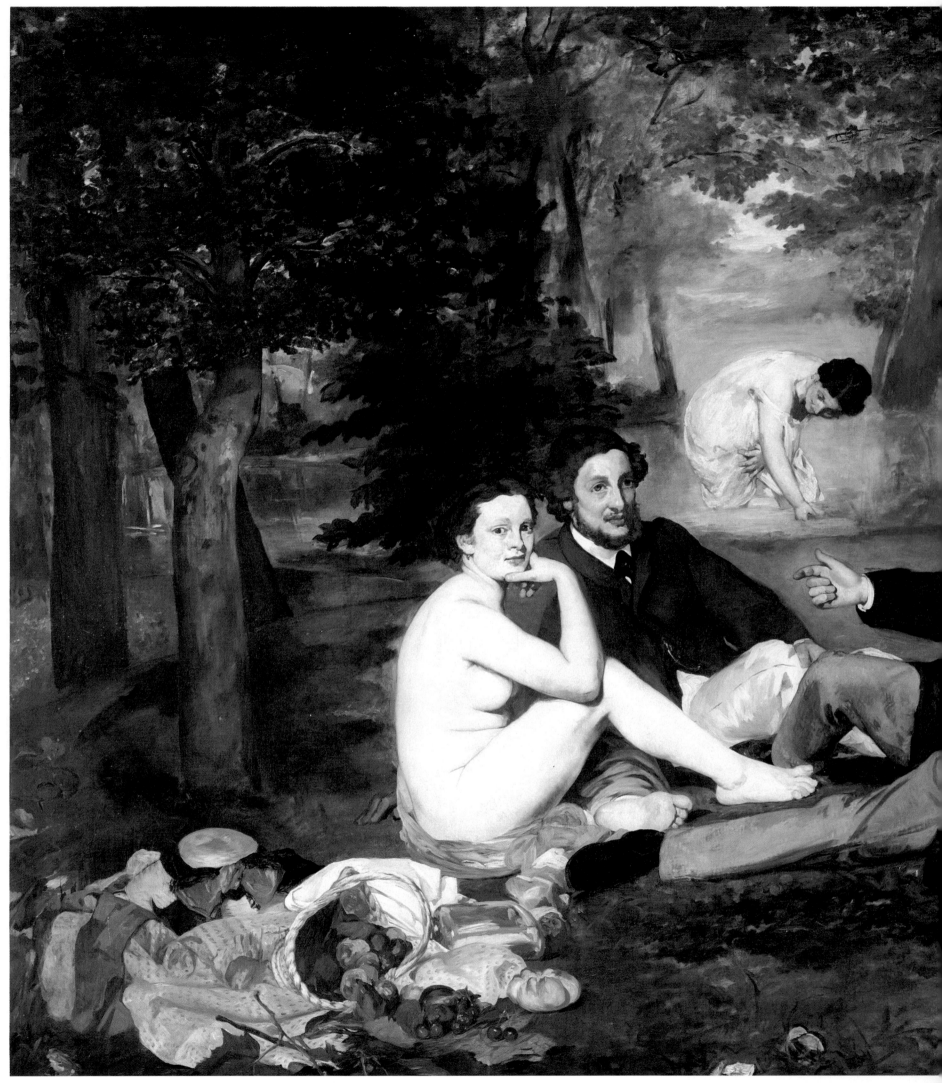

Edouard Manet
Luncheon on the Grass
1863
oil on canvas 208 x 263
Paris Musée d'Orsay

Luncheon on the Grass 35

What was so scandalous about *Bathing* (its original title)? Its enemies blamed it for two major reasons, namely that the subject matter was obscene and the pictorial treatment vague, inept or even ridiculous. "Mr Manet will be talented," wrote Ernest Chesneau, "On the day he learns drawing and perspective; he will have taste when he stops choosing subjects for their ability to shock".

The criticism was quite perceptive. Manet's detractors were better at discerning the innovation in this painting than were his supporters. Firstly, there was the subject matter. There was nothing surprising in the fact of a nude woman, this was a particularly popular theme at the time. What was really shocking was the fact that the men in the painting were fully clothed, and worse still, were dressed in the bourgeois style of the day. The woman's nudity was thus portrayed in all its crudity. Puritanical natures could not bear such a simple truth.

As far as the pictorial treatment was concerned, Manet introduced two important innovations that can be considered as landmarks in the history of art. The composition rejected the traditional illusion of perspective, opting instead for a sharp and blatant contrast of blocks of colour, completely omitting the subtle blending known as "fondu" so beloved of the "Pompiers". A simplified representation and a rejection of the photographic illusion which was so popular at the time were the embodiment of the new style of painting which was to last from the Impressionists to Matisse.

One heard the sound of mounting laughter, an increasing clamour, a swelling tide about to roll over at its peak (...) A huge mass, (...) crushed together in front of the painting (...) The relentless explosion, reaching its peak in a crescendo of uncontrollable laughter (...) It was almost a riot, the crowd was growing bigger, expressing itself through a range of idiocies, stupid remarks, silly, salacious snickering, the reaction of the moronic middle classes to a truly original work of art.

Zola
L'Œuvre
describing the public
at the 1863 Salon viewing

Edouard Manet
Lola de Valence
detail
1861
oil on canvas 123 x 92
Paris Musée d'Orsay

Thus, despite himself, Manet found himself the leading light in this new generation of painters. Yet, hitherto his life had been fairly uneventful. He was born in Paris in 1832. His father, a civil servant in the Ministry of Justice, had intended him for a career in the navy. Manet managed to ensure that this enforced vocation lasted no longer than his voyage to Rio on the *Havre et Guadeloupe* as a naval cadet. On his return to France, he succeeded in convincing his father to give up the idea. In 1850 he registered at Couture's studio with his friend Antonin Proust, who was to become Minister of Fine Arts of the Third Republic. Manet remained at the studio for six years, travelling in Holland, Germany and Italy. At the age of 26, he met Baudelaire while visiting a family friend. Some time later he encountered the young Degas while the latter was copying a work by Velasquez at the Louvre with an audacity that impressed him. The two men took an immediate liking to each other.

Manet was rejected at the Salon of 1859 at a time when he was still feeling his way, but he made up for this failure two years later in obtaining an honourable mention for two of his works: *The Guitar Player* and *Portrait of M. et Mme Manet*, his parents. The latter work already reveals Manet's taste for realism and his refusal to idealize his subjects. "They look like two caretakers," remarked a close friend who was disconcerted by the treatment.

38

Edouard Manet
Lola de Valence
1861
oil on canvas 123 x 92
Paris Musée d'Orsay

has the rather crude and austere look of real life (...) Everyone has complained that they consider this nude body indecent; it had to be so since it is real flesh (...) When our artists give us Venuses, they are altering nature, and are lying. Edouard Manet has asked himself why should he lie, why shouldn't he tell the truth; (...) For my part, I know that you have succeeded admirably (...) in energetically translating the truths of light and of shadow, the reality of objects and human forms into a special language".

Manet himself never understood the reason for the unleashing of such passions. On 4 May 1865, he wrote to Baudelaire : "Insults are raining down on me like hail, I have never had such a time of it (...) I would have liked your sound opinion about my paintings, for this outcry is getting on my nerves, and obviously somebody must be wrong". Finally, in August, somewhat disheartened, he packed his trunk and set out for Spain.

42 *A Spanish Interlude*

Berthe Morisot, the Model.
Théodore Duret (on his
portrait painted by Manet)
"The painting is entirely
in shades of grey (...) yet
Manet was not satisfied
(...) He added an
unexpected item (...)
a lemon (...) Apparently,
this painting in greys and
monotones did not please
him. He missed the colours
which pleased his eye".

Théodore Duret
Histoire d'Edouard Manet

On the advice of his friend Astruc, Manet left for Madrid to study the works of Velasquez and Goya in the Prado. On arrival, he went, as any French-man would, to the Hôtel de Paris. However, the appalling food made him so ill that he was just considering leaving again that very evening, when he happened to meet a fellow-countryman in whom he confided his misfortunes. The man, whose name was Théodore Duret, was returning from Lisbon and knew nothing about the Salon and Manet. By the end of the meal they had become firm friends and Duret, who was to be Manet's biographer, was unaware that he was entering the history of the Impressionists. This encounter did not prevent Manet from crossing back over the Pyrenees less than a week later, and ended his enthusiasm for things Spanish forever.

The next two years were rather bleak. In 1866, Manet suffered the rejection of his *The Fife Player* and at the following year's Universal Exhibition, the jury rejected his work automatically, along with that of Monet, Renoir, Sisley, Bazille and Courbet. The dispute turned nasty. Zola continued to defend Manet vigorously in the columns of *L'Evénement*, so vigorously, in fact, that readers actually complained to the editor who was so worried that he insisted on inserting contradictory articles to redress the balance. Zola refused to participate in this exercise and resigned from the newspaper.

Manet refused to be discouraged. He decided to imitate Courbet who was organizing his own exhibition, as he had done in 1885, on the Quai de l'Alma, just outside the Universal Exhibition. Manet found a wooden hut in which he hung fifty canvases and published a catalogue. "Manet opens in two days," wrote Monet to Bazille on May 21 1867. "He is going through agonies". This could be termed a premonition, for the show was a complete fiasco.

The year ended with Manet at his lowest ebb.

The Paris Universal Exhibition of 1867
The private garden, the big glasshouse
Paris
Bibliothèque des Arts Décoratifs

Edouard Manet
Portrait of Théodore Duret
1868
oil on canvas 43 x 35
Paris Musée des Beaux-Arts de la Ville de Paris

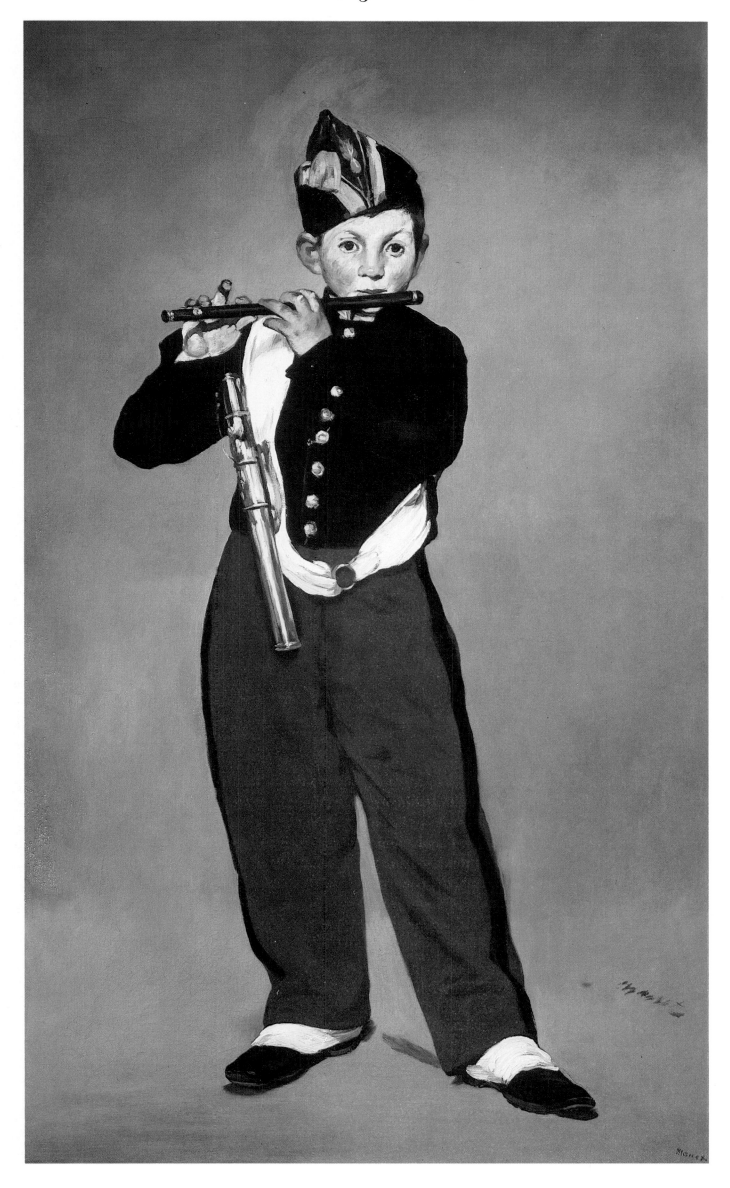

Edouard Manet
The Fife Major
1866
oil on canvas 161 x 97
Paris Musée d'Orsay

44 *Berthe Morisot, The Model*

Meanwhile, a young lady of good Parisian family was gaining quite a reputation as a landscape artist. Berthe Morisot was 26 at the time. She was the daughter of Prefect under the Empire who had become an arbitration judge in the Audit Court (Cour des Comptes), and she had the rare good fortune for the times in that her father was genuinely fond of painting and her mother did not object to her becoming a painter. They engaged a teacher for Berthe and her sister Edma. Berthe worked enthusiastically. In 1859, while visiting the Louvre, she met Fantin-Latour. In 1860, both sisters entered Corot's studio; he later sent them to Auvers-sur-Oise to study the landscape. It was here that Berthe became involved with Daubigny, Daumier and Guillemet, but she wrote to Corot that she missed him. "Work hard and confidently," he replied, "(and) do not think too much of old man Corot; nature is a much better counsellor". These lessons were productive since from 1864 onwards Berthe Morisot was a regular exhibitor at the Salon. Corot undoubtedly influenced her art but Manet definitely influenced her life.

Fantin-Latour crops up here again, in that it was he who introduced Berthe to Manet in 1868. They took to each other immediately. Very soon Berthe became both his pupil and his favourite model (*The Balcony* 1868-69). On May 2, 1869, she wrote to Edma, "I definitely consider him to have a delightful nature which I find infinitely pleasing.

His paintings continue to one the impression of some wild or even slightly unripe fruit". For his part, Manet wrote to Fantin-Latour: "The Morisot sisters are charming. What a pity they aren't men!"

On another occasion, Berthe, jealous of a rival, complained, "Manet keeps moralizing and asking me to take that wretched woman, Miss Gonzales, as a model (...) All his admiration is concentrated on her". This was probably a piece of coquetry, since she later wrote to Edma, "I am amazed and delighted for I have received the greatest praise. I am doing much better than Eva Gonzales".

This was also the opinion of Théodore Duret, who went even further, considering that "She was not (Manet's) pupil. (....) What she had to borrow from him was that new technique, that brilliant form of execution (...) which her own gifts as a great artist enabled her to appropriate for herself". Morisot possessed an additional attribute in that for a while she was able to convert Manet of the virtues of the "open air".

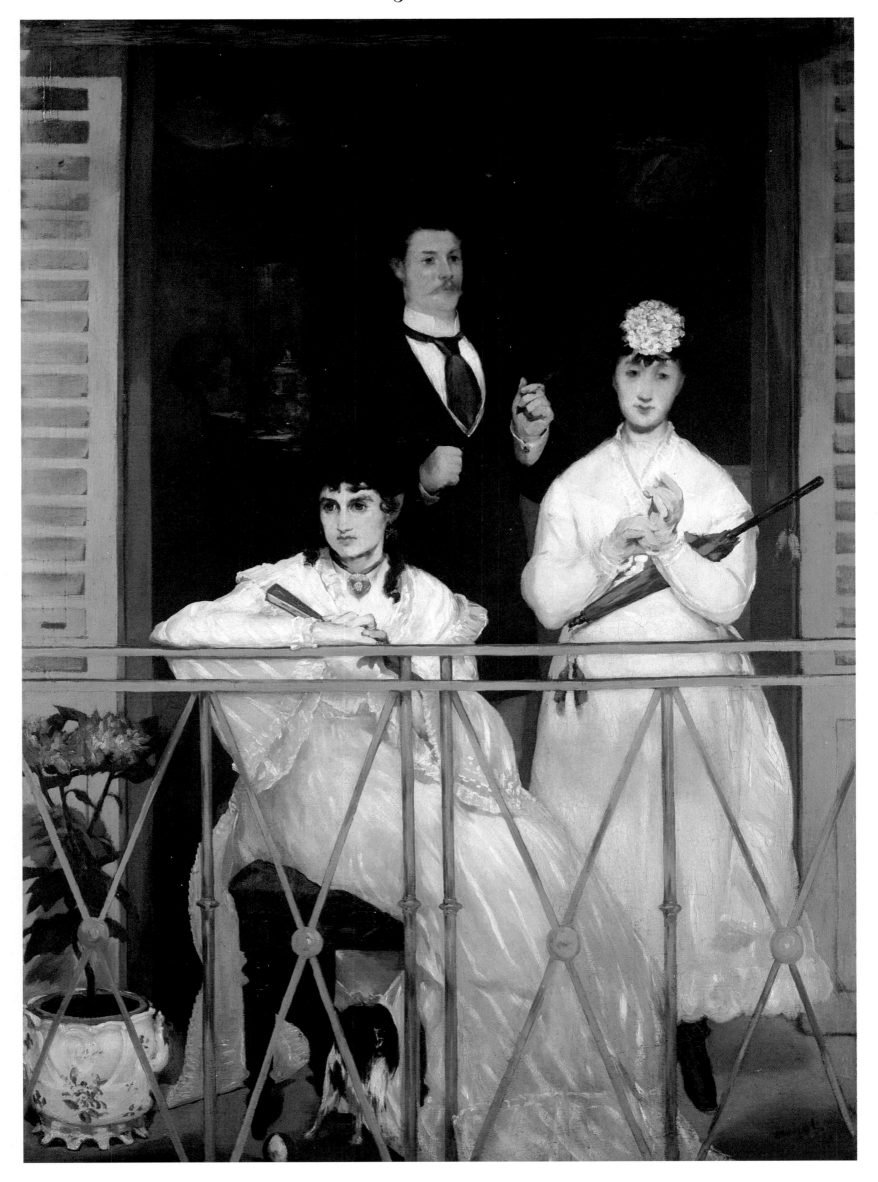

Edouard Manet
The Balcony
1868
oil on canvas 170 x 125
Paris Musée d'Orsay

46

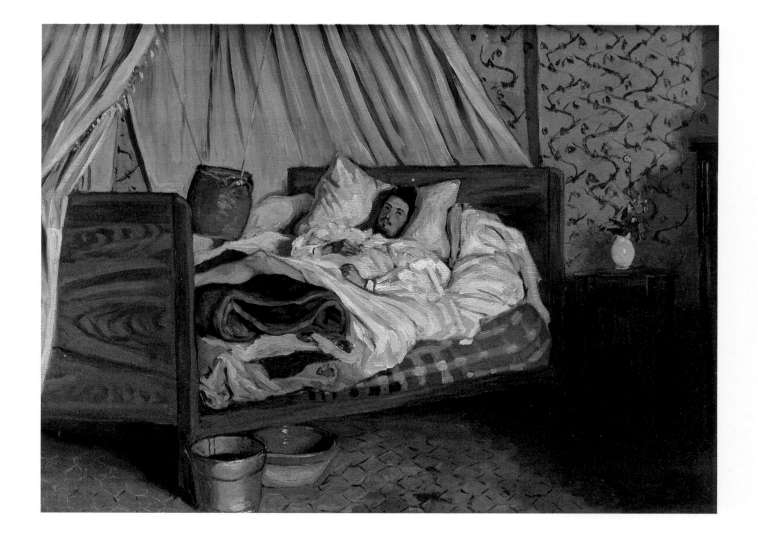

Frédéric Bazille
Makeshift Ambulance or Monet
after his Accident at the Inn at Chailly
1866
oil on canvas 47 x 62
Paris Musée d'Orsay

In 1863, Monet and his friends had set about discovering the pleasures of painting from nature. This naturally led them to the Forest of Fontainebleau where the painters of the Barbizon school were already working. Barbizon was a little hamlet, a strip of habitation which ran along the edge of the forest and was part of Chailly-en-Bière, the village which can be seen on the horizon of Millet's *The Angelus*. In addition to Millet, the other painters to be found there included Corot, Théodore Rousseau and Diaz. All them worked from nature, making their preliminary sketches in the open air. Their task had been greatly facilitated by the recent invention of zinc tubes. Renoir was to confide in his son many years later on the subject that "It was these tubes of paint, which are so easy to carry around, that enabled us to paint entirely from nature. Without these tubes of paint, there would have been no Cézanne, no Monet, no Sisley, no Pissarro, no such thing as Impressionism as journalists were to call it".

Monet and his friends lodged in Chailly itself, at the Auberge du Cheval Blanc. They only stayed for a week but returned in 1865. It was during that second visit that Monet was hit in the leg by a discus thrown by an English athlete. The leg was fractured, and Monet was forced to take to his bed. Bazille, who happened to be a medical student, undertook to look after him. The result of the accident was a little oil painting by Bazille entitled *The Makeshift ambulance*. Renoir and Sisley joined them and when Monet recovered, the four of them moved to Marlotte to Mère Anthony's inn, where Renoir painted the cabaret.

I am in Chailly only to oblige Monet. (...) Unfortunately (...) the weather has been awful and I have only been able to pose for him twice.

Bazille
writing to his parents
August 23 1865

48 *Large Canvases*

It was in Fontainebleau again that Monet began his *Luncheon on the Grass*, a huge painting whose title was a tribute to Manet. He completed several preliminary sketches, then stored his enormous canvas in an outbuilding of the inn. Bazille and Camille Doncieux, Monet's mistress, posed for all the figures in the painting. Courbet came to view it and quite liked it, but suggested a few changes. Monet followed his advice but was disappointed with the result, so he rolled up the canvas and abandoned it. He eventually returned to it, but it had been severely damaged by the damp. Monet saved what he could and threw the rest away.

In the following year, 1866, Monet decided to produce another large canvas. The result was *Women in a Garden* for which the only model was Camille. Courbet severely criticized the work and the hanging committee for the Exposition Universelle of 1867 rejected it for exhibition.

The only habitué of the Guerbois who refused to participate in these excursion was Degas. In fact, he was extremely hostile to the "Plein-airistes" as the open-air painters called themselves. "If I were the government, he said, I would send a squad of gendarmes to keep observation on people who paint landscapes from nature. (...) Oh, I don't wish anyone any harm, so I'd allow them to use small shot in their guns, at least to begin with".

So the others carried on without him and Monet, whose influence over his colleagues grew greater with each passing year, brought them to his home territory, that is to say to the other side of the Seine estuary, to Honfleur, just opposite Le Havre.

Claude Monet

Claude Monet
Luncheon on the Grass
1865-1866
oil on canvas 418 x 150 (fragment)
Paris Musée d'Orsay

Misadventures 49

Renoir, the most reluctant walker of the group, experienced several misadventures during his escapades in the forest. The first of these was the time he was attacked by a gang of Parisian youths, while painting on his own. Fortunately, a man suddenly appeared just at the right moment and rid him of the troublesome gang. The man was Diaz. He examined Renoir's work and complimented him upon it, but added, "Why is your painting so dark?" Renoir never forgot that remark.

On another occasion, shortly before 1870, he saw a desperate man dash out of a thicket. The man, whose name was Raoul Rigaut, was a journalist who was being hunted down by the imperial police. Renoir came to his rescue and helped him to escape to England secretly. This act of kindness was eventually repaid by Rigaut. During the Commune of Paris in 1871, Renoir was arrested by insurgents who took him for a spy. He was about to face a firing squad when Rigaut, who in the meantime had become the public prosecutor of the Commune, recognized his friend from Fontainebleau. Two minutes later Renoir was free. Rigaut himself was not so lucky; he was executed by troops from the regular army after the Bloody Week and the defeat of the Commune.

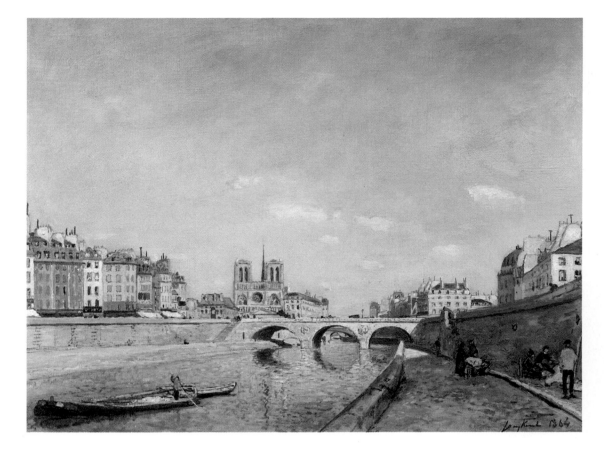

50 *A Painter among the Dockers*

If Manet was the undisputed role-model for the younger generation, he remained none the less a Parisian painter and always distrusted open-air panting and "impression" in the sense that Monet and his friends were to impart to the word. It was Jongkind and Boudin, both of whom were working on the Côte de Grâce, who were the real initiators of the style. In this respect, they deserve the title of pre-Impressionists.

Johann Barthold Jongkind 1819-1891 was born in the Netherlands, in the province of Overijssel. He was the son of a Protestant minister, and had come to France early in life. In 1848, a painting he exhibited at the Salon received an honorable mention, as did two more at the 1855 Salon. He then went to Le Havre where he found work as a docker. Some time later, he took up residence in the Rue du Puits in Honfleur. Jongkind was a engaging and colourful character, a hard drinker who ate prodigious quantities of shrimps. He used to stroll about the harbour in a frock-coat and wooden clogs, in the company of his friends, the fishermen.

Yet in contrast to his extravagant lifestyle, the delicate watercolours he produced at Honfleur fully convey the gentleness of the Côte de Grâce landscape. Jongkind was the painter par excellence of the "watery" atmosphere. He could capture the feel of transient ligh and his subject matter as well as his style are the forerunners of the Impressionist painting.

Johann Barthold Jongkind
The Seine at Notre-Dame
1864
oil on canvas 42 x 56.4
Paris Musée d'Orsay

*With Boudin
working from nature
in 1858*

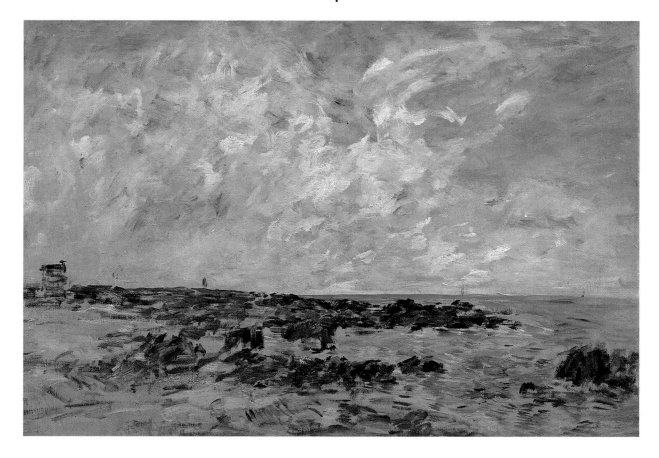

Another painter who loved Honfleur was Eugène Boudin who was born there in 1824. In its edition of Wednesday, 10 August 1898, two days after his death, the daily paper, *Le Havre*, wrote of him, "The son of a pilot from Honfleur, he learned to draw by instinct (...) the scenes which the water and the sky offered him. He became a bookseller by chance. When Troyon, who was the first to give him some advice, first met him, Boudin was only 20 years old. (...) He was moody, a day-dreamer and reserved, so he always worked at a distance (from the studios)".

Boudin was introduced to Baron Taylor, Inspector-General of Fine Arts, in 1848, who entrusted him with an assignment in Belgium and in the north of France. He returned to Paris for three years in 1851 and was able to work thanks to a special scholarship awarded to him by Le Havre municipality. At the end of this period, he returned to Honfleur, and lived at the Ferme Saint-Siméon, at the inn belonging to Mère Toutain, which stood in a magnificent position on a hill overlooking the town.

The area was already well-known to painters. Courbet, Couture, Diaz, Corot, Daubigny and many others had stayed there and it was on this coast that Boudin was to meet Baudelaire and Courbet. However, the most important encounter as far as Impressionism is concerned was Boudin's meeting with Monet in 1858. Monet had just turned 18 and had gained some notoriety as a carica-turist in Le Havre where he was a pupil at the local lycée. It so happened that Monet's and Boudin's works were on show at the same framemaker's. The artists were introduced to each other. Monet was on the defensive at first, but one day he accompanied Boudin to paint from nature. Thenceforward, Boudin initiated him into colour and open-air painting.

That same year, in an article about the Beaux-Arts Exhibition, in the *Journal du Havre*, F. Santallier wrote, "It would be unfair not to consider Monsieur Boudin as a painter with a future whose present work has already attracted much attention (...) Mr Monet's *View of Rouelles* has some of Monsieur Boudin's qualities".

As Boudin's pupil, Monet never forgot his advice when he left to study in Paris. In 1862, Boudin introduced Jongkind to Monet. Later, they were joined by Bazille, Sisley, Renoir and Whistler. "We live in Honfleur (and) eat at the Ferme Saint-Siméon, on the cliff," wrote Bazille to his family, "(...) That is where we work and spend our time".

Happy days! They were to continue on the banks of the Seine, on the outskirts of Paris. This is when the painters began to produce their first studies of the play of light and its fragmentation on water or the way in which it is diluted in mist and the sky. It is no accident that Boudin, who was their senior, was dubbed by Corot "the Master of the Skies".

Eugène Boudin
Rocks at Trouville
c. 1894-1897
oil on canvas 50 x 74
Le Havre Musée des Beaux-Arts

52

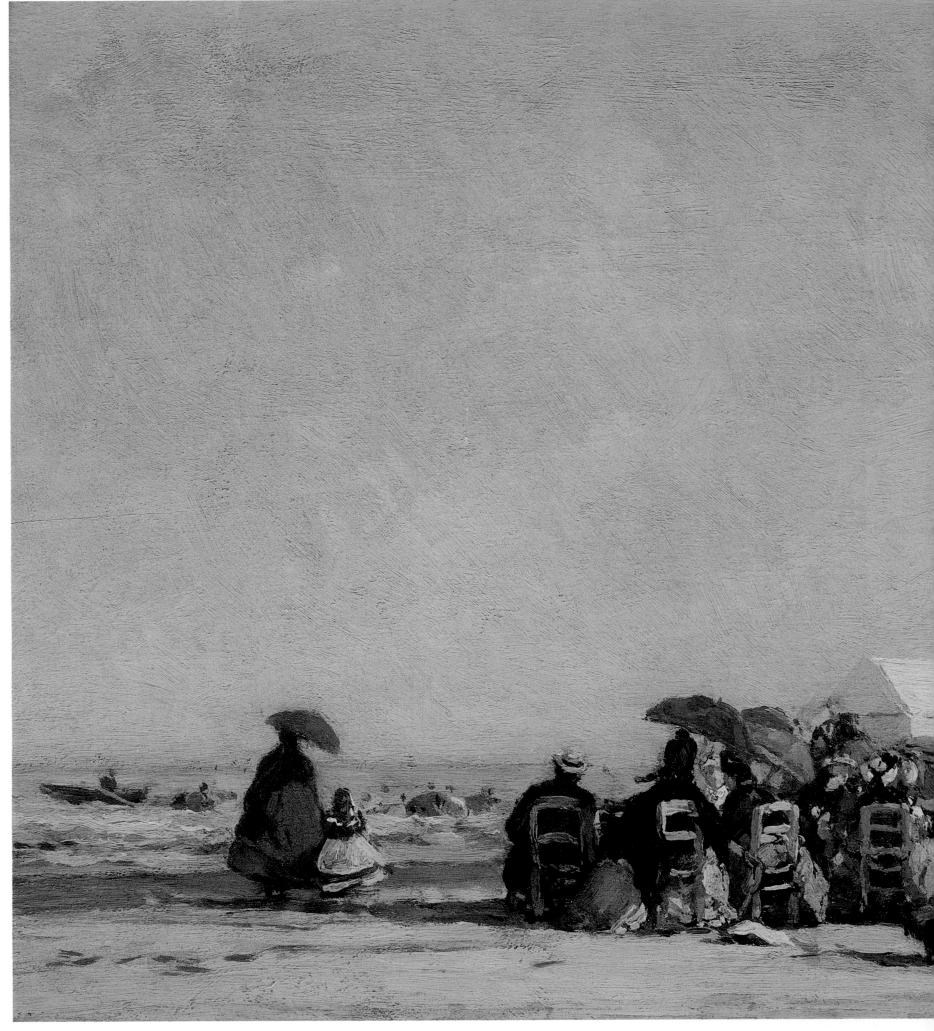

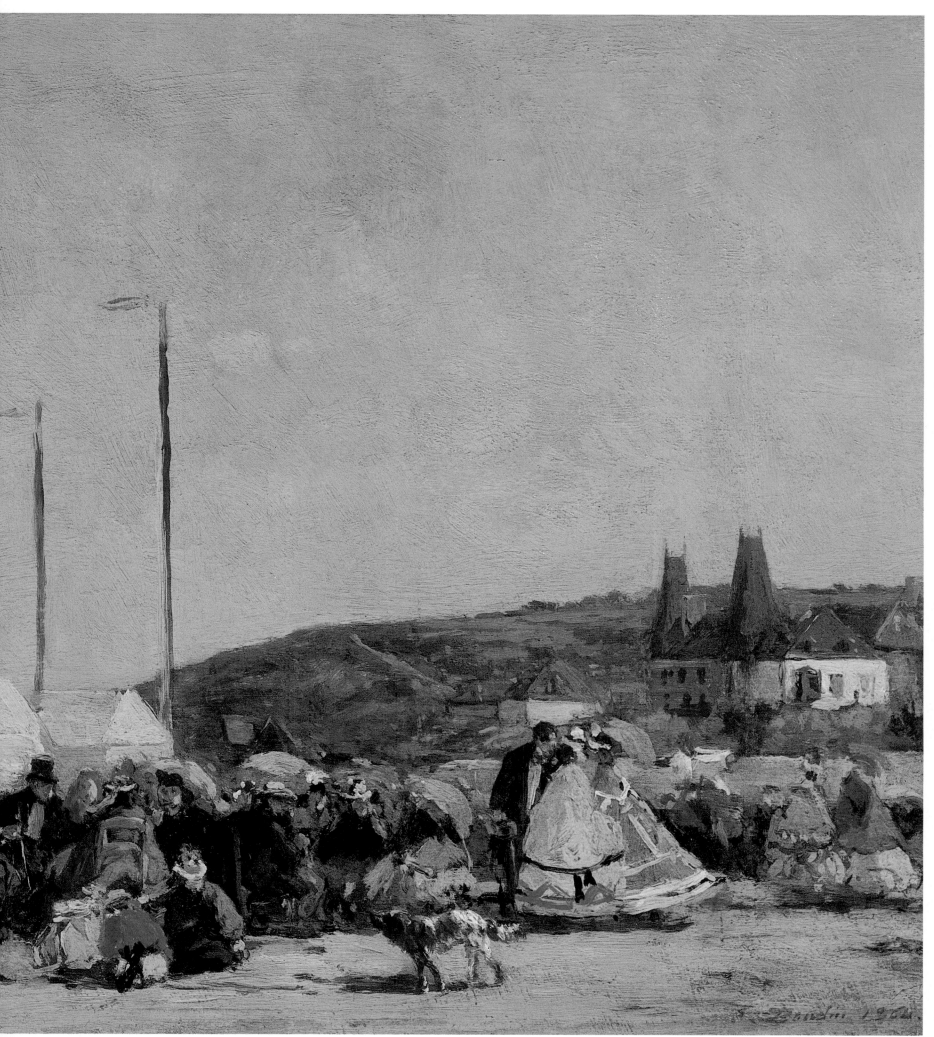

Eugène Boudin
The Beach at Trouville
1864
oil on panel 26 x 48
Paris Musée d'Orsay

54

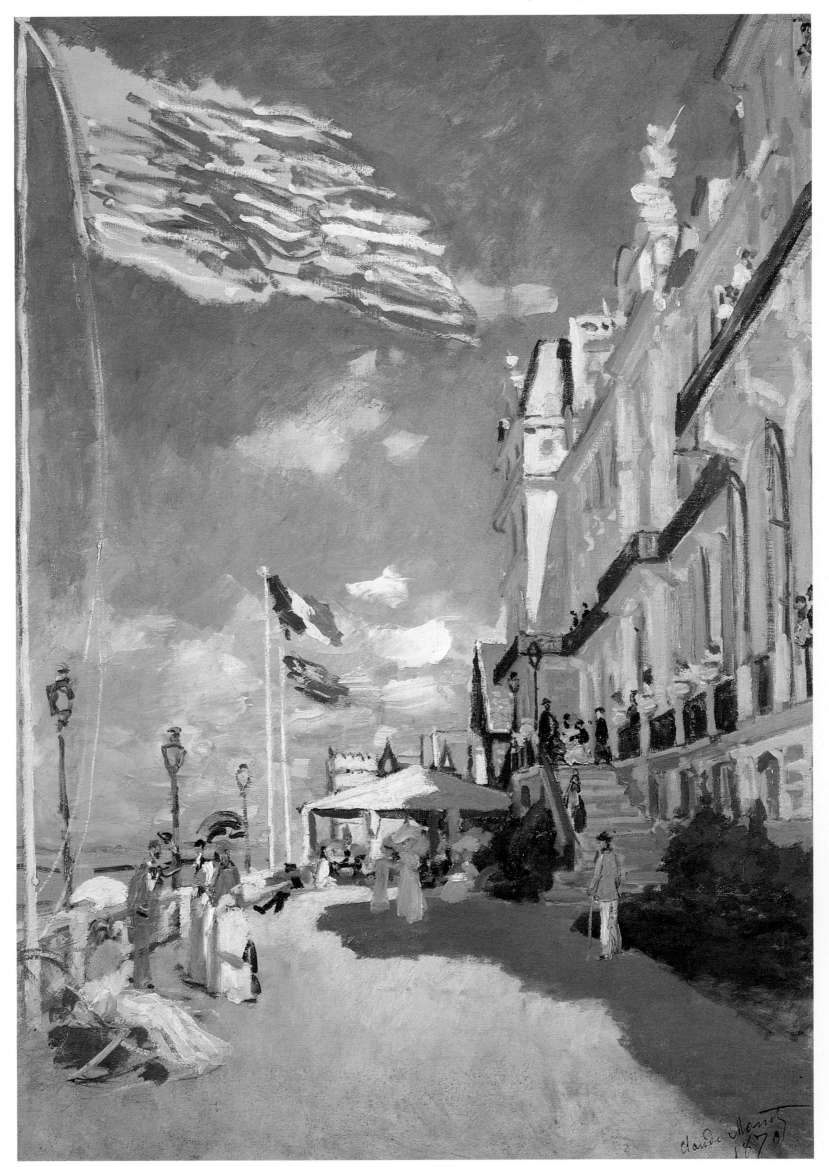

Claude Monet
Hôtel des Roches-Noires, Trouville
1870
oil on canvas 81 x 58
Paris Musée d'Orsay

Bennecourt's (...) yellow houses line the bank for almost two kilometres.

Zola
L'Œuvre
the village of Bennecourt

The Auberge Ganne 55

In 1866, as soon as the weather improved, Zola decided to set up house on the banks of the Seine, in Bennecourt, at Mère Dumont's inn, the Auberge Ganne. Cézanne and Monet went with him. Their days were spent rambling and bathing and "In the evenings," wrote Zola in *A Farce*, "The company would lie down on two bales of straw (...) at the far end of the courtyard (...) We (would smoke) our pipes and look at the moon (...). We disposed of well-known people, we (revelled) in hopes of overthrowing everything in a near future in order to bring forth a new art of which we would be the prophets".

Monet came back in 1868 and rented a house for six months but left when he ran out of money, entrusting Camille and his son to the care of some peasants while he set out for Le Havre to ask his family for help which they would not give. Fortunately, he was able to sell a few canvases to Gaudibert, a ship-owner in Le Havre. He returned to Bennecourt in early 1869 and fetched Camille.

However, he was so disheartened by his bad luck the previous year that he boycotted the Auberge Ganne and instead chose to live in Bougival where the three of them rented a little flat.

Monet and Camille's finances were in a catastrophic state. When Monet's work was rejected for the 1869 Salon, he was reduced to begging from Bazille for the money to buy some tubes of paint. "Dear friend," wrote Monet, "Do you want to know what state I am in, and how I have lived during the week in which I have been awaiting your letter? Well, ask Renoir who has been bringing us some bread from his home so that we might not starve".

Yet it is a paradox of bohemian life that these hard times were also days of freedom, freedom of life and freedom of creation. Monet had broken away from the academic rules once and for all, had assimilated Boudin's teaching, and was finally at liberty to give birth to "Impressionist style".

An old house, dumped by the Seine (...) and which seems to have been converted from a huge shed. Downstairs, there is a large kitchen and a room big enough for a dance-hall. There are another two rooms upstairs, big enough to get lost in.

Zola
L'Œuvre
the house rented
by Monet at Bennecourt

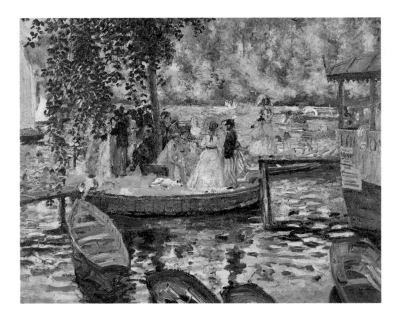

56 *La Grenouillère*

Just upstream from their flat on the island of Croissy near Chatou, there was a sort of floating café built on a pontoon which was called La Grenouillère ("The Froggery"). It was here that on Sundays, the new train service between Paris and Saint-Germain would disgorge a horde of a particular kind of "female frog". As Guy de Maupassant wrote in *Paul's Wife*, "Women and girls with yellow hair, large, bouncing breasts, exaggerated rumps, their faces plastered with white make-up, their eyes smudged with black and their lips blood-red, tightly-laced and corsetted into flamboyant dresses. (...) These females, who seemed to have dislocated thighs, would leap about inside their layers of skirts, showing their underclothes (...) and they swayed their bellies, and wiggled their bottoms and shook their breasts spreading around them the energetic aroma of sweating women".

It was here, torn between the torment of an empty plate ("We don't manage to eat every day", wrote Renoir) and the excitement of the holiday atmosphere that Monet and Renoir each painted their *Grenouillères*, on the same day, at the same time, side by side, which many experts consider to be the true beginnings of Impressionist painting.

The need to work fast, as much for lack of money as for the urge to catch the moment, and the technical impossibility of mixing certain colours without spoiling their brilliance and strength caused them (especially Monet) to use short brushstrokes, juxtaposed rather than blended, and released them from the dominance of the line and of drawing which was typical of officially-approved art. Henceforward, their painting was to be about colour more than anything else.

Pierre-Auguste Renoir
La Grenouillère
1869
oil on canvas 66 x 81
Stockholm National Museum

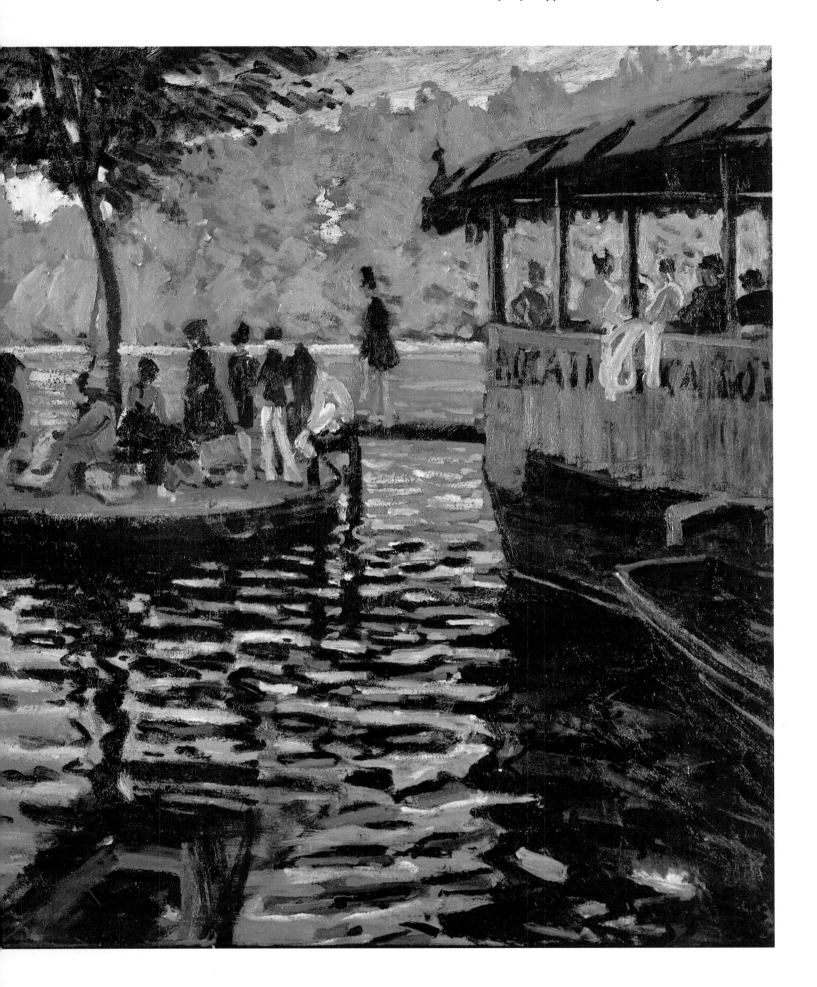

Claude Monet
La Grenouillère
1869
oil on canvas 75 × 99
New York Metropolitan Museum of Art

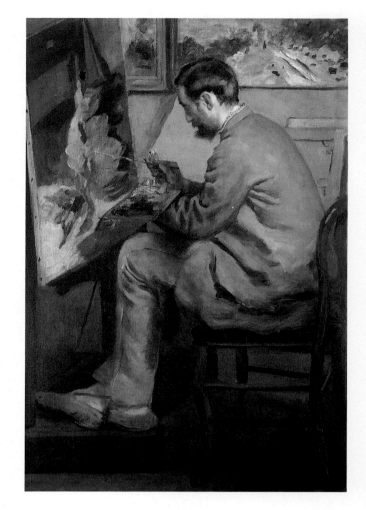

"*A Gang of Lunatics*"

The East Room is the halt in which great art expires, that dump in which gigantic paintings on historic and religious themes are heaped up.

Zola
L'Œuvre

As long as the Impressionists continued to assert their originality, they encountered the hostility of the Hanging Committee of the Salon. Even though all were accepted for the 1866 exhibition – with the exception of Manet, whose *Fife Player* was rejected – their paintings were deposited in what at the time was called "the dump". In 1867, a new wave of mass rejections discouraged their hopes. Between 1868 and 1870, Monet had two paintings rejected, Bazille had one, and Sisley's offering for 1869 was rejected as were all of Cézanne's offerings.

The Academy would not give in. "It is Monsieur Gérôme who has done the damage". wrote Bazille in 1869, "He has treated us like a gang of lunatics and has said that he believes it to be his duty to do everything in his power to prevent our painters from exhibiting". Of the rejected paintings, the most important is probably *Women in a Garden*, for which Camille had posed. The art historian, P. Francastel, has described the work as having been "Painted in the open air with blue and violet shadows and a sprinkling of circles of light filtering through the foliage. It is impossible to know if the light-coloured dresses of the women are white, blue or pink. The painting represents a complete style, as well as Manet's influence. *Women in a Garden* was a statement and the Hanging Committee were well aware of it".

Pierre-Auguste Renoir
Frédéric Bazille at Work
1867
oil on canvas 105 × 73.5
Paris Musée d'Orsay

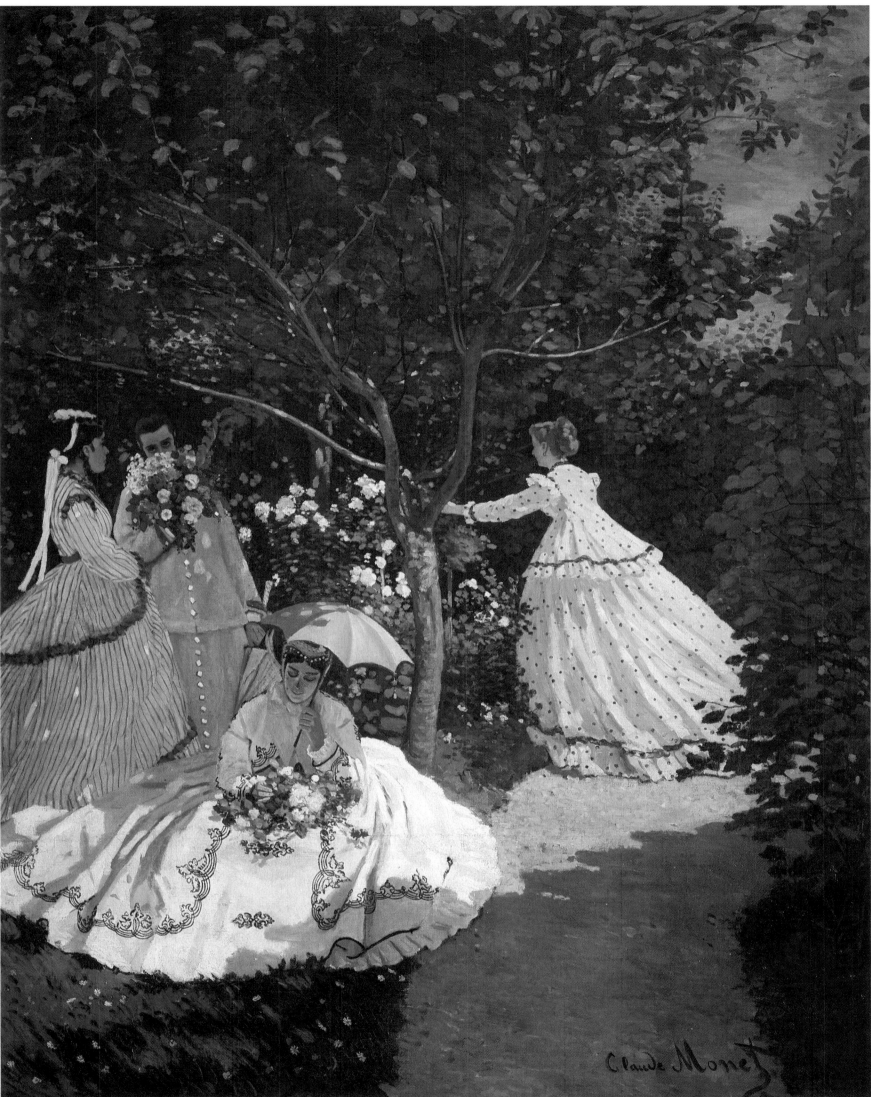

Claude Monet
Women in the Garden
1867
oil on canvas 255 x 205
Paris Musée d'Orsay

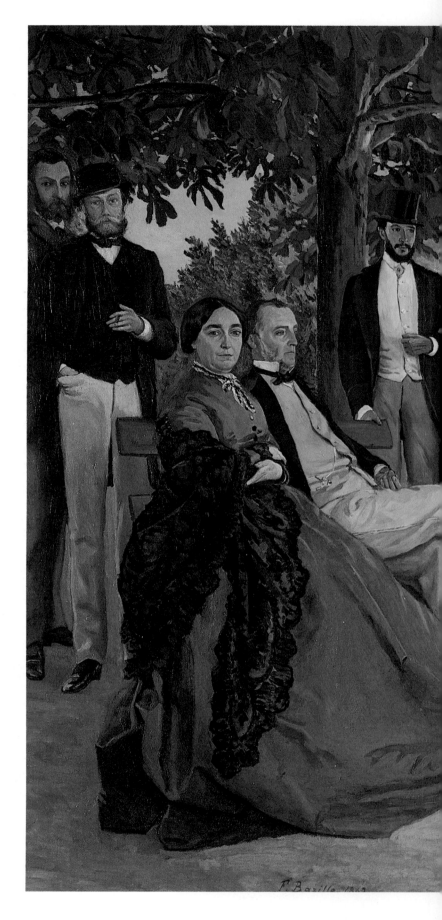

60 *"A Very Handsome Young Man"*

The following year, under the combined influence of Monet and Manet, Bazille painted *Family Reunion* 1867 whose connection with *Women in a garden*, which he had bought from Manet, is obvious although it remains more conventional in style. This canvas was exhibited at the 1868 Salon. His family can be seen posing on the terrace of the house they owned near Montpellier.

Bazille was born in 1841 in Montpellier, and was the son of a wealthy vineyard-owner from the south of France who was appointed senator for the Département of Hérault. He "really was a very handsome young man", wrote Zola, "(...) With a haughty manner, terrifying when angry but normally very kind and gentle".

Bazille was indeed very kind and generous and he helped Monet more than once out of difficult situations by posing for him, and at one stage sharing his studio in the Rue Furstenberg with him, in 1865. He later shared a studio with Renoir in the Rue Visconti, in 1866, finally opening his own studio in the Rue Condamine, near the Guerbois, to all his friends between 1869 and 1870.

Unfortunately, his works only cover a seven-year period, too short a time to allow him to completely assert his artistic style. He was conscripted into a Zouave regiment in 1870, and was killed by a sniper at Beaune-la-Rolande during the retreat of the Loire Army on November 28 1870. On that day the Impressionists lost a very dear friend.

This stupid death marks the end of an era, the era of apprenticeship. Pissarro, the oldest of the group, had just turned forty and Degas and Manet were fast approaching it. The others, Cézanne, Sisley, Monet, Renoir and Berthe Morisot were getting on for thirty. They were no longer pupils but were fully-fledged painters who were soon loudly and fiercely to claim their right to exhibit their work.

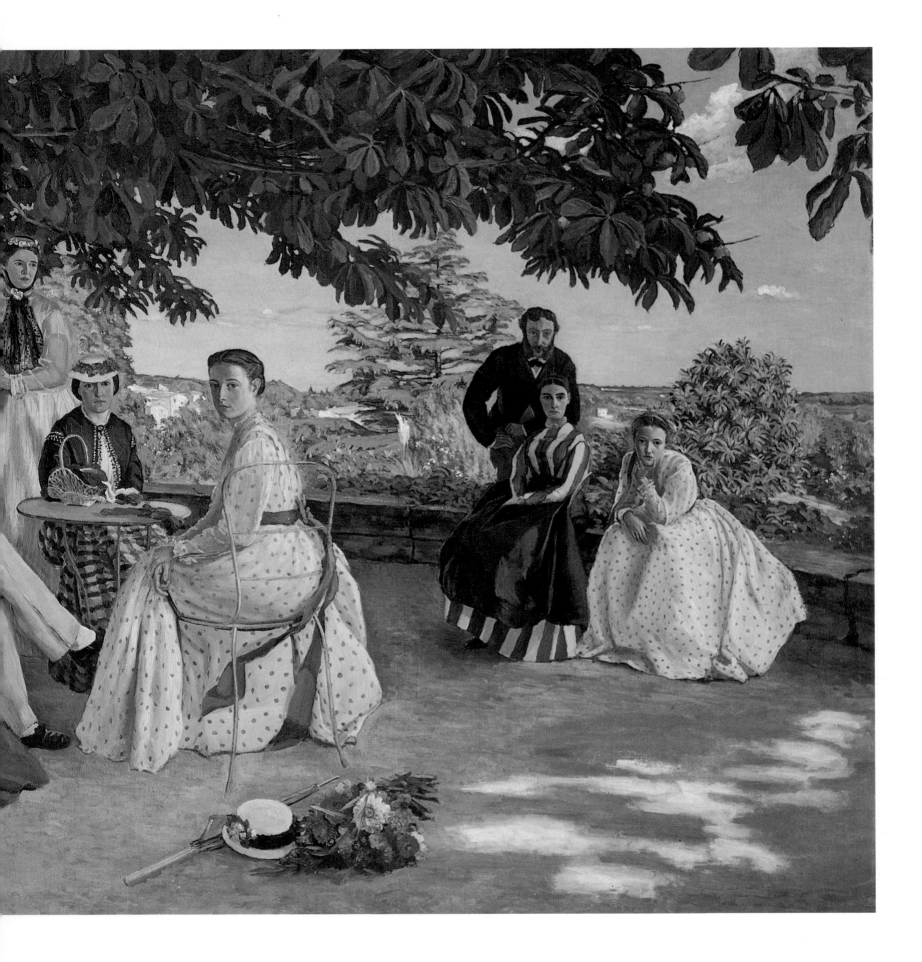

Frédéric Bazille
Family Reunion
1867 Salon of 1868
oil on canvas 152 x 230
Paris Musée d'Orsay

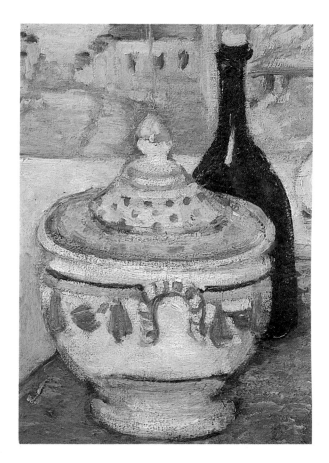

Paul Cézanne
Still-life with Soup Tureen
detail
c. 1877
oil on canvas 65 x 81,5
Paris Musée d'Orsay

II

the Intransigents

66

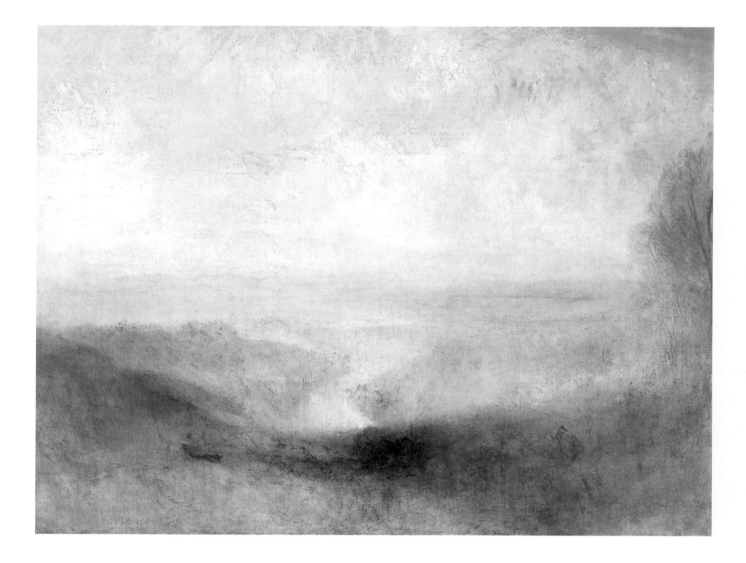

William Turner
1775-1851
Unfinished Landscape
Paris Musée du Louvre

Not all the Impressionists were as patriotic as their friend Bazille. Manet and Degas enjoyed the prestige conferred by the uniform but Cézanne retreated to Aix-en-Provence, where Zola was soon to join him and where they both quietly waited for France to be defeated. Boudin quickly exiled himself to Brussels where he had a few customers. Pissarro had already fled to London, driven out of Louveciennes by the Prussian advance. As for Monet, after a brief stay in Le Havre, he once again abandoned his wife and child and crossed over to England.

While in London, Monet met Daubigny who introduced him to the art-dealer, Durand-Ruel. The latter, a supporter of the Barbizon painters, had owned a gallery in the rue de la Paix, which he moved to 16 rue Laffitte in 1867. In 1871, as a refugee himself, he opened a gallery in London. "Early in 1871", he wrote, "I became acquainted with Monet whose works I had particularly noticed in the latest Salons, but whom I had never happened to meet for he was hardly ever in Paris. I immediately bought the paintings he had just completed in London".

Of course Monet and Pissarro met up again as soon as possible. Pissarro married over there. Both men were busy painting and their styles continued to develop. "Monet and I," said Pissarro, "were enthusiastic about London landscapes. Monet worked in the parks while I, who lived in Lower Norwood, a delightful suburb at the time, studied the effects of fog, snow and of springtime. (...)

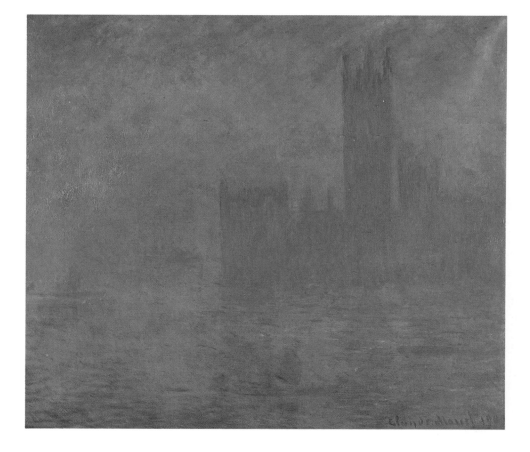

68

Mats for the Slaughterhouse

The watercolours and oils by Turner and Constable definitely influenced us". Yet these were hard times for the young French artists. "Without (Durand-Ruel)", Pissarro continued, "We would have starved to death in London". The English did not understand them. Although they were able to exhibit two paintings in the French section of the International Exhibition in South Kensington in 1871, the Royal Academy rejected all their work.

Pissarro was the first to tire of London. "That's right, my dear Duret", he imparted to his friend, "I am not going to stay here, it's only when you are abroad that you realize how great, beautiful and welcoming France is. How different it is here! All you encounter is scorn, indifference or even abuse. (...) With the exception of Durand-Ruel who has bought two small paintings of mine, my work has not caught on, not at all, I seem to be dogged by bad luck".

By June 1871, Pissarro was back in Louveciennes. What he saw there would have disheartened anyone. "I have lost everything, he said, I (...) have about forty paintings left out of fifteen hundred". Why had there been such a disaster? The Prussians had turned his home into a slaughterhouse and since they were wading in blood, they could not think of anything better than lay his paintings on the floor to make a path across the blood-soaked mud! No doubt it was to escape from such depressing memories that Pissarro returned to Pontoise in 1872.

That same year, Monet also decided to return to France and settled in Argenteuil.

Claude Monet
Tower of Westminster
1903
Le Havre Musée des Beaux-Arts André Malraux

James Abbott MacNeill Whistler
The Thames
1870
oil 52,7 x 63

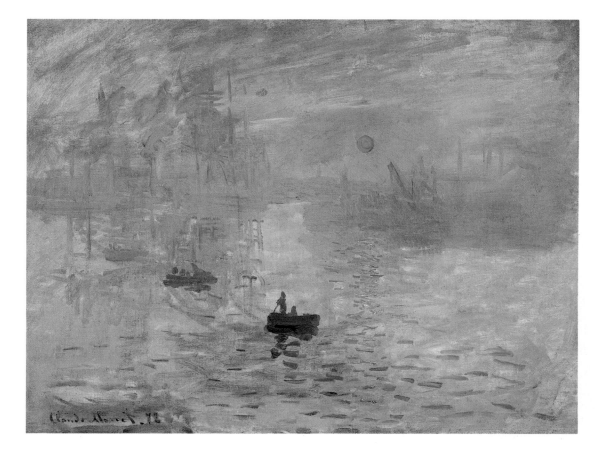

70 *The first Impressionist Exhibition*

After ten years of failure, and in spite of Manet's success with *Le bon bock* at the 1873 Salon, Monet and his friends began to try and devise a way to overcome their difficulties. Finally they hit on the plan of holding an independent exhibition. It was all the more urgent since France was experiencing an economic crisis and sales were dwindling. Monet was the initiator of the plan, supported by Renoir, Pissarro and Degas. Pissarro became enthusiastic and as a supporter of socialist ideals, formulated the idea of a co-operative association whose rules would be modelled on those of the Pontoise Bakers' Union. Renoir rejected the idea. Degas was hostile to the spirit of the Salon but, anxious not to repeat the failure already experienced in the Salon des Refusés, he sided with Renoir. A compromise was found, which inaugurated the "Société Anonyme des peintres, sculpteurs, graveurs, etc..." on December 27 1873. Discussions about an exhibition began immediately. Degas pleaded for the admission of some "conventional" artists. Pissarro wanted Cézanne, whose genius was unquestioned but whose boldness and intransigence were feared. After much discussion and bargaining, thirty names were selected. However, Manet declined the invitation to join, for fear of compromising his success in the previous year. All that remained to be settled was the matter of the premises.

It so happened that the photographer, Nadar, was leaving his premises at 35 boulevard des Capucines but was continuing to rent them. He placed them at his friends' disposal. Thus the exhi-bition could open on April 15 1874 and continued for one month. About 4000 people filed in front of the canvases but sales were few and prices low. *Impression, Sunrise* was bought for a thousand francs and *The House of the Hanged Man* by Cézanne for two hundred francs. To cover the costs of the exhibition, each artist had to be an average of 250 francs out of pocket. So the aim had not been achieved. Far from keeping afloat, some artists actually lost money in the enterprise.

The journalists, on the other hand, hugely profited by it. Some of them really made hay. It was Louis Leroy of *Le Charivari*, who even invented the term "Impressionism" for the occasion, in order to make fun of the exhibition, concentrating his derision on Monet's painting. The word was repeated a few days later by Jules Castagnary in Le Siècle, and so passed into posterity.

What should one think of such term? Elie Faure finds it appropriate. "Impressionism," he writes, "is the visual sensation of the instant captured on the wing by three or four men through a long and patient analysis of the nature of light and the complex elements of colour in their infinite complexity and variation". Therefore in the strictest sense of the word, Impressionism ought only to apply to the early works of Monet, Sisley, Pissarro, Renoir and Cézanne. But in a wider sense it refers to an important step in art, when painters attempted, as a reaction against academic rules, to go beyond the teachings of a Corot or a Courbet. In this sense, the number of painters included in the movement is infinitely greater.

Claude Monet
Impression, sunrise
1872
oil on canvas 47 x 64
Paris Musée Marmottan (has been stolen)

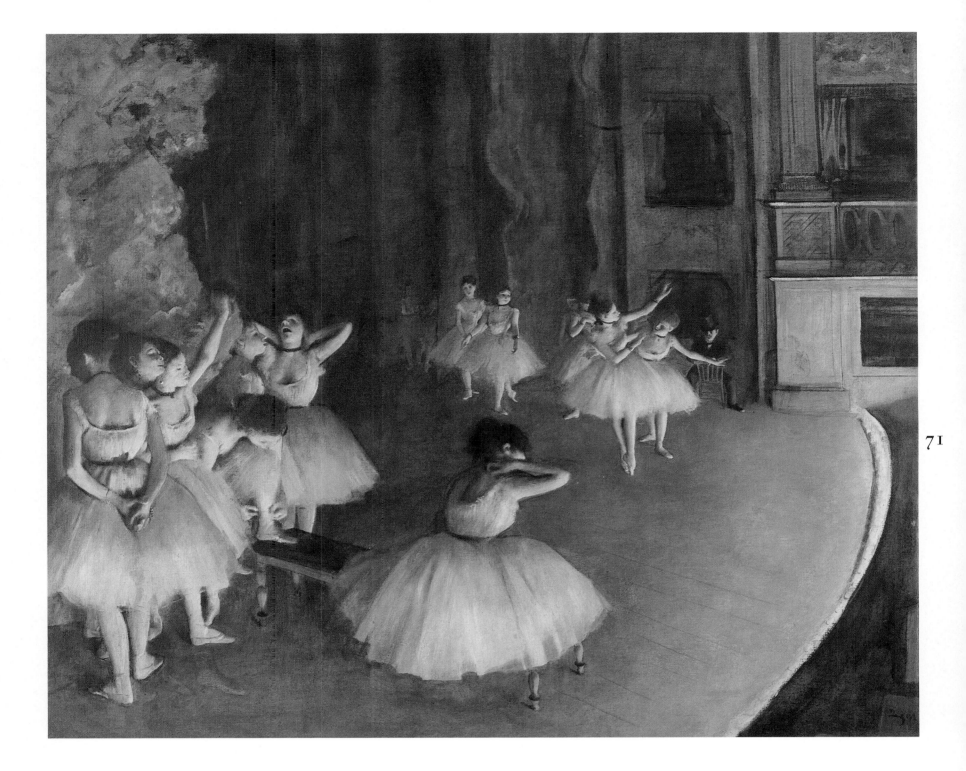

(The Impressionists have)
a similar aim : to express,
with complete sincerity,
the impression which aspects
of reality awakens in them,
without altering or
attenuating it, through
simple and extensive
processes (...) they do not
imitate : they translate,
they interpret.

Emile Blémont
Le Rappel
April 9 1876

For :
Monsieur Monet is the most
skilful and the boldest,
Monsieur Sisley, the most
harmonious and the most
timid; M. Pissarro who, was
basically the inventor of
this painting style, is the
most realistic and the most
ingenuous (...) the vision
of these three landscapists
bears no resemblance in
any way to that of their
former masters; (...it)
asserts itself with such
conviction that it cannot
be disregarded.

Armand Silvestre
L'Opinion nationale
April 22 1874

Edgar Degas
Rehearsal of a Ballet on Stage
1874
oil on canvas 60 x 81
Paris Musée d'Orsay

Five or Six Lunatics

An Impressionist is a man who, without knowing why, feels the need to devote himself to the worship of his palette, and who, having neither the talent or the necessary training to achieve anything reasonable, contents himself with banging the drum for his school of painting and offering the public canvases whose value is scarcely greater than their frames.

Emile Porcheron
Le Soleil
April 1876

In any case, the exhibition was a total failure. Neither Berthe Morisot, nor Degas, nor Boudin could sell any work. So Durand-Ruel organized an auction sale at the Hôtel Drouot in March 1875, hoping to find some buyers for the 73 canvases which buyers had boycotted in 1874. Once again, passions were unleashed, and there was further jeering, mockery and scorn. "There was total uproar during the sale", wrote Durand-Ruel, "Well, we were all insulted and especially Monet and Renoir of course! The public howled at us and called us idiots and people without a shred of decency. Works were sold for fifty francs for their frames alone. I bought many of them myself. Afterwards, I was lucky to escape being sent to the Charenton lunatic asylum".

The group's second exhibition opened in 1876, in the same atmosphere of hostility and hate, in Durand-Ruel's gallery at 11 rue Le Pelletier. The paintings on show included *The Cotton Exchange, New Orleans* and *Absinthe* by Degas, *Nude in the Sunlight* by Renoir and works by Sisley, Monet, Morisot and Pissarro. Yet the critics, true to themselves, continued their insults, "This is a new disaster (...)", A. Wolff wrote in *Le Figaro*, "Five or six lunatics (...) have assembled here (...) it is the dreadful sight of human vanity turning into dementia".

A total of eight exhibitions were held between 1874 and 1886. Only Degas, Pissarro and Morisot remained steadfast to the end. If the enterprise never brought them success, at least the Impressionists became famous and in the long run, they were even regarded more kindly, especially since bright, clear colours were beginning to triumph over tar and bitumen at the Beaux-Arts.

Claude Monet
A Field of Poppies
1873
oil on canvas 50 x 65
Paris Musée d'Orsay

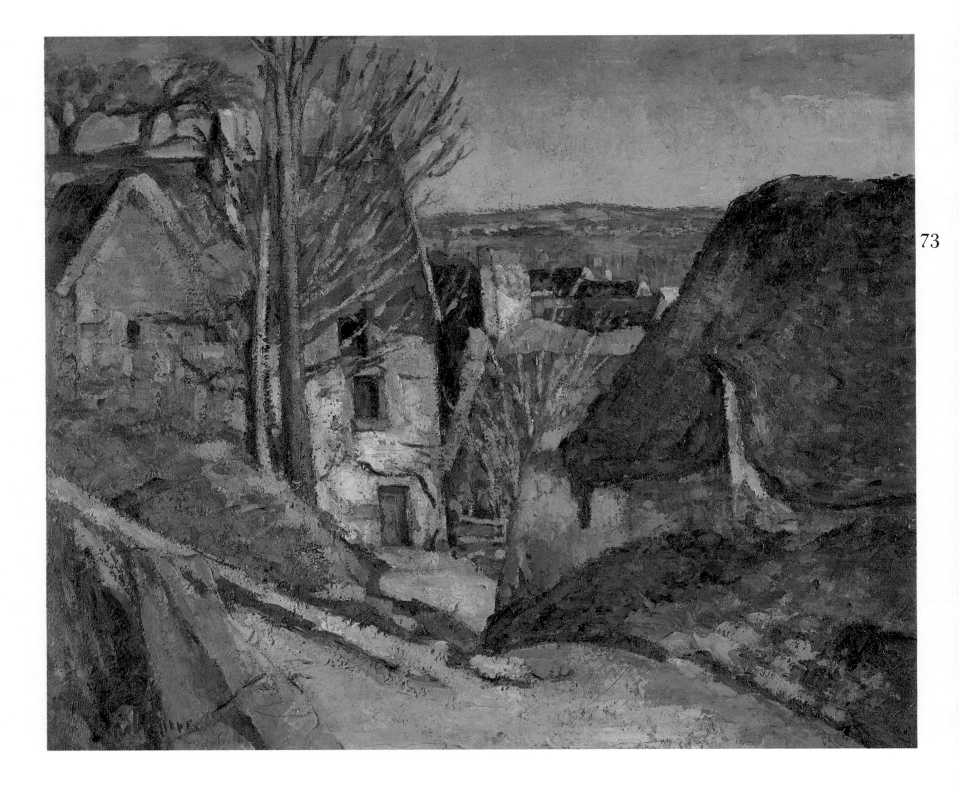

Paul Cézanne
The Hanged Man's House
1873
oil on canvas 55 x 66
Paris Musée d'Orsay

74

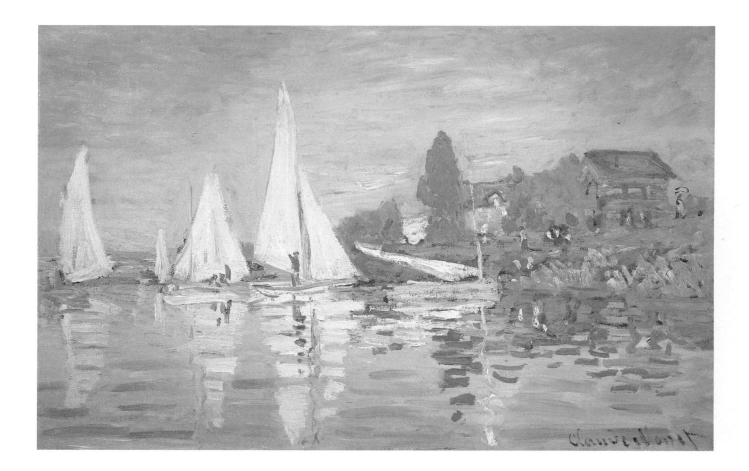

Claude Monet
Regatta at Argenteuil
c. 1872
oil on canvas 48 x 75
Paris Musée d'Orsay

Manet after Bazille's death

So, in 1872, Monet settled in Argenteuil, returning from London via Holland. It was during this period that he established his dominance over the group. Manet, who had persistently refused to submit, was eventually overpowered by his personality like everybody else. In fact, it was Manet who suggested that Monet should live in Argenteuil, a place he knew well since his parents owned a house almost opposite, on the other bank of the Seine, in Gennevilliers. Again, it was Manet who looked for a suitable house and finally found one right by the water. Monet occupied it from 1872 to 1874. The rent was quite high but by then Monet had quite a comfortable income thanks to Durand-Ruel, who had been buying his works since their meeting in London. He paid Monet 10,000 francs in 1872, and 12,000 in 1873. In all, Monet earned 36,000 francs in that two-year period. However he spent it as soon as he earned it and when the crisis came, he found himself in dire straits again. Thus, in 1874, he once again asked for help. In earlier times, he would have called upon Bazille. Now Bazille was dead, so he turned to Manet, through whom he was able to move into a little pink-walled, green-shuttered house, still in Argenteuil, for he loved the place too much to leave it.

About water :

I wish I were always near or above it, and when I die, I'd like to be buried in a buoy.

Claude Monet

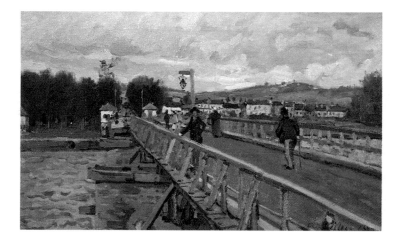

76 *A Strange Vessel*

Renoir and Sisley had come to join Monet and together, they painted Argenteuil. Monet wanted to be close as possible to the water, its mists and reflections, and for this purpose he had fitted out a strange vessel which he called his "studio-boat", which he painted in 1874. It was a flat-bottomed barque with a disproportionately large wooden cabin in which Monet could store his materials and rest when he felt like it. The cabin was extended even further forward by the addition of a striped canopy. This enabled Monet to paint in the open, while remaining protected from the sun or rain.

Manet, who painted him at work with Camille on this odd craft, nicknamed his friend "The Raphael of Water". It was here, despite the failure of their Independent Salons, that the Impressionists probably spent their happiest, most euphoric and productive days as painters. The contemporary canvases strikingly reflect this mood.

This was the height of the Impressionist Period. There was a uniformity of subject matter and of style. However, Monet was the most advanced among them in his research into the reproduction of the effects of light, whereas Renoir, Sisley, and Manet, in particular, remained more interested in subject matter and shapes. Thus, human figures became fewer and shapes less sharply-defined in Monet's paintings, while the opposite was true of the work of Renoir and Manet.

Alfred Sisley
Footbridge at Argenteuil
1872
oil on canvas 39 x 60
Paris Musée d'Orsay

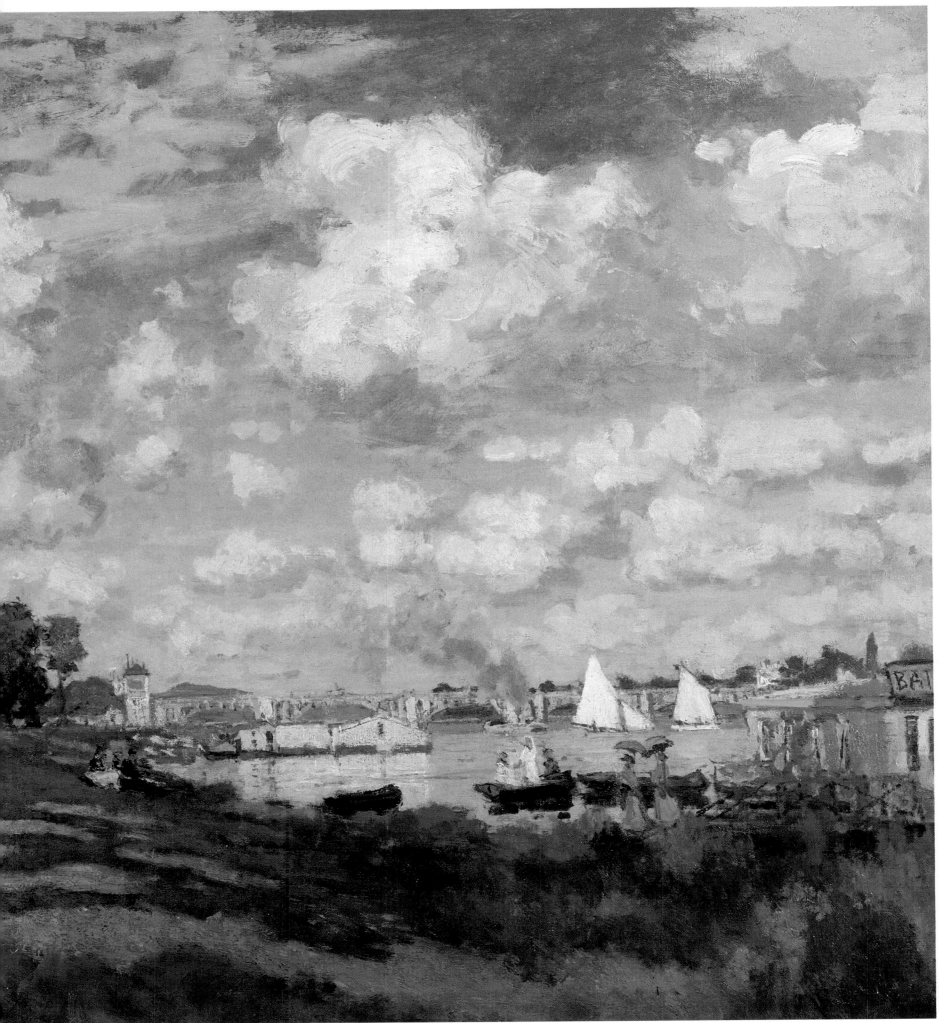

Claude Monet
Argenteuil Basin
1872
oil on canvas 60 x 80.5
Paris Musée d'Orsay

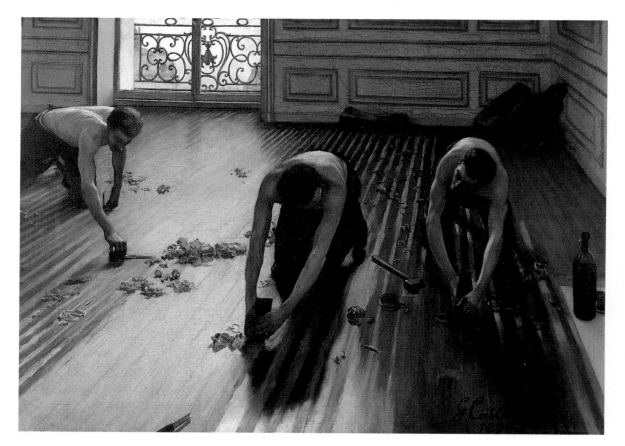

78 *A Convenient Private Income*

Argenteuil was also the scene of a meeting which was to prove fateful in the history of the Impressionists. One day in 1872, Monet saw a young man, dressed for boating, walking towards him along the river bank. The man was handsome and had a pleasant appearance. He introduced himself as an engineer who built racing skiffs which he tested himself in the races organized on the Seine in those days. His name was Gustave Caillebotte and he had just turned twenty-four.

Caillebotte immediately became an enthusiastic fan of Monet's work. Monet explained to him that he wanted to work as close to the water as possible, and conceived the idea of the studio-boat alluded to earlier. Caillebotte would not have been so much drawn to the Impressionists, had not he himself been a painter. Like them, he had been trained at the Ecole des Beaux-Arts and had also studied in Bonnat's studio. He had given up painting because he discovered a distaste for the style of the "Pompiers" and, unable to find a style of his own, he gave up painting altogether. His meeting with Monet encouraged him to take up his brushes again.

When Caillebotte's father died in 1873, he found he had inherited a considerable fortune. He thus began the pleasant and coveted existence of someone with an independent income, freed from the financial worries which undermined the very existence of his newfound friends. He was conscious of their problems and since he had an altruistic nature, he chose thenceforward to lead the dual career of artist and patron.

Although he is not a minor artist, his work has been overshadowed by that of his seniors.

Although the subject matter and use of colour is closer to Impressionism, it has a more conventional feel. Yet Caillebotte was one of the exibitors at the Second Impressionist Salon, in 1876, with *The Floor-planers*.

Perhaps unjustly, Caillebotte has gone down in history as a philanthropist and collector because the Impressionists are indebted to him for their first showing in a museum. In 1874, he started to buy paintings from Monet, and over the next twenty years he bought them from Pissarro, Sisley, Renoir, Degas, Cézanne, and Manet, until his death in 1894.

In 1876, he began organizing exhibitions. His help was extremely valuable. Indeed, in 1877, Durand-Ruel, who had been compelled to distance himself to some extent from the movement in order to avoid bankruptcy, would not hold the third Impressionist Exhibition in his gallery. Caillebotte performed the impossible and found other premises which were also in the Rue Le Pelletier as they had been in the previous year. He also covered most of the rent. This third exhibition was the first to be specifically entitled "Impressionist", though against the advice of Renoir and Degas. The former distrusted labels, and the latter hated schools of painting.

Caillebotte took his role so seriously that in 1876, he drew up a will in which he donated his collection to the state, although it was still at a fledgling stage; he was barely twenty-eight years old. This gesture, which at the time was both a little naive but truly enthusiastic, was to cause a storm to break when he died prematurely at the age of forty-six.

Gustave Caillebotte
The Floor-planers
1875
oil 102 x 146.5
Paris Musée d'Orsay

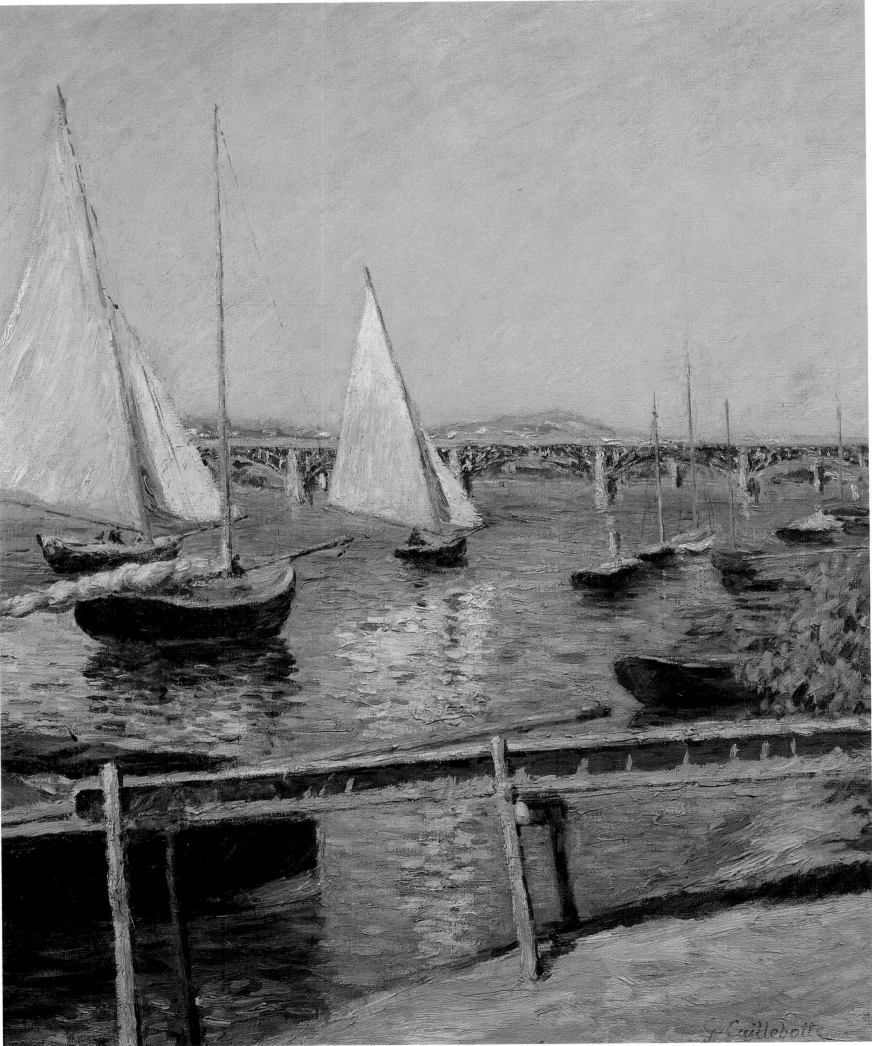

Gustave Caillebotte
Sailing-boats at Argenteuil
1888
oil on canvas 65 x 55
Paris Musée d'Orsay

80 *The Caillebotte Bequest*

The Caillebotte Bequest consisted of 67 paintings, 18 Pissarros, 16 Monets, nine Sisleys, eight Renoirs, seven Degas, five Cézannes, three Manets – and *The Floor-planers* by Caillebotte. The extent to which the artists are represented is revealing of Caillebotte's character, since the most heavily-represented artists were those who were the poorest in the Argenteuil period.

As Caillebotte's executor, Renoir had the difficult task of ensuring that the bequest was accepted. The members of the Institut were furious and campaigned in favour of an outright refusal. The Ecole des Beaux-Arts people were annoyed. To resolve the difficulty and create a delay, it was decided that a commission should be appointed, and it duly deliberated uselessly for three years. To complicate matters further, France was now plunged deep into the Dreyfus Affair, a dispute which revived the conservatives' hatred of the Impressionists whom they accused of being revolutionaries and, better yet, enemies of the state...

A compromise was finally reached in 1897. Twenty-nine paintings were rejected, including eleven Pissarros and eight Monets which were eventually sold abroad. The thirty-eight paintings which had been accepted were hung in the Musée du Luxembourg, despite protests from the die-hards of the Institut. For the first time, the Impressionists' work was entering in a museum, though the process had involved much bargaining! It took another forty years for the paintings to cross the Seine. It was not until 1937 that their works were exhibited in the Louvre, in the rooms of the Salle du Jeu de Paume, where they hung for half a century. Since then, they have come back to the left bank, to be installed in the new Musée d'Orsay.

Camille Pissarro
White frost
1873
oil on canvas 65 x 93
Paris Musée d'Orsay

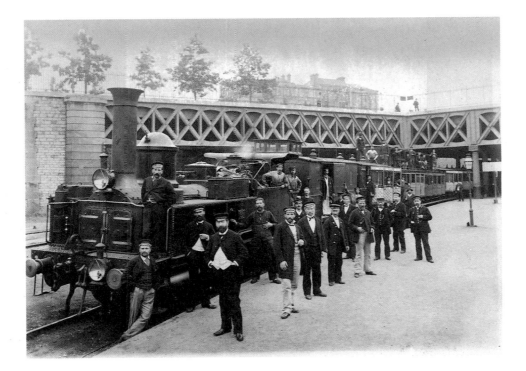

Zola committed a serious error of judgement in believing Monet to be the Parisian painter *par excellence*. He even claimed that Monet had a horror of nature. On the other hand, it would also be a mistake to reduce a consideration of Monet's work to the paintings he produced on the banks of the Seine. Monet, like his friends, enjoyed painting scenes from modern life – crowds, city streets and railway stations – though his aims were different from theirs. He knew how to paint modernity, crowds, streets and stations. The proof lies in his series of paintings of the Saint-Lazare station. These urban scenes were merely extensions of the research he did in Argenteuil.

By the time he was working on the Argenteuil paintings, his shapes were becoming indistinct, blurred, hesitant, almost intangible. This theme is also to be found almost unaltered in the plumes of smoke in Saint-Lazare station. The subject matter (a train and the vast metal framework of the station building) was considered absolutely devoid of æsthetic quality at that time. Monet could not have cared less. He was enthralled by the visual magic of the swirls of smoke which he had committed to mind and was intent on conveying on canvas. He had set himself the arduous task of expressing movement on a motionless canvas.

What kind of movement was this? Neither the false movement of the academicians, nor that of the passage of time, such as, for example, the speed of the locomotive – Monet's trains are stationary – but the scarcely perceptible tremble of an instant, like the rustle of a leaf on a branch, a ripple on the water or the fleeting vibration of a puff of steam. But how was he to capture that fleeting moment?

(...) Fantastic in broad daylight, (...) spectral, iridescent steam hovering and whirling over the engines, between the high cliffs of the houses which surround and dominate the constantly bustling platforms.

Paris Saint-Lazare Station
Looking Towards the Place de l'Europe or the Batignolles Bridge
c. 1865
Musée Carnavalet

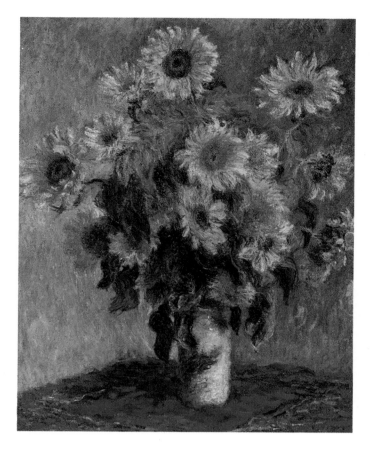

82 *The Series*

It was while Monet was painting the Saint-Lazare station and the Rue Montorgueil that he conceived the idea of a series of paintings. Since he could not express all the movements and all the moments in a single canvas, he would paint several of them at different hours of the day. This was a plan which was to govern all of his subsequent work, whether it was the Rouen Cathedral series or, especially, in the case of the famous water-lilies series.

Not only did form and line cease to be absolutes, but colour, in turn, became time-related, changing and altering according to time of day and season. Finally, no barrier remained between light and the artist's eye. "Monet is just an eye," said Cézanne, but what an eye!" An eye which was capable of discarding anything which might interfere with pure vision, with the unfettered relationship between the human eye and the light wave.

Monet painted seven canvases of Saint-Lazare, six of which were hung at the third Impressionist Exhibition. Zola wrote of them, "(...) beautiful railway station interiors. One can hear the roar of trains, one can see the outpourings of smoke rolling under the huge sheds. This is where painting stands today (...)". The misunderstanding remained. Zola only saw the subject matter, just when Monet was actually becoming more and more remote from his subject in order to concentrate exclusively on light. This misinterpretation was soon to drive Zola away from his old friend whose development he had never truly comprehended.

Claude Monet
Sunflowers
oil on canvas 101 x 81.5
New-York Metropolitan Museum of Art

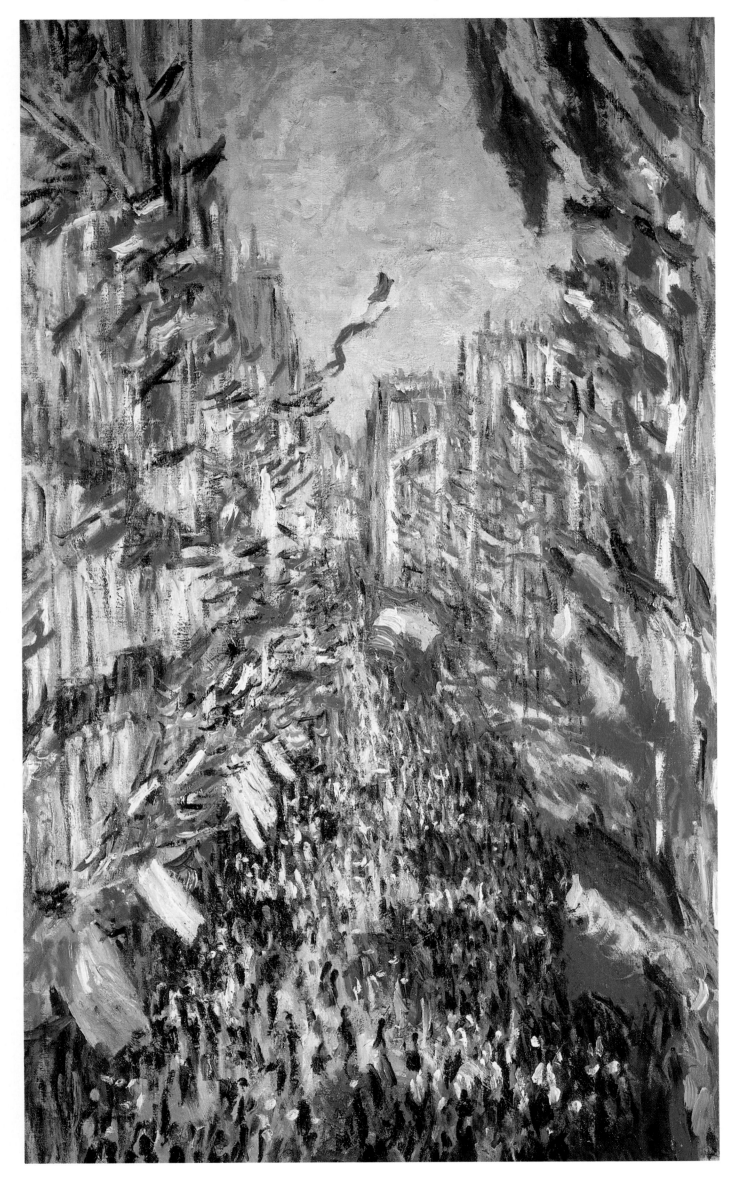

Claude Monet
Rue Montorgueil
1878
oil on canvas 81 x 50
Paris Musée d'Orsay

84

To express walking, movement, the bustle and criss-crossing of the passing throng.

Edmond Duranty
La Nouvelle peinture
1876

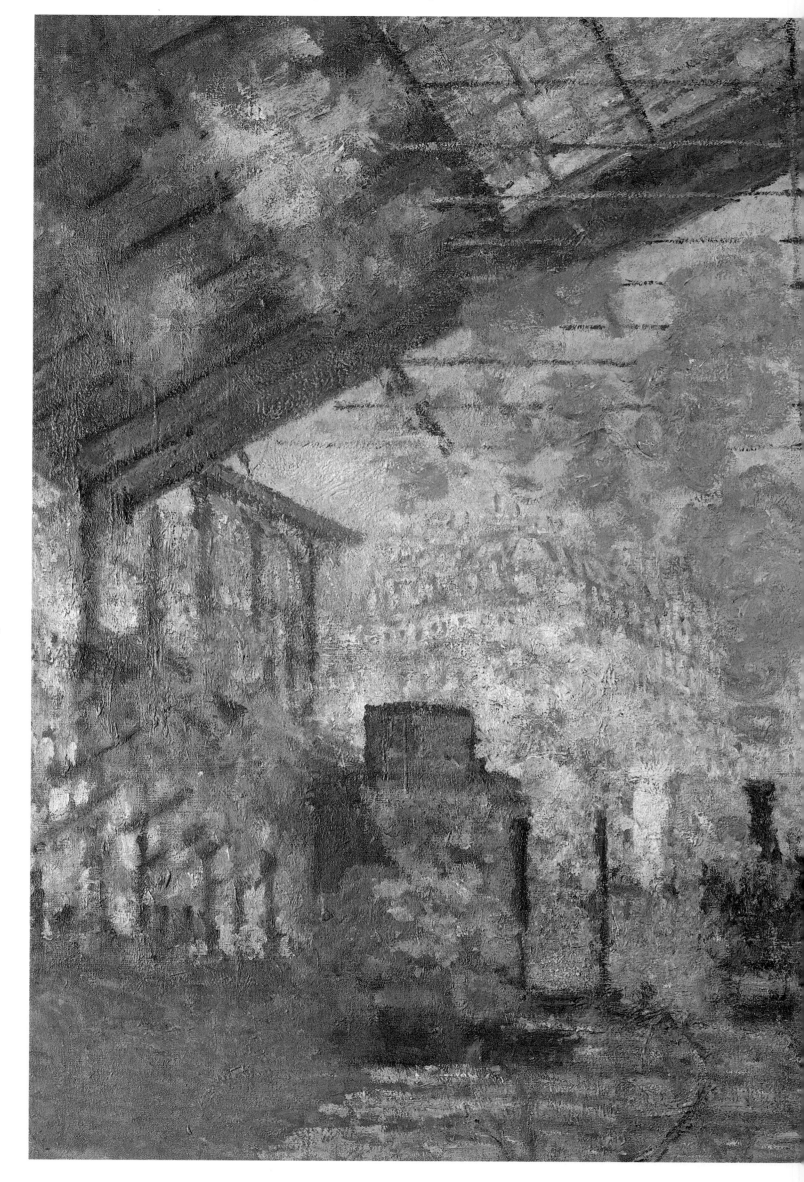

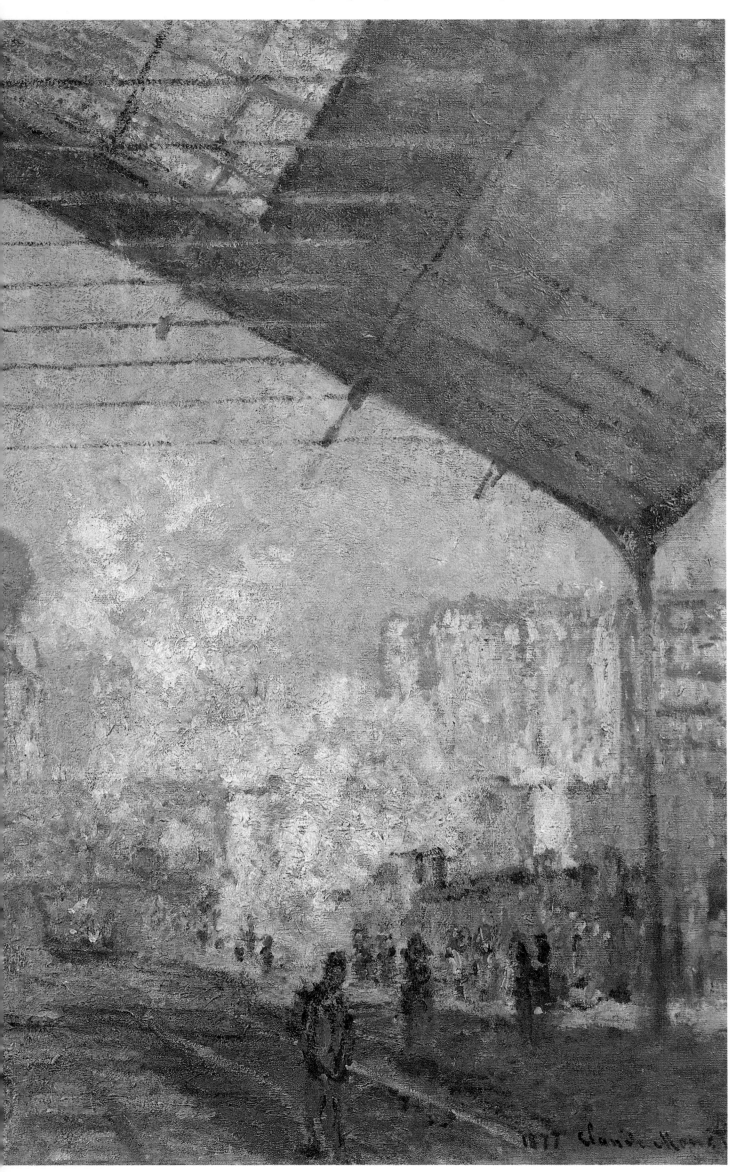

Claude Monet
La gare Saint-Lazare
1877
oil on canvas 75.5 × 104
Paris Musée d'Orsay

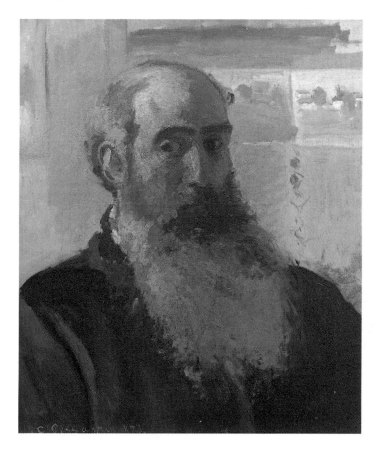

86 *A Native of the Netherlands Antilles*

Pontoise was another important meeting-place for the Impressionists in the 1870 s, where the artists gathered around Pissarro's powerful but likeable personality. The misfortune which Pissarro's work suffered during the Franco-Prussian War and which caused him to leave Louveciennes has already been recalled. He lived in Pontoise for 10 years, between 1872 and 1882.

Camille Pissarro was born on July 10 1830 at Saint-Thomas in the Netherlands Antilles, of a Creole mother and a French-Jewish father of Sephardic origin. At the age of eleven, he was sent away to France, to a private school in Passy. He stayed there for six years, and made many drawings.

Upon returning to Saint-Thomas, he became a salesman in his father's hardware store. He had no liking for the job. Camille wanted to paint and cared about nothing else. In 1852, he met a Danish painter called Fritz Melbye and set sail with him for Caracas.

Three years later, his father, who had finally accepted the fact that his son was going to be a painter, sent him back to France. Camille arrived at the age of twenty-five, in the year of the Universal Exhibition. He made the acquaintance of Corot and of Anton Melbye, Fritz's brother. Pissarro benefitted from the art lessons these men had jointly taught him and succeeded in having a painting accepted for the 1859 Salon. However, he was unable to repeat his success, either in 1861 or in 1863. In the meantime, he had met Monet and Cézanne at Suisse's academy, as well as Julie Vellay, with whom he decided to live right away.

Pissarro joined the Refusés group, where he attracted the attention of Jules Castagnary, the critic. It was in that same year, 1863, that Lucien, his first child, was born. His canvases were accepted in 1864 and 1866, but, life soon became very difficult for Pissarro, because by now, he had moved away from Corot's influence, and his paintings were becoming ever more shocking to bourgeois Parisian taste.

Camille Pissarro
Chestnut-trees at Louveciennes
1870
oil on canvas 41 x 54
Paris Musée d'Orsay

Camille Pissarro
Self-portrait
1873
oil on canvas 55 x 46
Paris Musée d'Orsay

87

Camille Pissarro
Winter Landscape at Louveciennes
1870
oil on canvas 37 x 46
Paris Musée d'Orsay

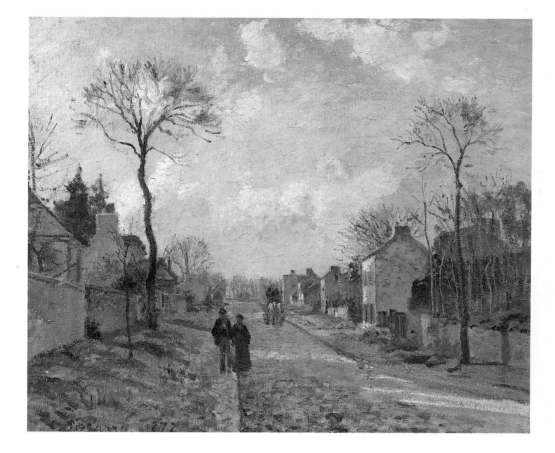

88 *Open House*

Pissarro had lived at Pontoise from 1866 to 1869, so it was quite natural for him to return after leaving the house at Louveciennes, from which he had saved about of his forty paintings, including *The Chestnut Trees* and *Winter Landscape.* Pissarro found the water a less interesting subject than did Monet, preferring rural landscapes.

Between 1872 and 1874, Durand-Ruel bought his work and Pissarro thought his troubles were over. He asked Guillaumin and Cézanne to join him, and Cézanne did so as early as January 1872. This was the start of a five-year period, during which the two men worked side by side, although Cézanne moved to Auvers-sur-Oise in 1873, staying at Doctor Gachet's, a few miles from Pontoise. When comparing Cézanne's *The House of the Hanged Man* 1873 with Pissarro's *Red Roofs* 1877, the similarity between both styles is obvious. "(He) was influenced by me in Pontoise and I by him", Pissarro wrote of his friend, in 1895.

Pissarro considered Cézanne to be the greatest artist in the group. Cézanne knew it, so he became gentler and, under Pissarro's influence, gave up his previous behavior which he himself termed "awkward". It was as if he were gaining confidence in himself, and his style of painting became less provocative and more positive. As for Pissarro, his own style did not change greatly in Pontoise but there is no question that this was his best creative period.

Unfortunately, the economic crisis and Durand-Ruel's inability to continue his purchases as well as the viciousness of the critics ("Palette scrapings evenly applied to a dirty canvas", was just one evaluation of Pissarro's work. "One cannot make head or tail of it, one cannot tell top from bottom, front from rear"). As if this were not enough, his daughter, Minette, died in 1874 at the age of nine.

This was a tragic year for Pissarro. "Shall I ever get out of this mess", he wrote, "And be able to concentrate peacefully on my work? My studies are joyless because I keep thinking that I ought to give up painting. (...) Sad". Was his attitude due to his financial worries, or because he needed a change of air? That summer, Pissarro accepted an invitation from his friend, Ludovic Piette, a landscape artist, and went to stay in Montfoucault, Brittany. A few months later, he was back in Pontoise, continuing to lead a hard life. The Pissarro family grew their own vegetables, and raised chickens and rabbits in order to survive. Yet, even during the bleakest times, they kept open house and entertained anyone who cared to visit. It was their way of defying their poverty.

Camille Pissarro
The Road, Louveciennes
1872
oil on canvas 45 x 54
Paris Musée d'Orsay

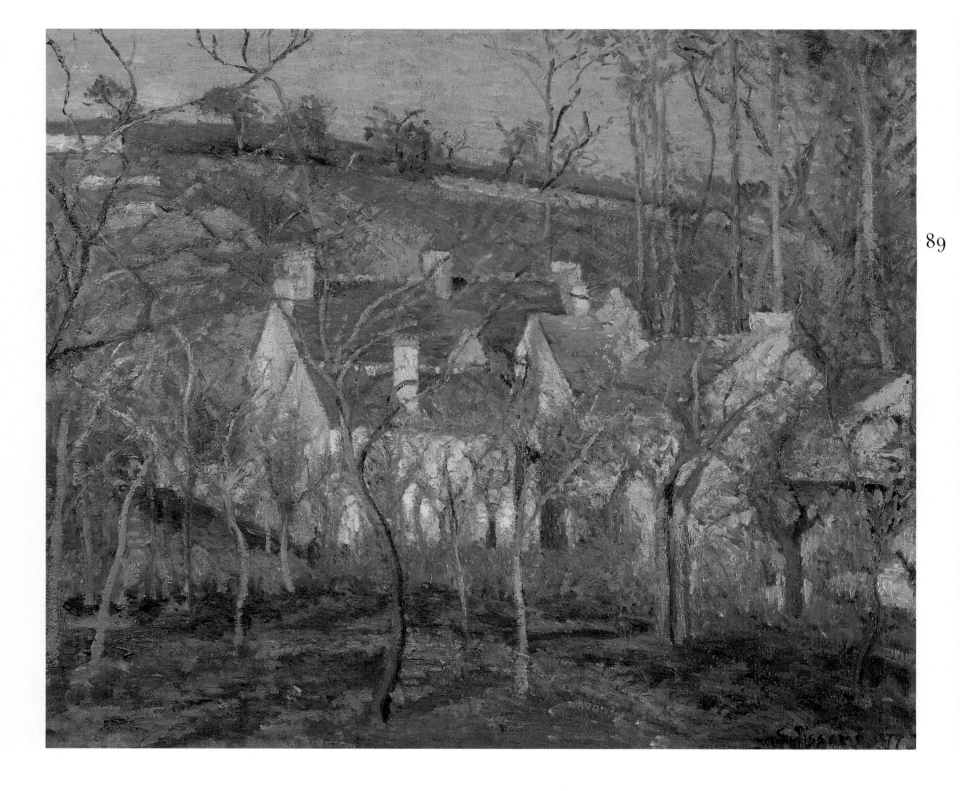

Camille Pissarro
Red Roofs
1877
oil on canvas 54.5 x 65.6
Paris Musée d'Orsay

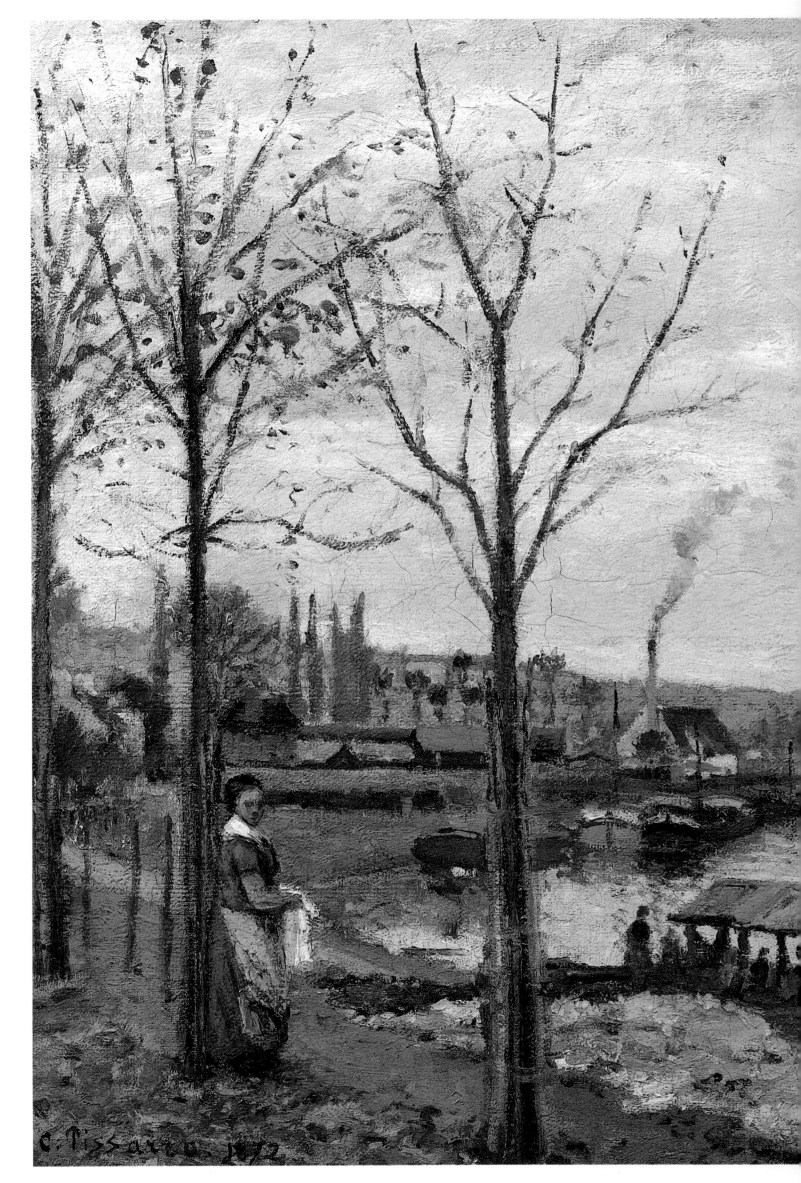

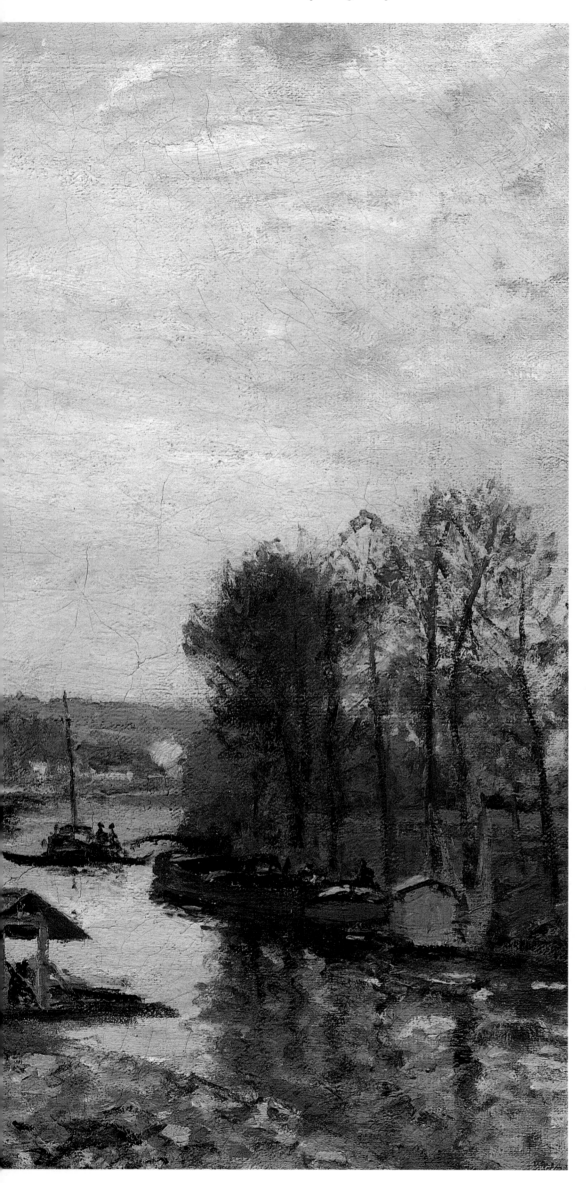

Camille Pissarro
Le lavoir, Pontoise
1872
oil on canvas 46.5 x 56
Paris Musée d'Orsay

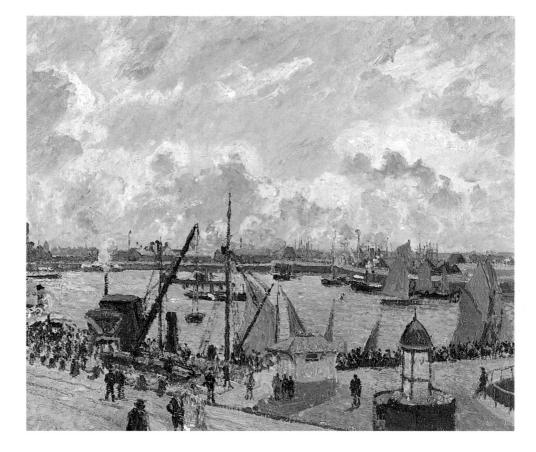

92 *"Corot's Pupil"*

If Pissarro's life was often hard, Sisley's was even more wretched. Yet it had begun quite auspiciously. Sisley was born in Paris in 1839, was believed to have been raised in the lap of luxury. His father was descended from an English family who lived in Kent. He lived in Dunkerque but had started a business selling artificial flowers in South America. Sisley's father believed his son would follow in his footsteps, so he sent him to England to learn the trade in the land of his forefathers. Sisley, however, was a shy and gentle young man who preferred museums to chops; business was not his cup of tea. He returned to France at the age of twenty-two and the following year, he entered the Ecole des Beaux-Arts and studied at Gleyre's studio where he met Renoir, Bazille and Monet.

Sisley joined his new friends on a trip to Chailly in the spring of 1863. Two years later, he sailed down the Seine with Monet and Renoir bound for Le Havre and its regattas. He then responded to an invitation from Monet and went to Honfleur. His true masters, however, were Courbet, Daubigny and Corot, all three landscape artists, and this was significant.

Their protection enabled Sisley to have two paintings hung at the 1866 Salon, as well as the painting accepted in 1867, as "Corot's pupil," a status which exempted him from the selection process. Sisley's work sold badly and for very little money but, with his father's help, he was able to get by. He was able to afford a studio in Batignolles, the City of Flowers, next to Bazille's. He was often to be seen at the Café Guerbois.

Alfred Sisley
Fog
1874
oil on canvas 50 x 65
Paris Musée d'Orsay

Camille Pissarro
Avant-port du Havre, Quai de Southampton
1903
oil on canvas
Le Havre Musée des Beaux-Arts André Malraux

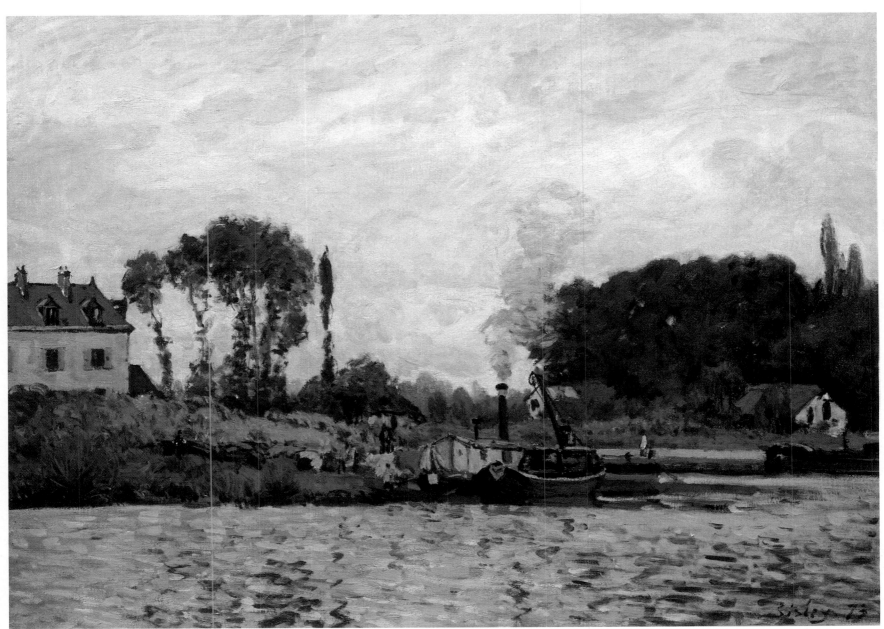

Alfred Sisley
Boats at Bougival Lock
1873
oil 46 x 65
Paris Musée d'Orsay

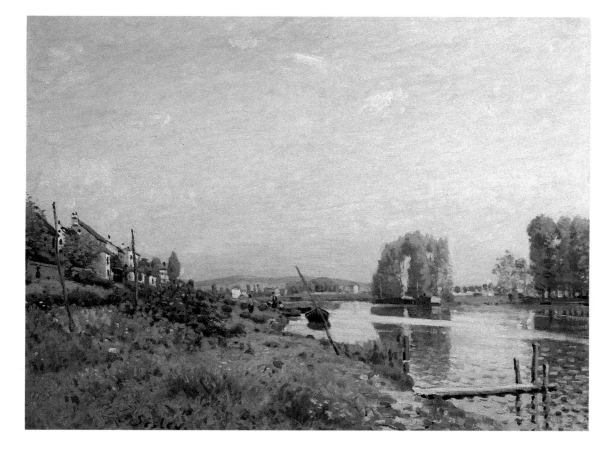

94 *A Table at Murer's*

Sisley suffered a crisis around 1870 but for reasons quite unconnected with the Franco-Prussian War. Hostilities had encouraged him to move to London in 1871, but the major event in his life was the death of his parents. His father died a ruined man, leaving him nothing. Sisley had the choice of either giving up his painting, which hitherto he had practised only as an amateur, or continuing to be an artist but accepting the prospect of poverty. He chose art and penury.

For the next twelve years, Sisley was constantly on the move. He stayed in Argenteuil, Bougival, Pontoise, Auvers-sur-Oise, Louveciennes, Sèvres, Veneux-Nadon, Moret-sur-Loing, Saint-Mammès, and Moret-sur-Loing again, where he finally settled in 1883.

In those days of extreme poverty, Sisley was occasionally helped by an eccentric individual called Eugène Murer. Murer owned a cakeshop at Auvers-sur-Oise. As Guillaumin's childhood friend, he was well acquainted with the Impressionists and started collecting many of their works. When he added a little restaurant to his shop, people came from as far away as Paris to see his collection. On seeing Sisley's predicament, Murer often invited him for a meal. Sisley paid him in paintings! Twenty years later, that would have been a swindle. At the time, however, Murer got a bargain and at least Sisley was able to appease his hunger.

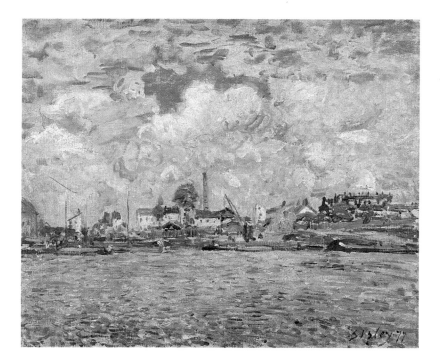

Alfred Sisley
The Seine at Daybreak
1877
oil on canvas
Le Havre Musée des Beaux-Arts André Malraux

Alfred Sisley
L'île Saint-Denis
1872
oil on canvas 50.5 x 65
Paris Musée d'Orsay

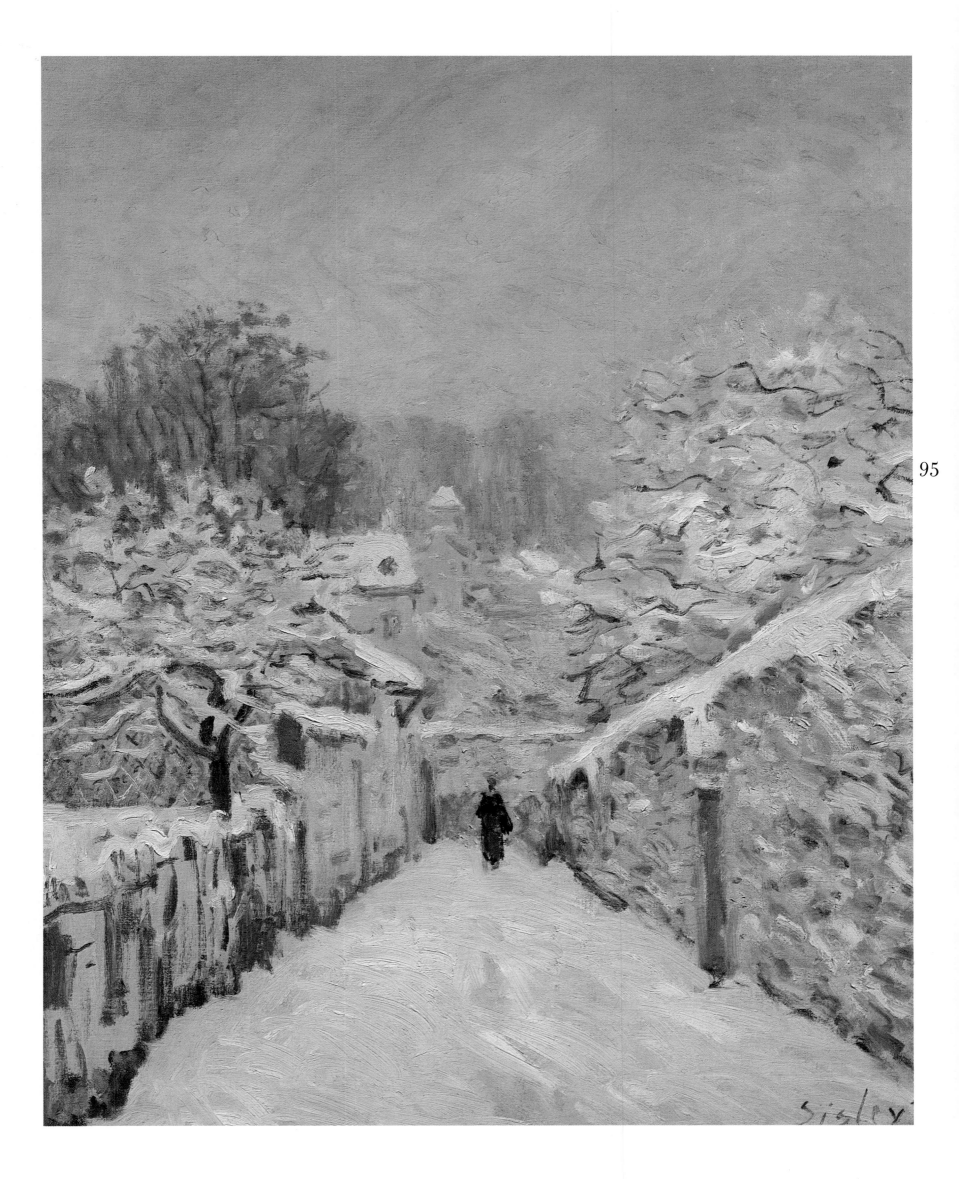

Alfred Sisley
Snow at Louveciennes
1878
oil 61 x 50
Paris Musée d'Orsay

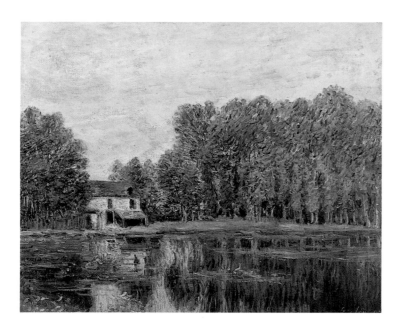

96 *"Harmonious and Timid"*

Despite his poverty, Sisley played an active part in the group, at least until he settled at Moret, near Fontainebleau. He was one of the founders of the Impressionist Salon and he exhibited in 1874, 1876, 1877 and 1882. Some critics noted his sensitivity, the pure lyricism of his vision, the subtlety and lightness of his brushstokes. He was praised for his restraint, the touching fragility of his shades of blue and pink, and for the delicacy of his snow scenes. In short, he was not exactly thought of as a tough guy. "M. Sisley (is) the most harmonious", wrote Armand Silvestre after the 1874 exhibition, adding, "and he is also the most timid". That was his whole problem!

Neither revolutionary nor academic in style, Sisley was consequently regarded as a minor painter. In 1875, at a sale at the Hôtel Drouot, none of his canvases fetched more than thirty francs. He was in desperate straits; by now he was married and had two children. In 1878, he wrote to Théodore Duret asking him to find him a patron who might grant him an allowance of 500 francs a month for six months in exchange for thirty paintings. Duret searched in vain for such a rare bird. Sisley's first one-man show at Durand-Ruel, in 1883, did not improve matters, nor did his exhibition at Boussod-Valadon's in 1893, and he fared no better with his show at Georges Petit's, two years before his death.

In 1899, Sisley passed away, destitute and in terrible pain. He died of cancer of the throat.

Alfred Sisley
Moret-sur-Loing
1892
oil on canvas 60.5 x 73.5
Nantes Musée des Beaux-Arts

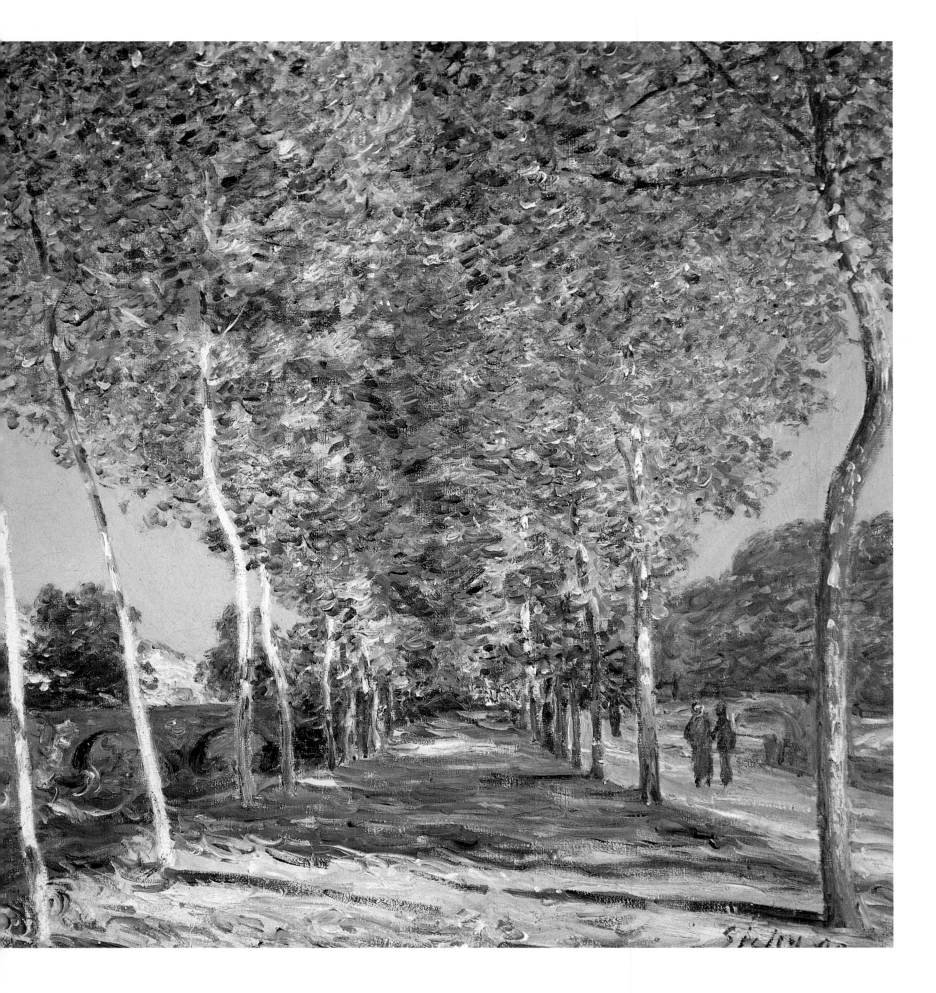

Alfred Sisley
The Poplars near Moret-sur-Loing
1890
oil on canvas 65 x 81
Nice Musée des Beaux-Arts

98 *Forty-three Thousand Francs*

It is said that Sisley is very gravely ill. He really is a wonderful and great artist. (...) I have looked at some of his works again (and they have) a rare beauty and grandeur, including the one of his Flooding which is a pure masterpiece.

Pissarro
in a letter
to his son Lucien
1899

Sisley adored the Ile-de-France, and painted the landscapes of the region all his life. Yet France never honoured the talents of this man to whom she even refused French nationality which he had vainly requested from 1895. "(He) has never known even the slightest comfort (...) he endured his plight with a courage that was the admiration of all", wrote Vollard.

So what is the verdict on the events of 1900, almost as soon as Sisley was dead? Was it posthumous homage or the ultimate injustice? At a sale at The Hôtel Drouot, Sisley's *Flooding at Port-Marly* was bought by Isaac de Camondo for the enormous sum of 43,000 francs. Sisley would never have asked for as much.

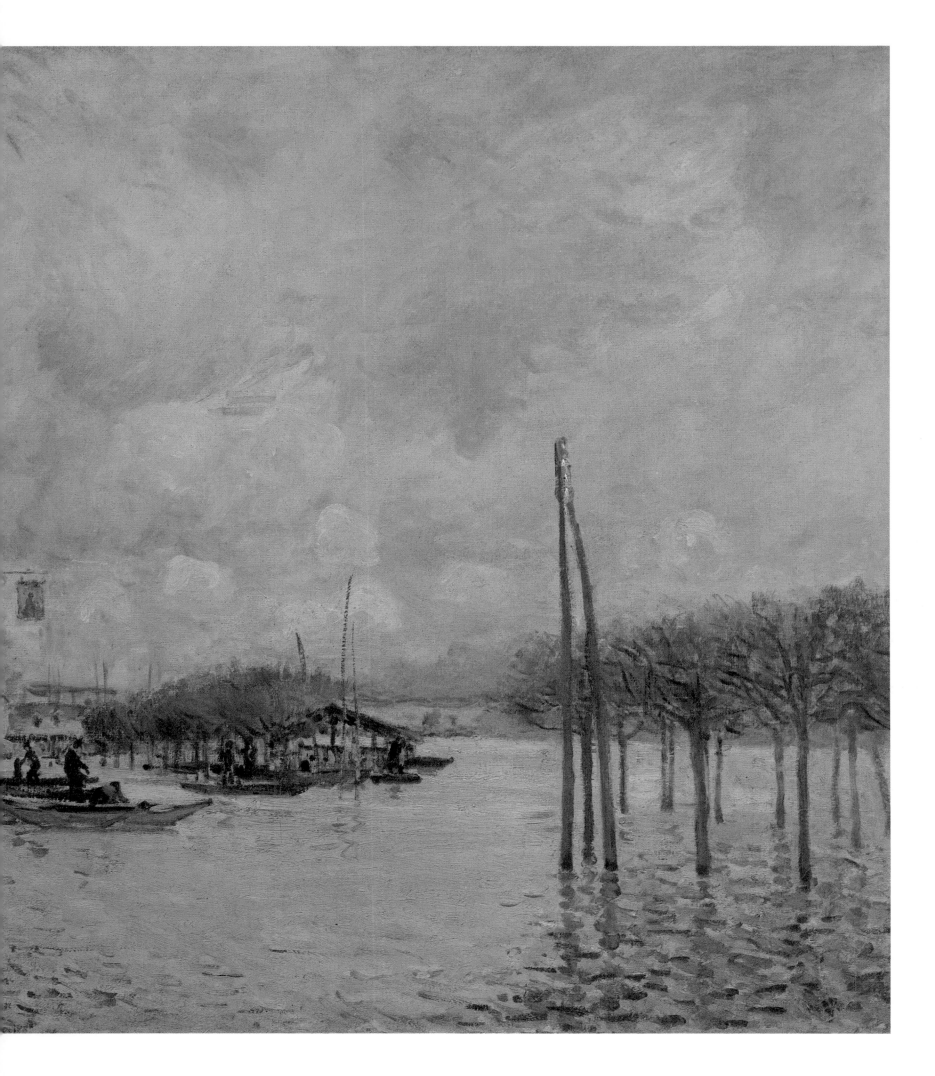

Alfred Sisley
Flooding at Port-Marly
1876
oil on canvas 60 x 81
Paris Musée d'Orsay

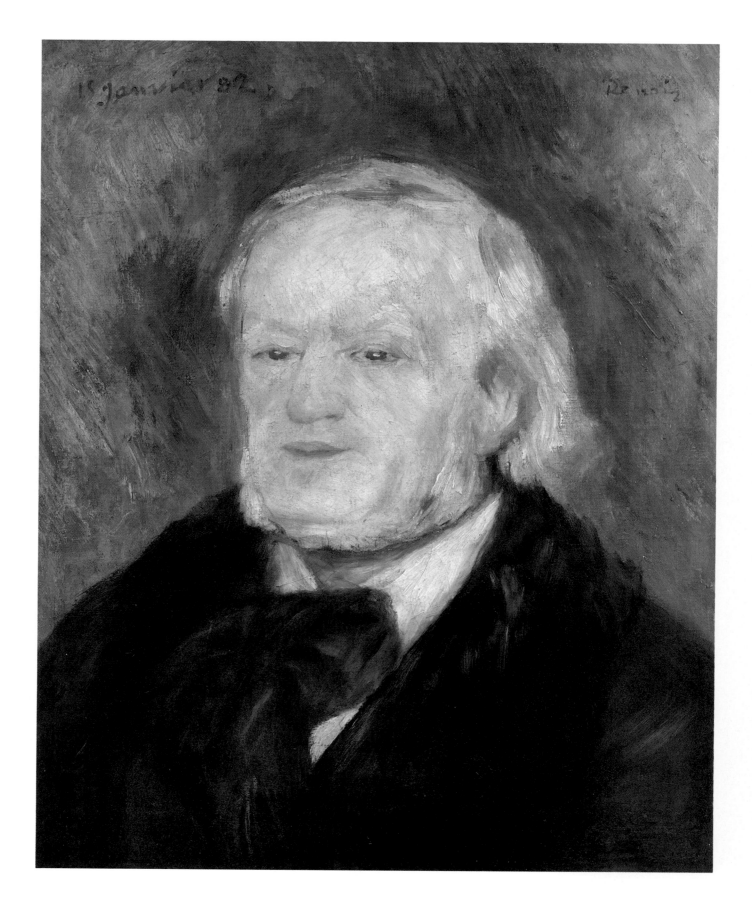

Pierre-Auguste Renoir
Portrait of Richard Wagner
1882
oil on canvas 41 x 32
Paris Musée d'Orsay

Unlike Monet and Pissarro, who as much from preference as from necessity, lived in the country after 1870, Renoir remained in Paris, despite his frequent trips to the banks of the Seine to visit his friends. This tailor's son had middle-class ambitions. He was born in Limoges in 1841, but was brought to Paris at the age of four. He had begun his career as a porcelain painter, in a pottery in the Marais district of Paris. When he was put out of work by the introduction of printed transfer designs, he began decorating window-blinds and fans. It was a meagre livelihood but it enabled him to learn his craft, then master it, as a result of which he was allowed to enter Gleyre's studio in 1862.

Renoir was not a dogmatist. If he was not a conventional painter, it was not so much because he held certain views as because he loved painting. For him, painting was a pleasure, an expression of faith in life. "For me," he said, "A painting must be something pleasant, cheerful, and pretty, yes, I do mean pretty! " He was an enemy of extremism and in love with beauty, a true moderate. Politically, he regarded himself as a liberal. As far as painting was concerned, he hated the work of Van Gogh and Gauguin, shocked by its outrageousness.

Degas was irritated by the charm which Renoir saw not only in elegant ladies but also in the little girls of Montmartre.

Georges Rivière
Degas

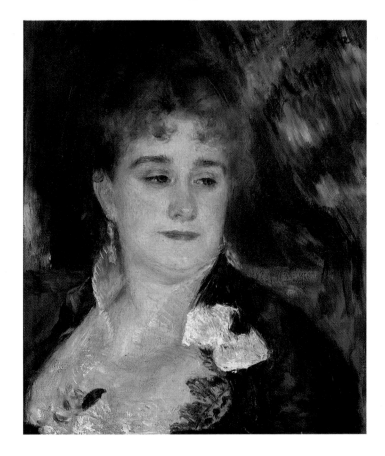

102 *Madame Charpentier's Salon*

It is therefore not surprising that from 1874, he became a portraitist of fashionable people. To this end, he took advantage of the support and protection of Madame Charpentier, whose portrait he painted in 1876. The work was praised by the critics at the Salon of 1879. Renoir had been introduced to Madame Charpentier by the writer, Théophile Gautier. She was the wife of a publisher of realist and naturalist writers who held a salon on Fridays at 11 rue de Grenelle. These soirées were pleasant and lively. It was here that Renoir met and mingled with Gustave Flaubert, Guy de Maupassant, Emile Zola, Alphonse Daudet, Victorien Sardou, the Russian writer Turgeniev, Edmond de Goncourt and J.K. Huysmans – quite an impressive list! The fact that the famous political figures Léon Gambetta, Georges Clemenceau and Jules Ferry also attended the salon shows it to have been a fairly representative cross-section of the progressive Parisian society of the time.

Renoir obtained 1,000 francs for the *Portrait of Mme Charpentier.* This was very little compared to the 50,000 francs earned by the fashionable Bonnat, but a tidy sum for the former apprentice who now saw his dreams of rising up the social scale coming to fruition.

Music must not be omitted from the brief survey of Renoir's life. Renoir was extremely fond of music and was a regular at the Pasdeloup Concerts at the Cirque d'Hiver. The composer, Emmanuel Chabrier was one of his friends. Oddly enough, he liked the work of Wagner which was so different in spirit to his own. Renoir met Wagner in Palermo, and painted his portrait on the basis of one very brief sitting. Apparently, the man had fascinated him. "I liked Wagner a lot," he later confided in Vollard. "I was fascinated by the passionate fluidity I found in his music; but one day, a friend took me to Bayreuth, and I must confess that I was bored to death!"

It was just like Renoir, enthusiastic but even-tempered.

Pierre-Auguste Renoir
Portrait of Madame Charpentier
1876-1877 shown at the 1879 Salon
oil on canvas 45 x 38
Paris Musée d'Orsay

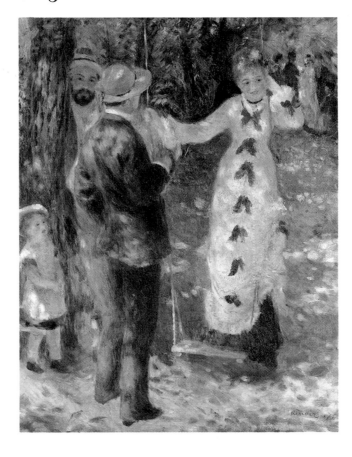

If Renoir had made it, as Pissarro used to say, he had still not settled down. His liaison with Lise Tréhot had lasted for seven years, and had ended in 1872, because Renoir rejected any thought of marriage, so Lise broke off their relationship, and shortly afterwards married an architect.

Then Renoir became infatuated with a young model, Marguerite Legrand, whom the Montmartre in-crowd called "la petite Margot". Although Renoir was fascinated by Parisian high society, he retained a special affection for the inhabitants of Paris's working-class districts. He was fond of the dance-halls and popular entertainments, he loved the crowds and the streets.

At the time, the steep hill of Montmartre was topped by two windmills, the Radet and the Blute-fin, which stood at the end of the Rue Lepic. They were relics of the days when Montmartre used to grind flour for the Parisians, before it began growing iris-roots for the perfume industry. Times were changing, so around 1850, Debray, the owner of the Blute-fin windmill, decided to turn his shed into a dancehall on Saturdays and Sundays. The windmill, which was now disused, was used as a sign for the dance-hall. Since it was reputed to serve good biscuits of a type known in French as "galettes", the Blute-fin became known as the Moulin de la Galette.

The decor was rudimentary and not particularly attractive, place was unadorned, and rather plain, but its easygoing atmosphere attracted many people. An open-air dance floor and tables under the lantern-hung trees were all that the inhabitants of Montmartre needed to come and enjoy themselves. The recipe was plain but good.

Renoir was one of them. "This young and happy crowd, busy dancing, offered a lively sight that Renoir dreamed of capturing in a large painting," wrote his friend, Georges Rivière.

Worries and misery were left at the door of the dance-hall.

Georges Rivière
Renoir et ses amis

Pierre-Auguste Renoir
The swing
1876
oil on canvas 92 x 73
Paris Musée d'Orsay

*The Moulin de la Galette
windmill in Montmartre*
photograph c. 1870-1880
Bibliothèque Municipale de la Ville de Paris
(photo Charmet)

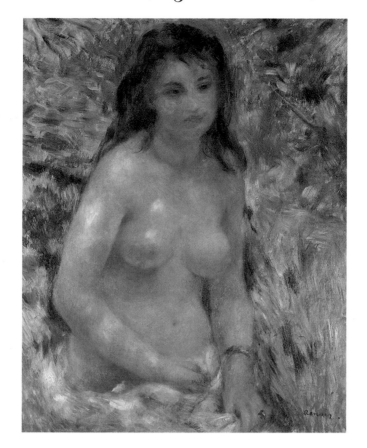

IO4 *12 Rue Cortot*

Renoir had a direct vision of life, of groups of people, of romantic conversations, of scenes of leisure, of the elegance of the theatre, and he was the painter of the freedom of life, through which he paraded the fantasies of his youth.

Gustave Geoffroy
Claude Monet

Renoir had had the idea but needed to find the means to achieve it. His studio in the rue Saint-Georges was too small and too far from the Windmill. Yet despite the problems involved, Renoir was bent on painting this huge work from life. He therefore had to carry his canvas back and forth every day! He started to look for premises nearby at a low rent, and found a place by chance, at 12 rue Cortot, on the north side of the Montmartre hill.

The building was an 18th-century farmhouse in a rather dilapidated condition. Renoir installed his materials in the cowshed. It was in the garden of this house that he painted *The Swing* 1876 and *Female Torso in the Sunlight*, shown at the second Impressionist Exhibition, in 1876. This latter work, and *The Moulin de la Galette*, shown the following year, were the last of Renoir's paintings to be fiercely attacked, before the success of *Portrait de Madame Charpentier*. A hostile critic reproached him with covering his figures with "mould," and with presenting the viewer with "a mass of decomposing flesh". This was the last gasp of the ultra-conservatives who refused to see the evidence of innovation in colour as presented by Renoir and could only see putrefaction in a painting in which light flowed over the bodies. This brings us back to another point about the *Moulin de la Galette*.

Throughout his career, Renoir showed a preference for compositions featuring several figures and for portraits, to a far greater extent than the other Impressionists. He had a warm, sentimental attachment to them which today one would term psychological and which he considered indispensable for his painting. This explains why he always preferred to paint his friends rather than professional models, a fact which is not due to the fact that his income was so modest. Renoir was undeniably more sensuous than intellectual by nature.

*Old Montmartre
In the Maquis in 1900*
pre-1914 postcard
private collection

Pierre-Auguste Renoir
Nude in Sunlight
1876
oil on canvas
shown at the Second Impressionist Exhibition in 1876
G. Caillebotte Bequest 1894
Paris Musée d'Orsay

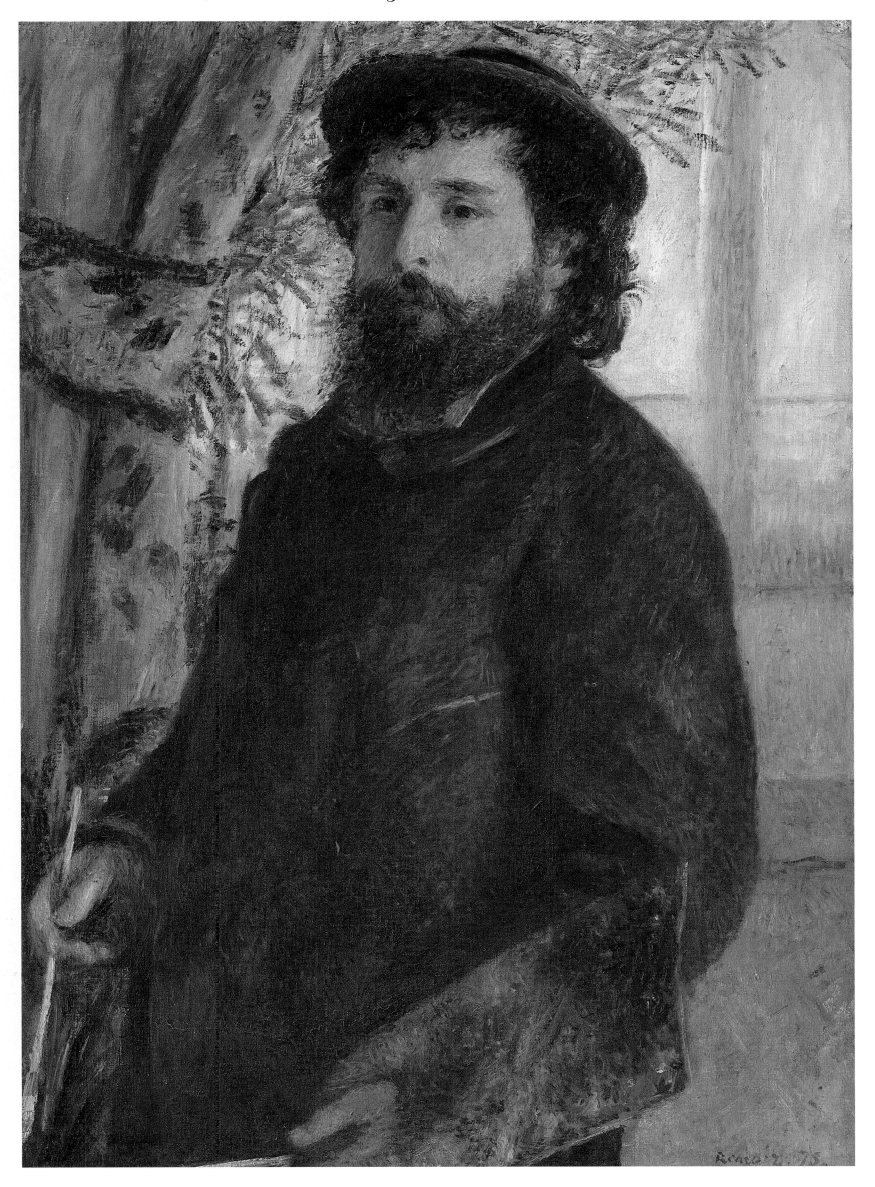

Pierre-Auguste Renoir
Claude Monet
1875
oil on canvas 85 x 60.5
Paris Musée d'Orsay

106 *The Moulin de la Galette*

Once the studio had been found, Rivière and Franc-Lamy offered to transport the canvas, and Renoir appealed to the people of Montmartre for models. As he told Vollard, "I was lucky enough to find some young girls at the Moulin de la Galette, who were quite happy to pose for me, like the two who are in the foreground of my painting". These "young girls" who were street-walkers, in fact, had "lovers" who might have objected to these sittings. Renoir must have been charming and persuasive. Not only did the pimps raise no objections, they even posed for some of the male figures. Little Margot also posed, dancing with the lanky Cuban painter, Pedro Vidal de Solares y Cardenas. Franc-Lamy, the engraver Norbert Goeneuthe, Paul Lhote, and Henri Gervex were also models.

After this considerable feat, Renoir became a celebrity in Montmartre, and, remembering his own humble origins, tried to help the urchins who hung around, more or less abandoned, in the narrow lanes of Montmartre, left to themselves while their mothers went off to work, sometimes far away. He intended to open a day-nursery, before its time, and which dubbed a "Pouponat," from the French word "poupon," meaning "tiny baby". He organised a huge ball to finance this project. The ball was a great success but a financial flop, but the idea was taken up by Madame Charpentier and was to be put into practise, even before Poulbot's charitable work.

Tragedy intervened to end these happy times. Margot, who had been ill since late 1878, died at the end of February 1879, leaving Renoir with only the memory of a liberated, uninhibited young woman.

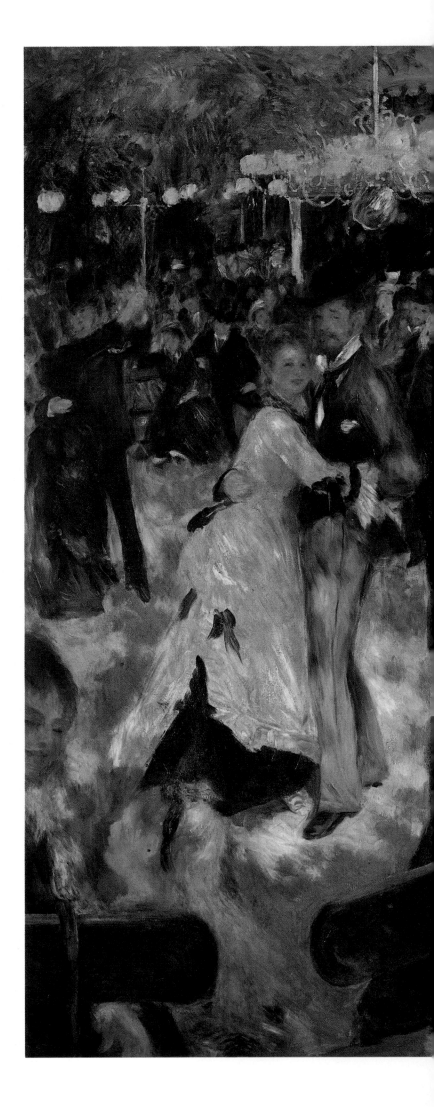

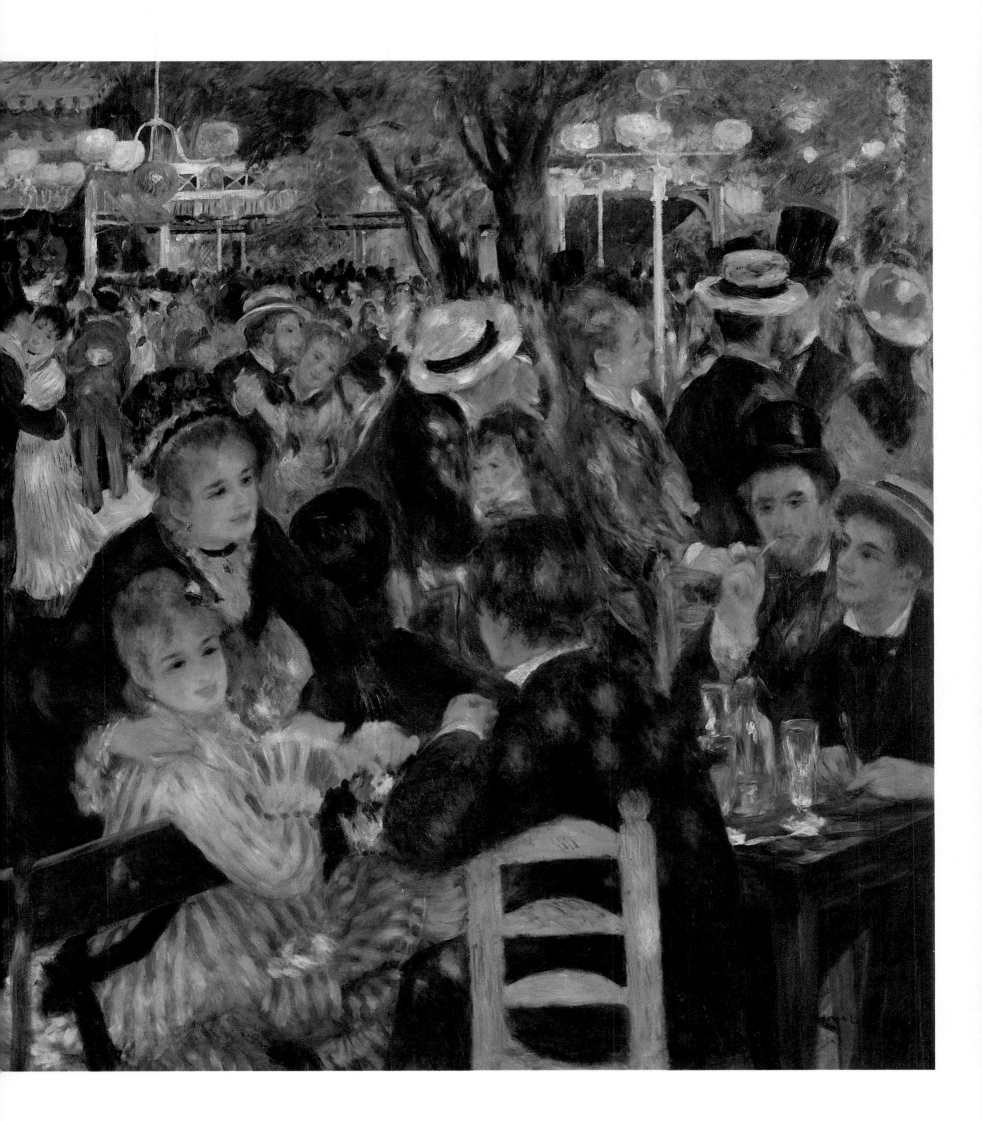

Pierre-Auguste Renoir
Bal du Moulin de la Galette
1876
oil on canvas 131 x 175
Paris Musée d'Orsay

108 *The Restaurant Fournaise*

Margot's death and Renoir's meeting with Aline in 1879 mark the beginning of a change in his work which was fully accomplished after 1881.

In 1879, Renoir was accepted for the Salon and refused to exhibit at the fourth Impressionist Exhibition. He did so in 1880 and again 1881, no longer wishing to be regarded as an "independent" and even less as an "intransigeant." He held it against Pissarro for being both a Socialist and a Jew. In short, Renoir kept his distance, he was all for charity but wanted nothing to do with revolution. As for his friend Monet, he had settled in Vétheuil after Camille's death. Their meetings became rarer. The days when they painted together had gone.

In his thirst for respectability, Renoir was easily persuaded by Prince Bibesco never again to set foot in La Grenouillère, obviously a disreputable place, abandoning it for the Restaurant Fournaise, a much more respectable establishment, in Châtou on the island of Croissy. There were fewer frogs here and more genuine sportsmen. Renoir was a regular visitor between 1878 and 1882. "I could find all the beautiful girls I wanted," he said. He had no ulterior motives in this assertion, he was thinking purely of his painting. "Renoir only loves women with the tip of his paintbrush," gossiped Jeanne Samary, an actress at the Théatre-Français, who had tried unsuccessfully to seduce the man who had produced a beautiful portrait of her.

There was a grain of truth in this. In fact, Renoir himself admitted that "you'd have to be crazy to spend your time boring yourself with street-walkers when you could be enjoying yourself painting". Not that Jeanne Samary was a prostitute, of course, but anyway he had Aline.

Aline Charigot was the daughter of a grape-grower from Essoyes, who had emigrated to the United States. She was a young seamstress who worked with her mother in a shop in lower Montmartre. At noon, the ladies had lunch in the back room of the "Chez Camille" dairy, in the Rue Saint-Georges. The place served simple food – the dish of the day and cheese from the counter. Since the dairy faced his apartment building and since, like a true bachelor, he never cooked, Renoir lunched there occasionally. That was how he came to meet Aline.

Very soon, Renoir took Aline to Fournaise, on the banks of the Seine, and he asked her to pose for him as often as possible. Physically, Aline was Renoir's ideal. She had a voluptuous, shapely body and a small face with a roguish mouth and a snub nose. She was everything he admired in a woman.

They had met in the autumn of 1879. When Renoir had the idea of painting the *Luncheon of the Boating Party*, in the course of the summer of 1880, he naturally placed her in the foreground.

Chatou: the Restaurant Fournaise
postcard

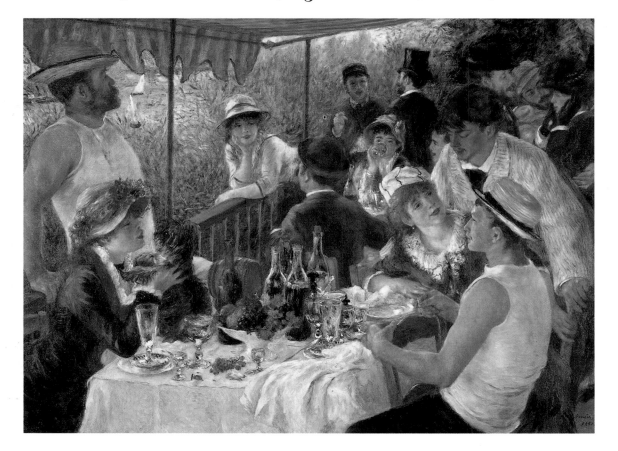

The Luncheon of the Boating Party was a turning-point in Renoir's work. "That summer of 1880," wrote Georges Rivière, "can be considered as a landmark in Renoir's career. In fact it ends the series of scenes from Parisian working-class life. Thenceforward, the painter would hardly ever again be seen at work at the Moulin, at Bougival, or in the Place Pigalle".

What was the reason for this break with his past? *Luncheon of the Boating Party* was a complete success. Théodore Duret describes it thus: "The boating party has just lunched under the restaurant awning. The Seine and its banks (...) create a brilliant background. (...) The women particularly attract one's attention (...). They are so relaxed and unrestrained, (...) but they also look especially gentle, displaying that mischievous charm (which Renoir) was the only painter who could bring out in women". Jeanne Samary and Aline are shown in the painting, the latter holding a Pekinese. Paul Lhote is leaning back against the railings, his face in profile, and Gustave Caillebotte sits astride a backwards-facing chair. The whole painting exudes the relaxed atmosphere of the happy ending to a good meal ending. What went wrong?

Renoir explains it himself thus. "A break occurred in my work. I had thoroughly explored Impressionism, and had come to the conclusion that I could neither paint nor draw. In short I had reached an impasse". He was exaggerating, but this remark is significant. In the *Luncheon of the Boating Party*, Renoir had achieved the ultimate expression of his early research. He realized that this painting was the culmination of his art. If he had continued in this direction he would have been repeating himself, applying a formula and giving in to a systematic working method. To rediscover the joy of painting, he needed to innovate and explore new directions. Furthermore Aline, like her predecessor Louise, was talking of marriage. Renoir asked her to leave him time to think it over, and left for Algeria.

About Aline:

(Renoir) had come to the point where he simply put his palette down and stared at her instead of painting, thinking to himself, "Why bother?", since what he wanted to create already existed.

Georges Rivière
Renoir et ses amis

Pierre-Auguste Renoir
Luncheon of the Boating Party
1881
oil on canvas 129 x 173
Washington Phillips collection

The Banks of the Marne
painting
c. 1870-1880

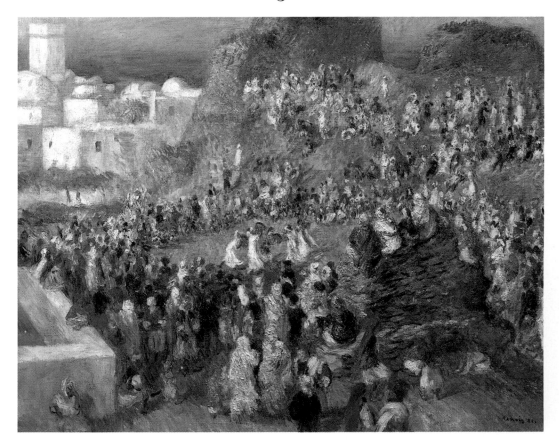

110 *The Italian Lesson*

Monsieur Renoir is an Impressionist, but he is better defined as a romantic Impressionist. Over-sensitive by nature, he is always afraid of being overassertive.

Philippe Burty
La République Française
April 25 1817

Renoir was thrilled with the colours of Algeria. For a while, he believed that the new subject-matter would be enough to bring back his pleasure in painting. He painted the countryside *(Field of Banana-trees)* and townscapes *(Arabian Festivities in Algiers)*. However, he soon realized that he missed the company of real friends whom he could depict in his paintings. His oil paintings of Algeria, despite of their beauty and their plethora of colours, look contrived, and are haunted by the memory of Delacroix. This return to the style of Delacroix is proof of the doubts which tormented Renoir at the time. It also shows the artist's deepest inclinations. Renoir preferred the exuberance of the greatest romantic painter to the austerity of Courbet, who is considered as one of the precursors of Impressionism. This marks a major distrust of the painters of his own school. He wondered anxiously whether he had been mistaken in following Monet. Were not all of the Impressionists mistaken? Were they not merely the victims of their own desire to break with tradition, as their critics claimed, and would it not be better to return to this tradition? Renoir understood that Algeria was merely a staging-post. His self-questioning, which was a mixture of personal and artistic preoccupations, led him naturally to Italy, the cradle of western art.

Renoir visited Venice in the autumn of 1881, then went to Rome, Naples, and Palermo. He undertook this journey as a return to classical tradition. He lodged at little inns, ate on the terraces of the trattorias and did a lot of sketching. Here he was at the age of forty, embarking on the grand tour he had been unable to take at twenty.

Renoir loved Venice for its traditional atmosphere, but in Rome he began to miss France. As homesick as his compatriot, Joachim du Bellay, had been three centuries earlier, he wrote to a friend one day that the ugliest Frenchwoman was more beautiful than the most beautiful Italian girl – a very personal opinion! Nevertheless, he studied Raphael and he came to believe that Impressionism had led him to neglect his drawing. The mastery of line and modelling, essential elements in Italian painting, taught him a valuable lesson.

Renoir overcame his homesickness travelling further south to the Mezzogiorno. It was in Palermo that he met Wagner. Then from Sicily, he crossed over to Algeria again, as if to complete the circle. His long pilgrimage to rediscover his art, was coming to an end. He informed Aline of his return, and when the train entered the Gare de Lyon, she was waiting for there waiting for him at the station.

Pierre-Auguste Renoir
Arabian Festivities in Algiers
1881
oil on canvas 73 x 92
Paris Musée d'Orsay

Pierre-Auguste Renoir
Field of banana-trees
1881
oil on canvas 50 × 71
Paris Musée d'Orsay

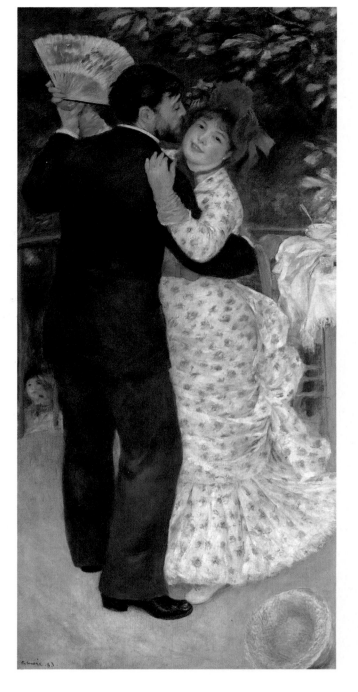

I love (women) who can't read and wash their babies' bottoms themselves.

Renoir

Immediately upon his return, Renoir adopted his new style which was called "Ingresque," in reference to Ingres, but which Renoir himself called "sharp". In other words, Renoir's style tended to become more classical. His outlines became clearer and more incisive, the drawing was more in evidence and his palette was simplified, showing a preference for cool colours. The two paintings, *Dancing in the Country* and *Dancing in Town*, conceived as a pair, perfectly illustrate Renoir's attempt to discipline his work henceforward. *Dancing in the Country* shows Aline dancing with Paul Lhote, already seen in *Luncheon of the Boating Party*, while Suzanne Valadon, a painter and Utrillo's mother, posed for the second.

Renoir settled down to living with Aline. Their first son, Pierre, was born in 1885. Aline was not yet twenty-five and was greatly admired by Renoir's friends. "Your wife looks like a queen visiting the jugglers," Degas told the lucky man one day when they went to an exhibition together. Aline was also a perfect hostess and she became famous in the world of art, for her bouillabaisse soup and other dishes. Renoir was eventually unable to resist her talents, and in 1890, he yielded to her pleas, overcame his bachelor's reserve and the lovers married. Four years later, their second son, Jean, was born. "A big baby boy," wrote his father announcing the event.

Jean later wrote, "My mother gave my father a lot – peace of mind, children for him to paint, and a good reason for no longer going out at night".

Pierre-Auguste Renoir
Dancing in the Country
1882-1883
oil on canvas 180 x 90
Paris Musée d'Orsay

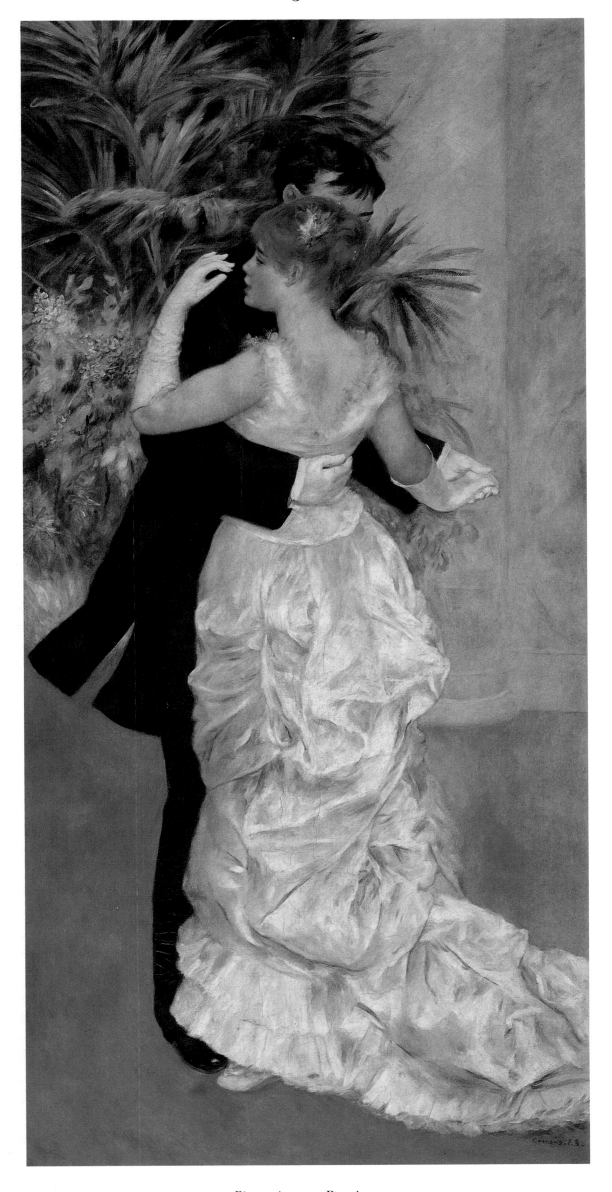

Pierre-Auguste Renoir
Dancing in Town
1883
oil on canvas 180 x 90
Paris Musée d'Orsay

114 *Pearly Tones*

The Wasteland of Montmartre : (...) Behind the hill of Montmartre and beyond the fortifications (...) there lies an area crowded with shanties and rag-pickers'.

Maurice Leblanc
La vie extravagante de Balthazar

Meanwhile, Renoir was getting tired of the "sharp" style, which was quite unsuited to his temperament. After a short period of discouragement, he decided to revert to a freer style, using warmer colours and less emphasis on line. This final period of his work has been called "pearly," because of its characteristic flesh tones.

Young Girls at the Piano illustrates this change of direction. This painting was purchased by the state in 1892 thanks to the urging of the poet Stéphane Mallarmé; it was the first of Renoir's paintings to enter the French national collections.

As the family had grown larger, the Renoirs moved to the top of the hill of Montmartre, to a small two-storey house with a little garden at 6 Allée des Brouillards. Renoir set up a studio in the attic, but he did not use it much. As in his dance-hall days when he had painted at the Moulin de la Galette, he needed to separate his workplace from his home, so he rented a studio in the rue Tourlaque. The Allée des Brouillards looked nothing like it does today. It was still almost countrified, surrounded by the greenery of the Maquis, the "bush" as this part of Montmartre from the Moulin de la Galette down towards the rue Caulaincourt was still called.

Paris, the "Maquis" of Montmartre
looking towards the rue Caulaincourt
photograph by Marville
c. 1860-1870
Paris Bibliothèque de la Ville de Paris

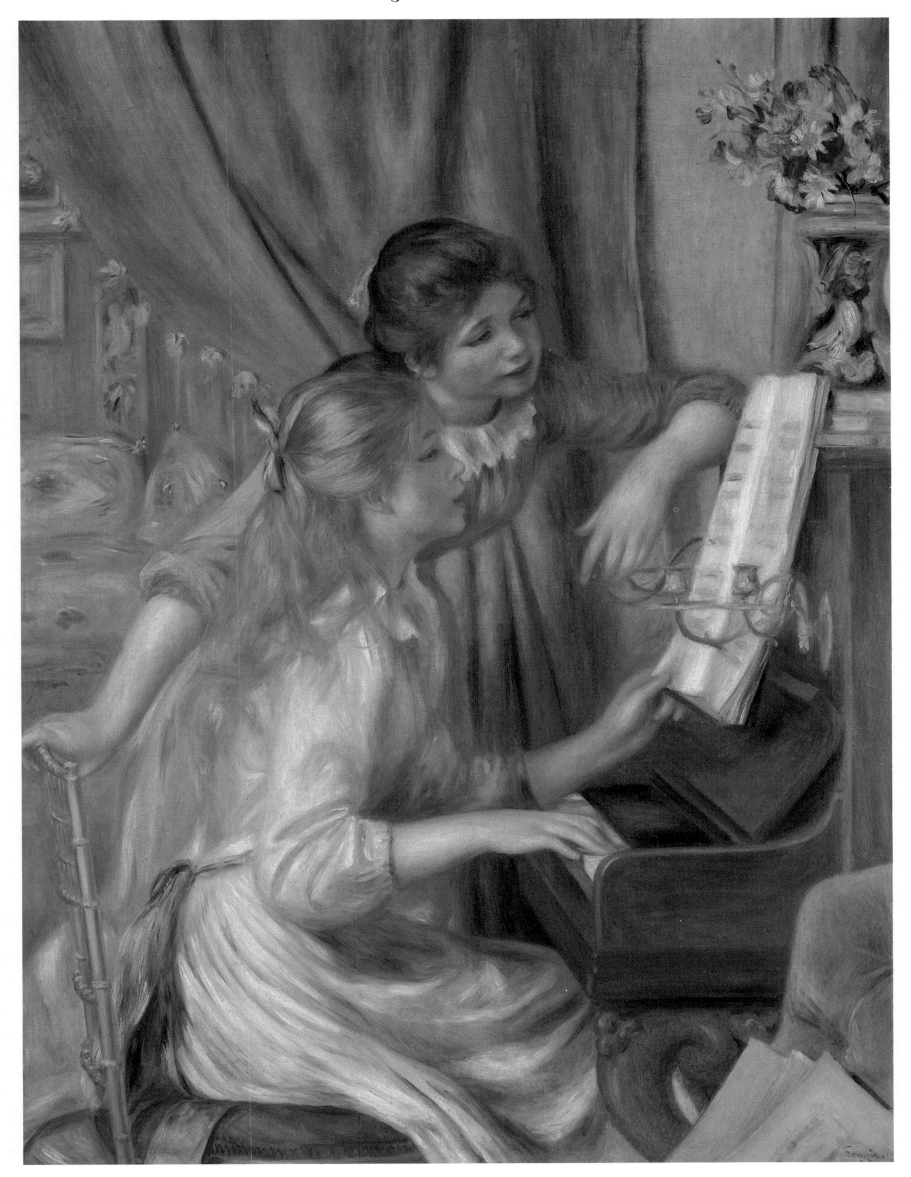

Pierre-Auguste Renoir
Young Girls at the Piano
1892
oil on canvas 116 x 90
the first work bought by the state thanks to Mallarmé, in 1892
Paris Musée d'Orsay

116 *Cousin Gabrielle*

By the 1890s, Renoir was earning a comfortable living. Aline seized the opportunity to hire a cook and a maid, and brought her cousin Gabrielle, fifteen years her junior, to come up from Essoyes to look after little Jean. Gabrielle became Renoir's favourite model. Théodore Duret was obviously thinking of her when he wrote in 1906, "I doubt that any painter has ever interpreted women more seductively. Renoir's light, swift brushwork expresses their grace, litheness and lack of restraint, he gives their flesh a transparent quality, and tints their cheeks and lips with brilliant carmine. Renoir's women are bewitching".

In 1899, *La Grenouillère* fetched 20,000 francs, and some time later, the *Portrait of Madame Charpentier* sold for 84,000 francs. Renoir saw himself rise to the top of the social scale when, in 1900, he became a Chevalier of the Legion of Honour. Much has been made of a letter he wrote to Monet about the occasion to apologize, because he feared that his friend would interpret it as a betrayal. It is also said that Pissarro made fun of him for compromising with the Establishment. This may be true but the award could simply be regarded as an expression of gratitude for Renoir's strenuous efforts in dealing with the Caillebotte bequest.

Pierre-Auguste Renoir
Gabrielle with a Rose
1911
oil on canvas 55 x 46
Paris Musée d'Orsay

After 1900, Renoir and his family spent more and more time away from Paris. Aline had won her husband over to the delights of her birthplace, and Claude, their third son, was born at the village of Essoyes in 1901. Renoir loved the simple, unsophisticated Burgundian wine country.

However, his first attack of arthritis forced him to spend some time in the south of France in 1899. He returned each summer, and finally settled there for good in 1914, after buying a house at Les Collettes near Cagnes-sur-Mer, in 1908.

The surroundings were delightful, but the artist's health was deteriorating. He fell off a bicycle and fractured his arm and then his left eye was affected by a degeneration of the optic nerve. Once his right arm was completely paralyzed by arthritis, he learnt to paint with his left, but even that hand failed after 1912. He persisted and had his brushes tied to his arms.

Renoir never gave in, despite his ill health and the misfortunes that befell his family, despite Aline's death in June 1915, and the wounding in action of his sons, Jean and Pierre. He even found a new model, Dédée, in 1916. In 1917, at the age of seventy-seven, he began *The Bathers*, which was definitely his last masterpiece.

"It's just now when I no longer have any arms or legs," he wrote, "That I feel like painting large canvases. I dream of Veronese's *Wedding at Cana*, how unlucky I am!" Yet he was also glad that he was still working. He was able to see his beloved *Wedding at Cana* one last time in the Louvre in 1919. Hanging right next to it was his *Portrait of Madame Charpentier*. The portrait had brought him good luck.

Renoir died in his sleep in Cagnes, one night in December 1919, and was buried at Essoyes, Aline's home town.

Pierre-Auguste Renoir
Bathers
1918-1919
oil on canvas 110 x 160
Paris Musée d'Orsay

Edgar Degas
Self-portrait
c. 1854-1855
oil on canvas 81 x 64.5
Paris Musée d'Orsay

I f Degas was like Renoir in that he was a wonderful painter of women, he was very different from his friends in other ways. In fact, for a time some art critics did not consider either of these artists as Impressionists. This judgement was merely reinforced by Degas' background and his difficult nature, which often bordered on the misanthropic. However, how else could one explain the fact that he was one of the leading instigators of the 1874 Exhibition? And why, out of the whole group, was he the fiercest opponent of the Salon? The answers to the enigma of Degas' ambiguous career and the marginality of his work may be found in his early years.

Hilaire-Germain-Edgar de Gas (who simply signed his work "Degas") was the eldest son of Auguste-Hyacinthe de Gas, a member of a banking family from the *ancien régime* that fled to Italy during the French Revolution. Some of the family remained in Italy. Degas' mother was Marie-Célestine Musson, a Frenchwoman of Creole origin, and a descendant of the Musson family of New Orleans, who were cotton-brokers. Edgar was born in Paris on July 19 1834 and raised in the elitist world of the international aristocracy and high finance. He studied classics at the Louis-le-Grand Lycée (high school) in Paris, then went to law school at the Sorbonne. He seemed destined for a conventional career. However, in 1853, two years after his mother's premature death at the age of 34, he decided to become a painter.

Edgar Degas was of average height, well-proportioned, and distinguished-looking. He held his head straight (...) wore a top hat (...) most of the time he wore tinted glasses to protect his failing eyes. (...) His face was framed with his chestnut whiskers, neatly clipped like his moustache and smooth hair.

Georges Rivière
Degas

120

Degas studied for a few months at the Ecole des Beaux-Arts under Louis Lamothe, a disciple of Ingres, but when he failed to win the Rome Prize, he left the school. However, he had struck up an acquaintance with Bonnat and Viscount Lepic. The latter was a strange individual, an archeologist, painter and engraver whom Degas later painted walking across the Place de la Concorde. Degas used his family connections to spend some time in Italy, where he stayed with his Bellelli relatives in Florence. The portrait he painted of them is now in Paris at the Musée d'Orsay. "This was the most extraordinary time of my life," he wrote to his friend, the painter Valernes. "Apart for a few words scribbled down to give my family news of me, I wrote nothing, I was sketching".

On his return to France, Degas painted several pictures on historical themes because this was the customary subject-matter for paintings being shown at the Salon. His style was still strongly influenced by classicism. Yet, as François Fosca has written, Degas "was incapable of painting a scene which he could not view as if he had witnessed it himself". He needed the stimulus of reality to really express his gifts. "Degas had the eye of a photographer," Jacques-Emile Blanche said of him, "(...) His brain later corrected the proof". Degas' meeting with Manet at the Louvre in the early 1860s thus proved fateful. It was thanks to Manet that Degas adopted Baudelaire's famous advice, namely, "Renounce the mythological panoply of the classics and opt for art which expresses modern life". The discussions at the Café Guerbois accelerated this development.

This was a development rather than a complete break, because from Degas' earliest self-portraits he shows a clear preference for psychological truth and a refusal to idealize the subject. The *Self Portrait* painted in 1854 already depicts a melancholy young man whose pouting expression displays dissatisfaction and disillusion. Between 1860 and 1870, Degas attempted to translate modern realism as well as his vision of the world through such portraits. His *Portrait of Thérèse de Gas, Duchess of Morbilli*, when he had already overcome the influence of Ingres, reveals his scorn of outward show and rejection of elaborate settings and costumes (so beloved of the fashionable painter Carolus-Duran) in favour of seriousness, detachment and his own brand of pessimism. Degas was clearly seeking his own truth through that of his model; in this, he was truly a modernist.

Edgar Degas
1844-1917

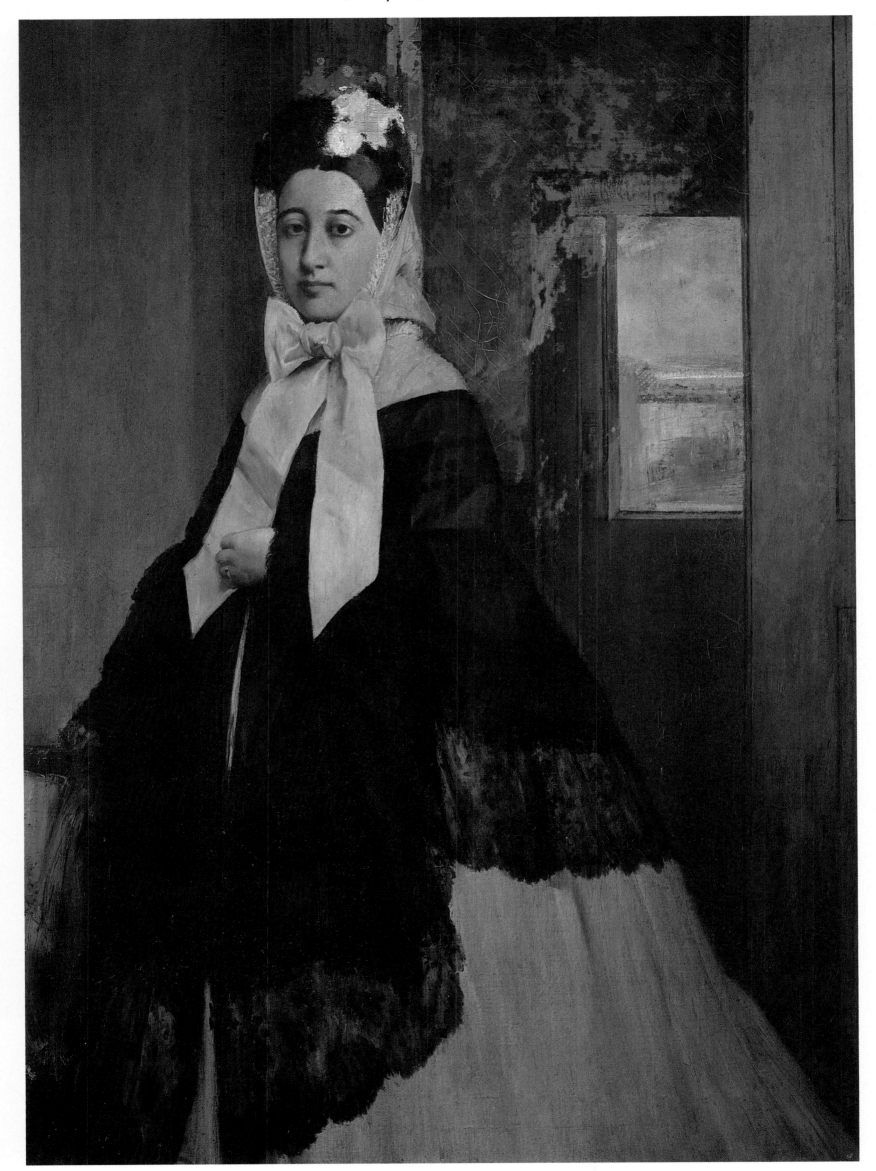

Edgar Degas
*Portrait of Thérèse de Gas
Duchess of Morbilli*
1863
oil on canvas 89 x 67
Paris Musée d'Orsay

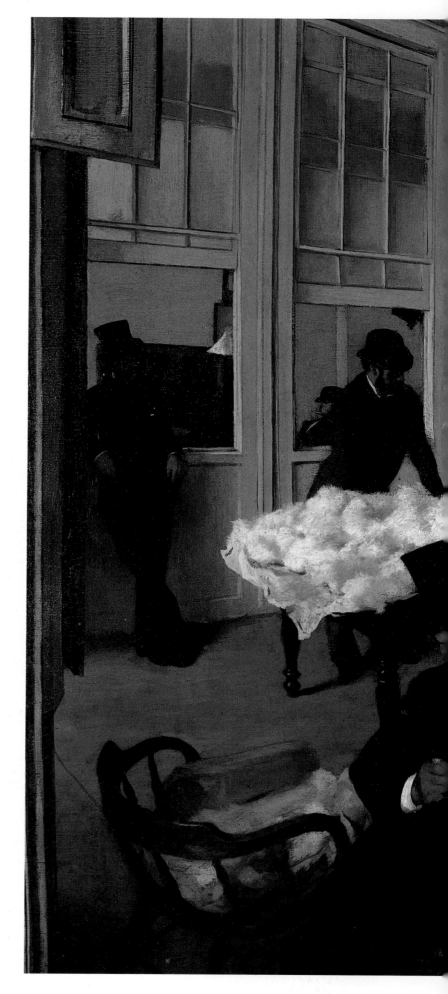

122 *A Trip to New Orleans*

There is nothing but cotton here (...) people live for and from cotton (...). My only effort will be to produce a few family portraits; I cannot avoid it and I certainly won't complain if it proves to be less difficult (...) and the models less fidgety.

Degas
in a letter to Henri Rouart
December 5 1872

Degas served as an artillery officer in a gun battery on the fortifications during the Franco-Prussian War of 1870. After the war, he was not tempted to join the other Impressionists on the banks of the Seine, but chose to travel to New Orleans in 1872, where his brothers, Achille and René, had inherited the Mousson cotton brokerage business. This new world filled him with enthusiasm. In November, 1872, he wrote to his friend, the painter Fröhlich, "Nothing pleases me so much as the negresses of every shade holding the little white babies in their arms, looking even whiter against the white houses with their fluted, wooden columns and their orange groves, the ladies in muslin (...) and the steamboats (...) and the contrast with the busy office operated so energetically with this vast, black force of animal labour (...)".

Degas brought back from his trip The *Cotton Office in New Orleans* which was shown at the second Impressionist Exhibition in 1876 and was the only painting bought by a museum, the Musée de Pau, during his lifetime, in 1878. Here again, care is taken to individualize the figures, and there is the same rejection of idealisation and lyricism, and the artist's detachment from his subject matter. There is another feature which was to become basic to his work, namely, an original composition which encloses the figures in a clearly-defined, three-dimensional space. Monsieur Musson, Degas' uncle, is seated in the foreground, examining cotton samples. Behind him, reading a newspaper, is René de Gas, the artist's brother; the other brother, Achille, is leaning against a partition.

Although *The Cotton Office* has something of the spirit of the Dutch school of painting, the work also displays a final emancipation from the conventional academic style and an undeniable perspective on contemporary life.

Degas again wrote to Fröhlich, "To produce good fruit, you have to espalier the trees. You have to remain your whole life with outstretched arms, your mouth open to assimilate what is happening and what is going on around you, and you have to experience it".

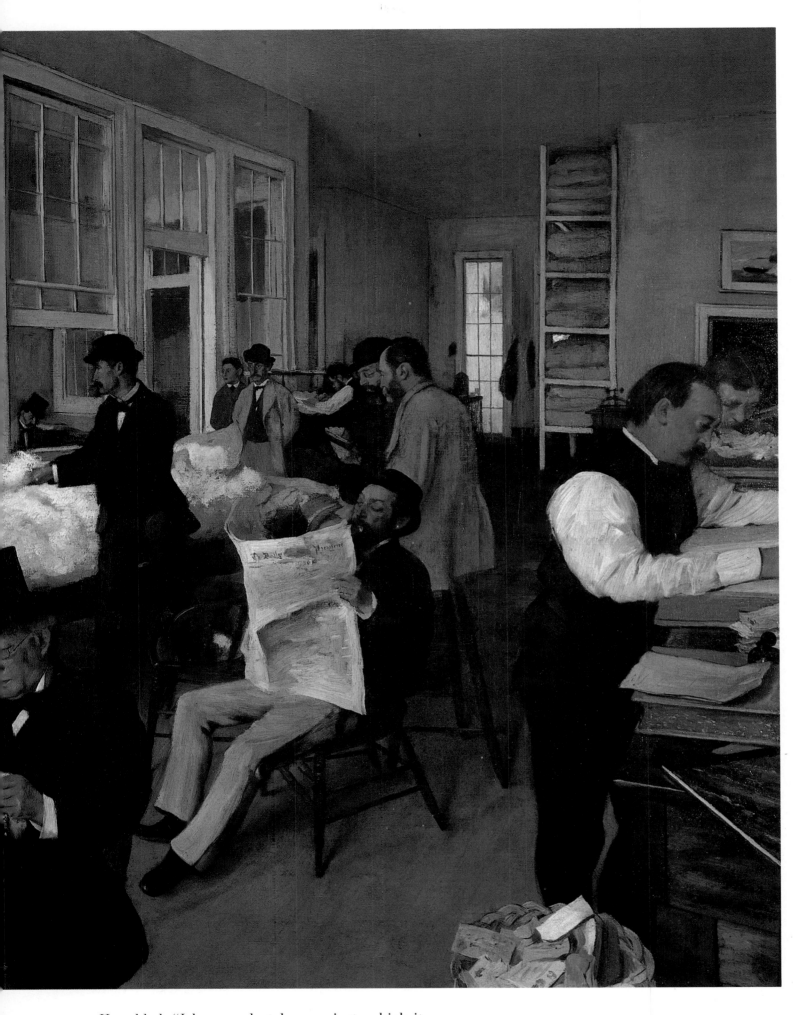

He added, "I have undertaken projects which it would take me ten lives to complete. I shall abandon them in six weeks' time without regrets to return to my home and never leave it again". And, in fact, he was so homesick for Paris that he left New Orleans never to return.

Edgar Degas
The Cotton Office in New Orleans
1873
oil on canvas 71 x 92
Pau Musée des Beaux-Arts

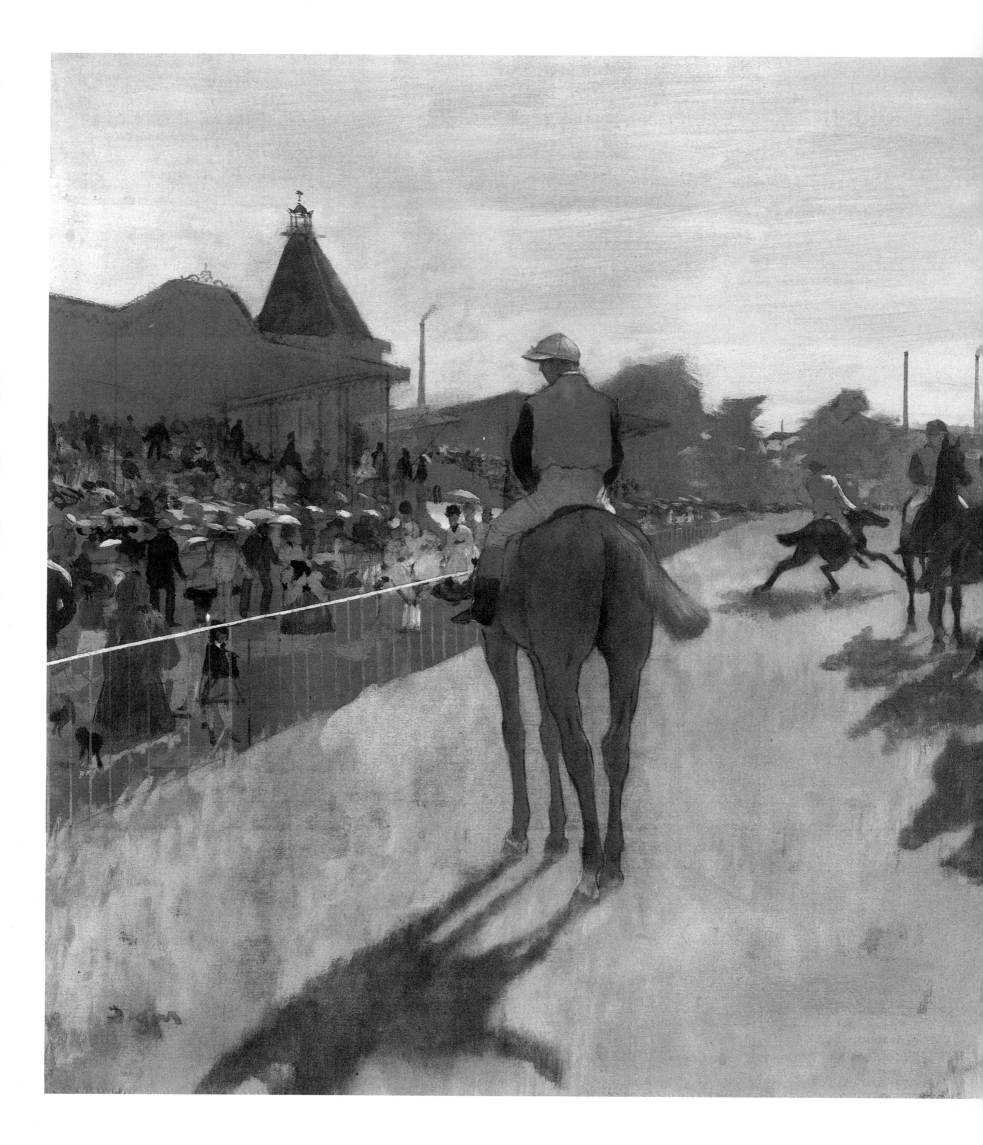

Edgar Degas
Racehorses in front of the Stands
c. 1879
oil on canvas 46 x 61
Paris Musée d'Orsay

"*Luxuriously pure*" 125

Back in France in 1873, Degas launched himself into the great battle of Impressionism, but he did it in his own way, always retaining his independence of judgement and his originality. In his search for subject-matter which reflected modern life but did not neglecting drawing technique, he began to consider the racecourses. Paul Valéry explained it thus, "In the racehorse, Degas discovered a rare subject which fulfilled the conditions which his nature and his times imposed upon his choice. Where was purity to be found in modern reality? Realism and style, elegance and precision were all combined in the luxuriously pure body of the thoroughbred".

In fact, Degas had been interested in horses since 1860. Through his friend, Valpinçon, a collector who had introduced him to Ingres, he had been able to stay at Menil-Hubert, in Normandy, near the Haras du Pin, where he had often sketched the horses, and he continued to do so in New Orleans. In a way, this complemented his work as a portrait-painter; in portraits, he tried to unveil a psychological truth, and in horses, he sought to catch real movement. In both cases, he was pursuing life. As François Fosca wrote, "Degas is really the first artist in whom indifference to anything which is not real is brought to its culmination, the painter who comes closest to being a zoologist and physiologist".

I am a racehorse.
I run in the big races,
but I am content
to be paid in my ration
of hay.

Degas

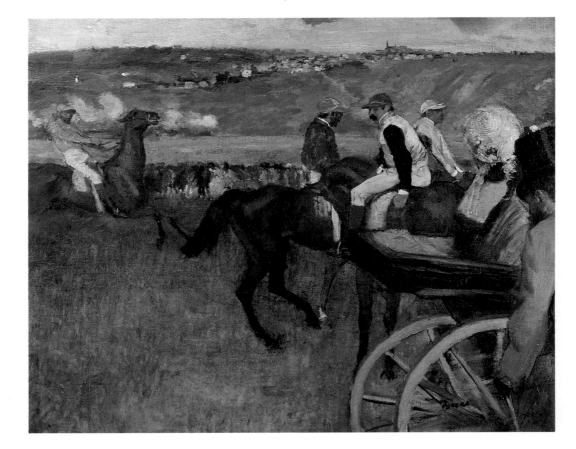

126 *A Product of the Imagination*

Degas' preoccupation with naturalism was similar to that of Zola and his naturalist æsthetics. However, Degas hated the author of the *Rougons*, because he suspected him of using his friends to become famous in the literary world. The publication of the *Works* gave him partial justification for his suspicions. His dislike became definitive when Zola published the famous article "J'accuse" in *L'Aurore*, in defense of Dreyfus, for Degas, like all the monarchist aristocrats, was a fierce anti-Dreyfusard.

Degas particularly enjoyed talking to Duranty during evenings spent at the Nouvelle-Athènes, a café where the Impressionists used to meet after 1870. These discussions prompted Duranty to write a little book entitled The New Painting, published in 1876. "Farewell to the human body treated like a vase," he wrote, "Just for its decorative curve (...) what we need is (...) the modern individual (...) at home or in the street". Clearly, this was an opinion inspired by Degas.

However, on one fundamental point, Degas was to remain adamant. Throughout his life, he fought against open-air painting. He frequently expressed his views on the question. "Yes," he admitted, "If leaves did not rustle, how sad trees would be! and so would we". But, he added, commenting upon a painting produced in the open air by his friend Jeanniot, "Above all, a painting is a product of the imagination, it must never be a copy. (...) The air that one sees in the works of the great masters is not breathable air".

In this respect, Degas was firmly against the techniques of Monet and Boudin, who considered that "Three brush-strokes from nature (were worth) more than two day's work at the easel". Degas' horses, which look so alive, so vibrant, were less the product of a transient impression captured from life than of sustained observation, methodically memorized, to be worked over again in the studio. Incidentally, Manet, the master of them all, worked in exactly the same way.

Edgar Degas
Racecourse Amateur Jockeys Near a Car
c. 1877-1880
oil on canvas 66 x 81
Paris Musée d'Orsay

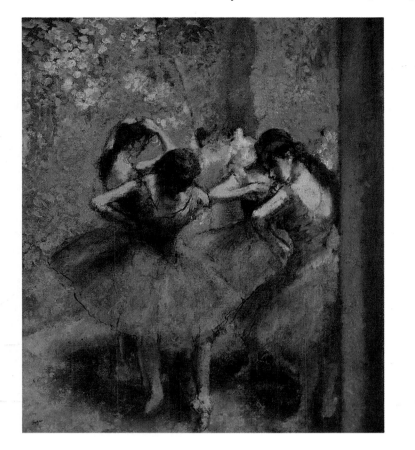

*It is impossible for me to live
a long way from my studio
and not to work.*

Degas
to Lucien Halévy
August 1893

From his youth, Degas was a regular opera-goer. The Paris Opera was located in the Rue le Pelletier before the fire of 1873. This was his world. As an aristocrat, he would watch the performance and dine afterwards in town with celebrities such as Halévy, Breguet, and Haas, whom Marcel Proust later used as a model for Swann. Degas' father was a great music-lover, who held concerts in his home on Mondays to which Degas invited his friends. Pieces by Mozart or Glück would be performed. That is how Degas met the bassoonist Dihau whose now-famous portrait he painted in *The Orchestra*.

What Degas most appreciated in this world of musicians, dancers, and ballet-masters, was what he considered the quintessence of modern life – a world of make-believe. He once told his Impressionist friends, "You need nature, but I need artificial life".

Upon his return from New Orleans, Degas' attention shifted from the orchestra to what had served hitherto merely as a background in his paintings – the ballerinas on the stage. Degas made quantities of sketches, choosing pastel because it allowed greater freedom of technique and perhaps greater speed of execution. In fact, since 1876 he had found himself in financial difficulties, and for the first time in his life he was forced to produce work and sell it in order to live. Upon his father's death, the Bank of Antwerp asked the Gas Bank to repay loans granted to finance René's business in New Orleans. René could not meet his undertakings, so his brothers, Achille and Edgar, took over the debt as a matter of honor.

Degas sold his mansion in the Rue Blanche, and moved to Cité Frochot until 1886. "For years," Georges Moore wrote, "He locked himself in his studio, day in day out, refusing to open the door even to his closest friends".

Talking (...) about anything which can bewitch the truth and make it look like madness.

Degas
to the painter
A. de Valernes

Edgar Degas
Blue dancer
c. 1890
oil on canvas 85 x 75.5
Paris Musée d'Orsay

Edgar Degas
Dancer with a Bouquet, Bowing
1878
pastel 72 x 77
Paris Musée d'Orsay

Movement, Space, and Memory

It took Degas ten years to rebuild his finances. Does this mean that during the whole period, he was just painting to make money, as he sometimes insinuated? Certainly not. Degas really loved the world of the ballet. In a letter to the sculptor, Albert Bartholomé, in January 1886, he confided in him nostalgically, "Apart from my heart, I have a feeling that everything in me is growing old (...). Even my heart has something artificial about it. The dancers have sewn it up in a pink satin purse, slightly faded pink satin like their ballet shoes". In any case, he had too much respect for his work to neglect even the smallest detail of it. "When he handed over a painting," the dealer Durand-Ruel related, "His dearest wish was that it should not sell, and he would not have failed to belittle it, had he been given the opportunity (...). When he visited us, we had to watch him to make sure he didn't take anything away with him!"

In his long series of paintings of ballerinas, Degas broke away from the influence of Ingres. His talent asserted itself in his completely new way of re-creating the illusion of space and in viewing the scene from a variety of most unexpected angles; he also excelled in balancing crowded and empty spaces, whose interplay suggests both movement and the space with which he identified. Concepts of time and space are combined. Yet while Monet was intent on capturing an instant of light, a motionless and suspended moment, Degas managed to translate a whole series of movements into a single moment. "Nothing in art," he told Bartholomé, "should look accidental, not even movement".

This entailed a huge amount of reconstructional work in the studio. "No art is less spontaneous than mine," he remarked. "What I do is the result of meditation and of the study of the great masters; inspiration, spontaneity, and temperament mean nothing to me. The same subject must be worked over again ten times, a hundred times".

Actually, the Impressionism of Degas is an Impressionism refashioned from memory. Degas would say, "It is very good to copy what you see, but it is even better to draw what you only see in your memory. It produces a transformation during which imagination collaborates with memory. You only reproduce what has made an impression on you, that is to say, the basics. In this way, your memory and your imagination are freed from the tyranny of nature".

Edgar Degas
The Etoile (Ballet at the Opera)
c. 1876
pastel 60 x 44
Paris Musée d'Orsay

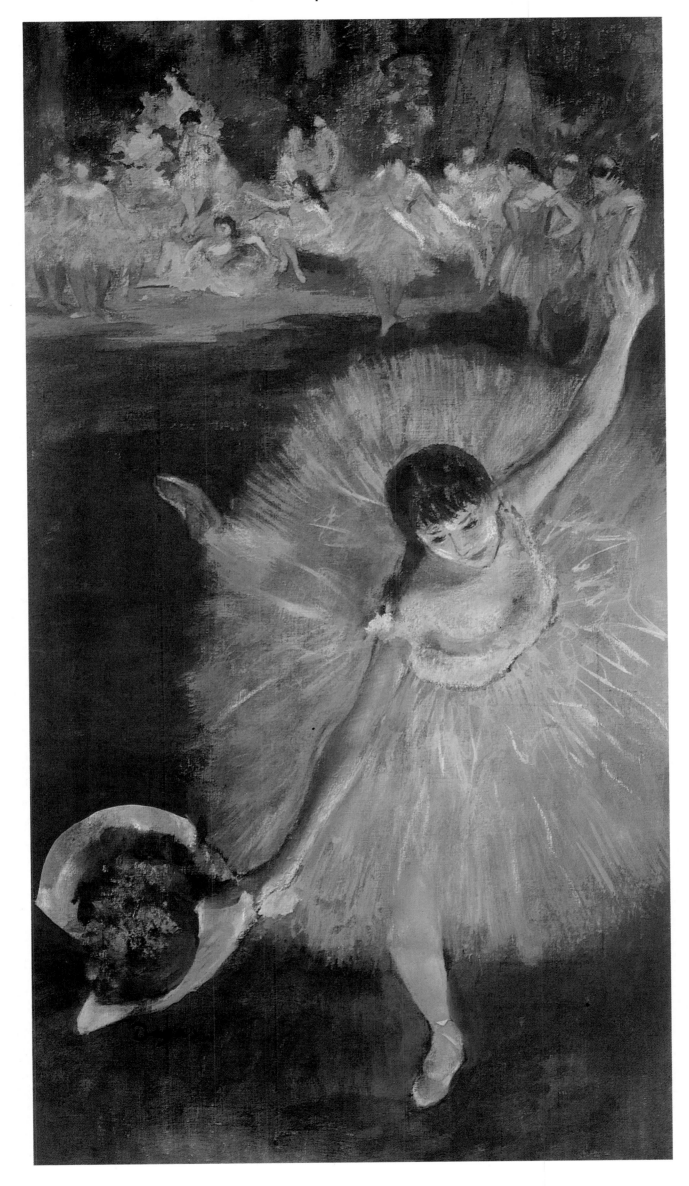

129

(Degas) tried and dared
to try to combine the
instantaneous with the
painstaking work in the
studio, to capture the
impression in a thorough
study, and the instant within
the space of considered
desire.

Paul Valéry
Degas, Danse, Dessin

Edgar Degas
Fin d'arabesque
1877
tempera and pastel 67.4 x 38
Paris Musée d'Orsay

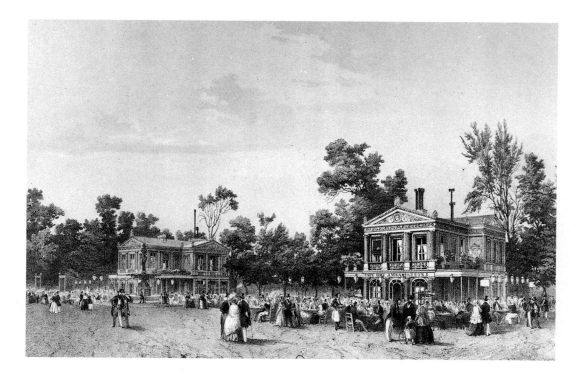

130 *"It is admirable!"*

Besides the Opera, Degas quite enjoyed the cafés-concerts, the French equivalent of the music-hall. Here he could pursue his study of psychology at his leisure. There were "personalities" who particularly attracted his attention, though he was never tempted to succumb to the exaggeration which such subject-matter might produce in another painter. Paul Valéry wrote of Degas, "Free will predominates. (....) He only seeks the truth in style and style in the truth". And, Georges Rivière added, "What Monsieur Degas hates most is an overindulgence in romanticism, the dream as a substitute for life (...). He is an observer; he never seeks to exaggerate". Indeed, Degas never did exaggerate, but he did emphasize, through the use of contrasts.

It was these very contrasts that he liked in Thérésa, the "singer with the glove". "She opens her wide mouth," said Degas, "and out come the most vulgar, refined, spiritually gentle voice ever heard. Where else could such feeling and taste be found? It is admirable!"

The cafés-concerts were a sort of counterpoint to the Opéra, in a similar register, though of course they were more vulgar, less strict, and far more lively. As an extension of his series of portraits of the singers, Degas produced a series of erotic paintings, commissioned by Ludovic Halévy, and probably sketched in Parisian brothels. Vollard used a few of these paintings to illustrate Guy de Maupassant's *The Tellier House*, but unfortunately René de Gas destroyed most of the series when the artist died, claiming thereby to protect his brother's memory.

The Café des Ambassadeurs
in the Champs-Elysées
lithograph from the Second Empire period
Paris Bibliothèque des Arts Décoratifs

The Café des Ambassadeurs
in the Champs-Elysées
lithograph by Provost
c. 1845-1848
Paris Biibliothèque Nationale

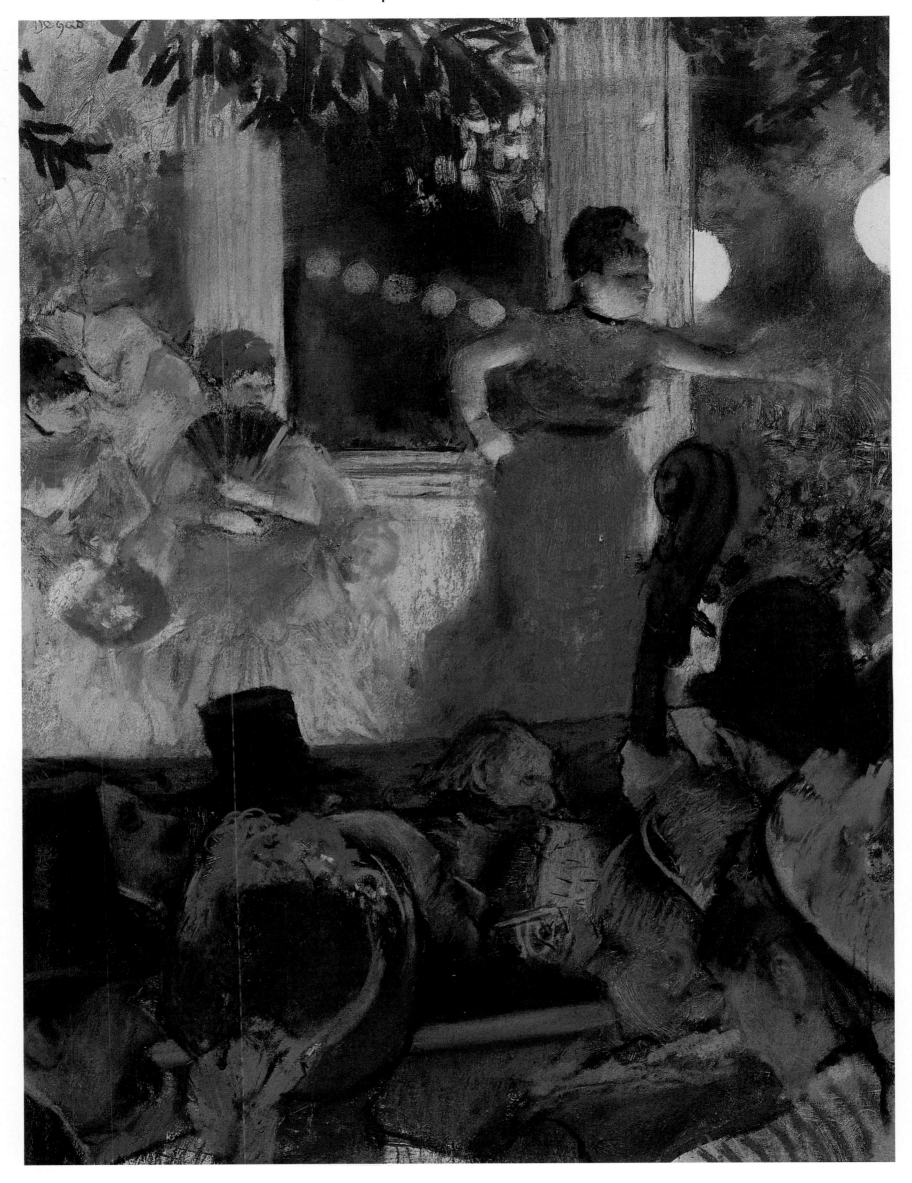

Edgar Degas
"Aux Ambassadeurs"
c. 1876-1877
pastel on monotype 37 x 27
Lyon Musée des Beaux-Arts

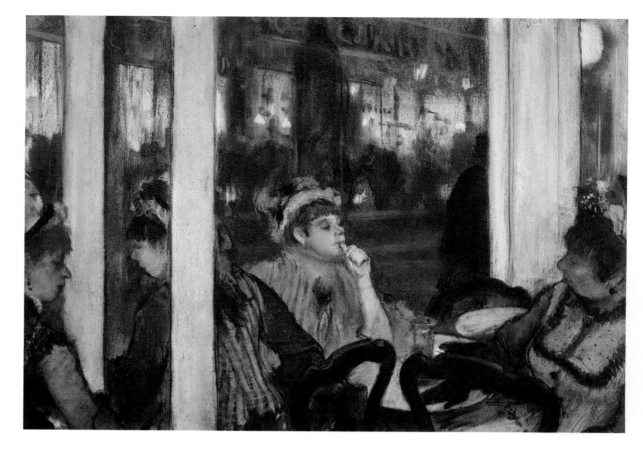

*Degas'character as seen by Paul Valéry:
Bluntness (...) to the point of brutality (...) blatant intransigence (...) merciless judgements delivered through wit (...) summary and sarcastic executions (...) an always tangible bitterness (...) dreadful changes of mood (...) violent outbursts.*

Paul Valéry
Degas, Danse, Dessin

132 *Unadorned*

Monsieur Degas is an observer, he has never tries to exaggerate. (...) Here are some women at the entrance to a café, in the evening, and one of them is tapping her fingernail against a tooth and saying, "not only that". (...) The boulevard whose bustle is gradually diminishing, is in the background. It is an extraordinary moment in history.

Georges Rivière
L'Impressionniste
No. 1, 1877

At the last Impressionist exhibition, held in 1886, Degas exhibited a series of pastels entitled *Nude Women Bathing, Washing, Drying Themselves, Rubbing Themselves Down, Combing their Hair or Having it Combed*. This title was a kind of manifesto, in which Degas stressed his concern for objectivity. As in *Laundresses Ironing*, he was not trying to present an idealized female form, but a body shown at work, sometimes strained almost to the point of physical torture. Degas scrutinized these bodies with a detached, analytical eye, in fact, with a scientific eye. "I show them unadorned," he told Jeanniot, "like animals 'washing themselves'"

The result was that anyone viewing these pictures, whether they liked them or not, was forced to admit that Degas had attained his goal and had turned spectators into voyeurs. Some, including Huysmans, severely criticised the project, describing these women at their ablutions as "amputated limbs, tossing bosoms, waddling legless cripples". The paintings gave Degas the reputation of being a misogynist, a reputation he never lost.

This was a complete misrepresentation of the painter's artistic development. After these nudes of 1886, Degas progressively abandoned psychological analysis to concentrate more intensely on colour. His drawing remained bold and elaborate but the subject-matter had been eclipsed and gradually hid itself behind the technique. The models became anonymous and were merely a pretext for painting and for variations on colour. Oddly enough, Degas' later work was akin to that of Renoir. The belated interest he showed in dabs of color restored him to the Impressionism of his youth.

Some critics have explained this phenomenon as the result of the painter's failing eyesight, but it would be more accurate to regard it as the logical evolution of his work towards pure painting, served by his brilliant technique. His last works combined gouache, oil-based tempera, charcoal, brush, and dry or wet pastel, while the cross-hatching and overlays made the patches of colour so vibrant that no-one could not fail to recognize a nude by Degas.

Edgar Degas
Women on a Café-Terrace
1877
pastel on monotype 40 x 60
Paris Musée d'Orsay

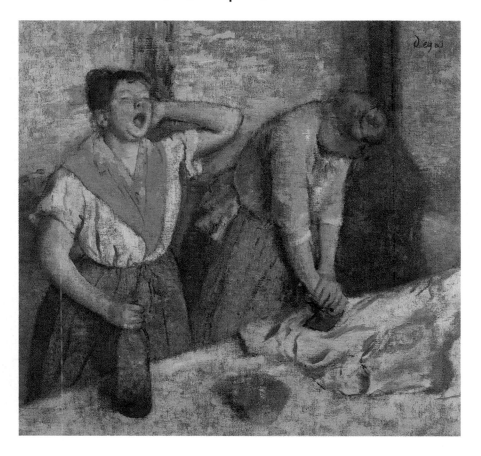

Fortunately for Degas, not all his contemporaries shared Huysmans' opinion, and by 1886 he had restored his finances to their former state. He left the studio in the Cité Frochot, and moved into an old house at 37 rue Victor-Massé (which was called rue de Laval at the time.) On the upper floor, he displayed his collection of paintings which he had rebuilt after his decade of poverty. They included no less than twenty works by Ingres, 13 by Delacroix, 12 by Forain and eight by Monet, to name but a few. In the words of Paul Valéry, his house was that "of a confirmed bachelor's where the dust is at home", and his studio, which has often been described, was in total chaos. "Once an item had entered that studio, not only it never left, but it was never moved either". commented Vollard.

However, in spite of his increasing success, Degas was becoming more embittered with old age, and ended by quarrelling with almost everyone. The last twenty years of his life were miserable. Almost blind and forced to vacate his home because of a dispute with his landlord, in 1912, Degas moved into a flat which Suzanne Valadon had managed to find for him at 6 boulevard de Clichy. Degas, who could no longer paint, remained idle all day long but never losing his legendary bad temper.

Hearing that *Dancers Practising at the Bar* had been sold for 400,000 francs, he exclaimed, "A painting I sold for 500 francs! I never thought the one who painted it was an idiot, but I know that the one who bought it at such a price is an ass!" The ass in question was the dealer Durand-Ruel, who was acting on behalf of Mrs Havemayer.

When Degas was buried in autumn 1917, barely thirty people attended his funeral. They included the aged Monet who had made the effort in memory of better days.

I was, or seemed to be, difficult with everybody, as if I were urged on by a sort of savagery, which stemmed from my self-doubt and my bad temper. I felt so imperfect, so poorly-equipped, so feeble, whereas I was sure that my artistic calculations were so correct. I was angry with everyone and with myself.

Degas
in a letter to de Valernes
October 26 1890

Edgar Degas
Laundresses Ironing
c. 1884
oil on canvas 76 x 81.5
Paris Musée d'Orsay

M. Degas, Peintre Diogénial
drawing by Barrère
Paris Bibliothèque des Arts Décoratifs

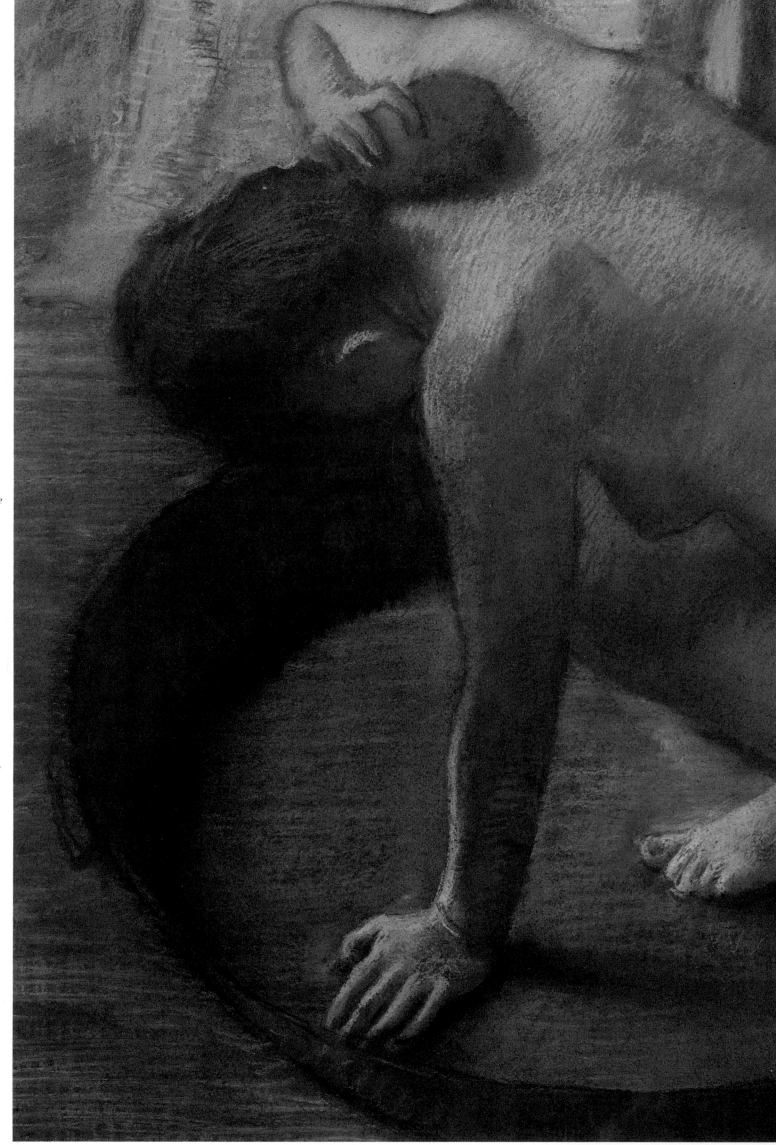

134

The way objects and people look can be unexpected in a thousand ways in real life. One's vantage point is not always from the centre of a room (...). The lines are not always straight (...) mathematical symmetry (...) they are cut unexpectedly. Our eye (..) seems to be enclosed within a frame, and it can perceive objects at the side only when they overlap the edge of the frame.

E. Duranty
La Nouvelle Peinture
1876

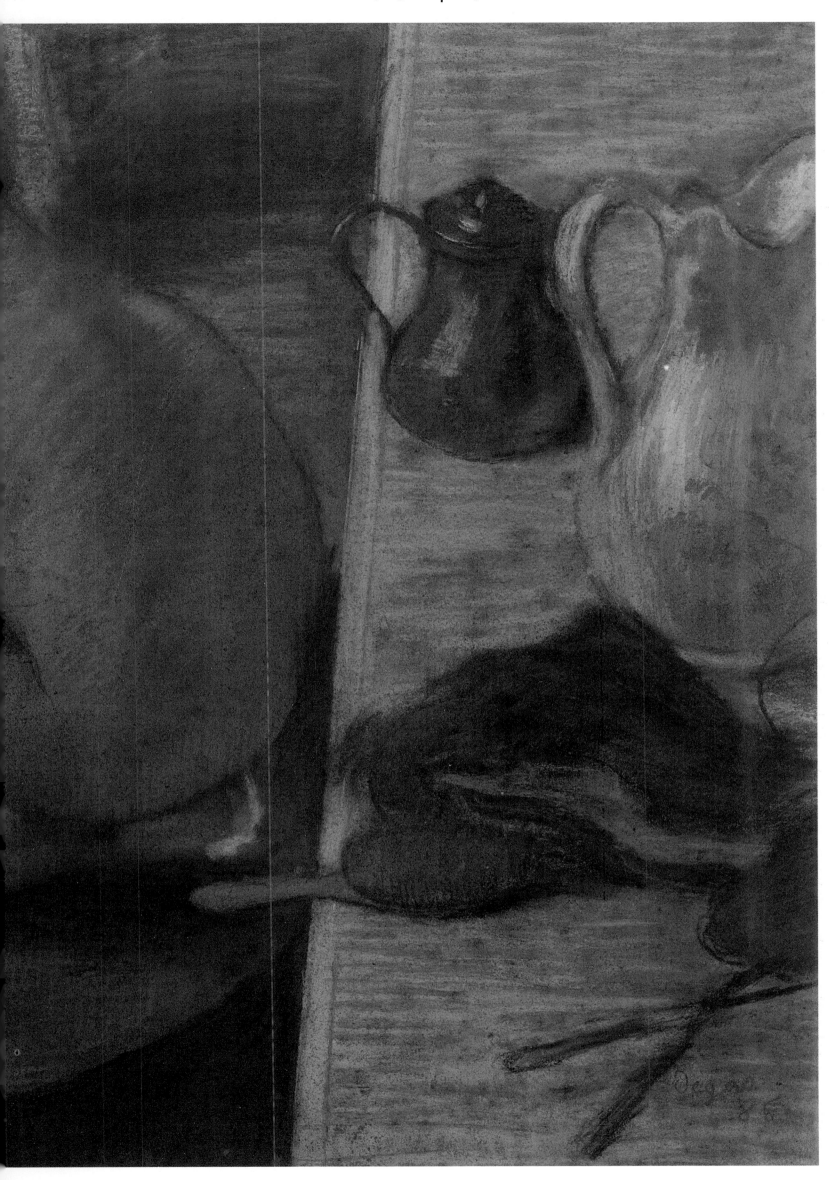

Edgar Degas
The Tub
1886
pastel on board 60 x 83
Paris Musée d'Orsay

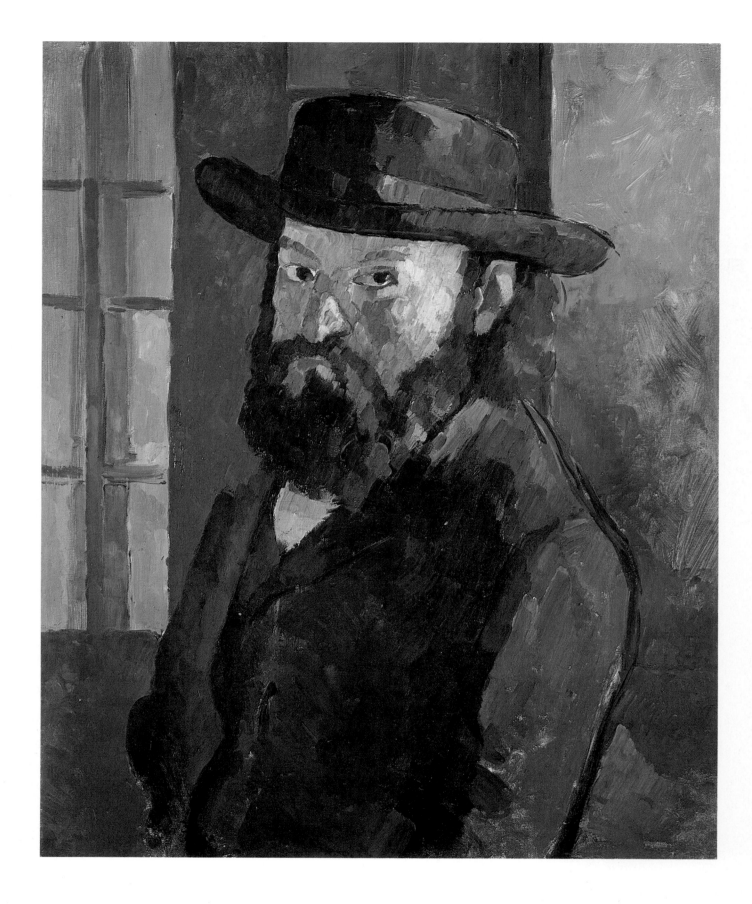

Paul Cézanne
Self-portrait
1880
oil on canvas 51 x 61
Berne Kunstmuseum

Cézanne was certainly less of an Impressionist than any of the rest. In the strictest sense, he was an Impressionist for a mere five years, between 1872 and 1877, when he worked with Pissarro at Pontoise and Auvers-sur-Oise. Prior to that time, he was still under the influence of the romanticism of Delacroix, whom he revered. Afterwards, he became Cézanne.

It will be recalled that he had taken refuge at L'Estaque, near Marseilles, in 1870, to avoid military service. He remained there until the end of the Paris Commune, with Hortense Fiquet, a model who became his lover in 1867. At that time, his painting was dark and melodramatic. The violence of his subject-matter was matched by the violence of the treatment. His brushstrokes were thick and heavy, and this impasto seemed to echo the painter's doubts and anguish about his own art.

It was ten years now since he had left Aix-en-Provence to come to Paris, at the insistence of Zola, his childhood friend. He had spent 10 years in attempts and failures, shuttling between Paris and his home town, and was regularly rejected by the Salon. Even his Impressionist friends were deeply divided about the merits of his work. One day, when Guillaumet was defending Cézanne, Manet retorted, "How can you like dirty painting?" Only Pissarro firmly believed in him and ranked him above all the rest. Sometimes, Cézanne felt completely discouraged and was not yet able to detach himself from the influence of the old masters, Tintoretto, Goya, Daumier, Courbet, and even Delacroix.

Cézanne works; he is asserting himself ever more strongly in the direction his nature made him take originally. I have great hopes for him. Besides we believe that he will be rejected for ten years.

Emile Zola

Paul Cézanne
The Temptation of Saint Anthony
c. 1870
oil on canvas 47 x 56
Paris Musée d'Orsay

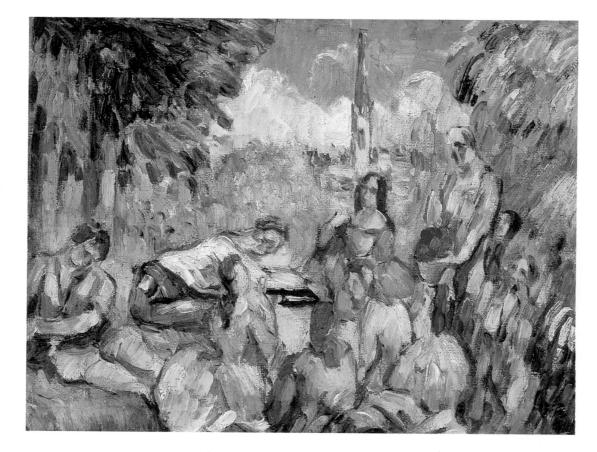

Feeling Blue

Cézanne wrote to Zola in 1886 from Aix, whence he had gone after his painting was rejected at the Salon that year, "All the paintings I have done indoors, in a studio, will never equal those I did in the open air. When you reproduce outdoor scenes, the composition of the figures on the ground is surprising, and the landscape is magnificent (...). But I must tell you again that I am feeling blue and for no good reason. As you know, I cannot explain why I get this feeling which returns every evening when the sun sets".

In spite of this plea for open-air painting which brought him closer to the other Impressionists, Cézanne still did not know whether to paint in his studio or from nature, whether to represent fantasy which was often sexually-inspired or scenes from nature. He returned to Paris and moved into a small studio next to the wholesale wine market, which he shared with a friend from Aix, Achille Emperaire, deserting Hortense most of the time, although she was pregnant. Cézanne was even more of a loner than Degas. He did not enjoy the company of his peers, he was distrustful, aggressive on occasion and certainly deeply hurt by the fact that all his efforts had not led to even the faintest sign of recognition. Yet he was one of the fiercest critics of his own work. When he was not slashing his paintings or hanging them from trees at Jas de Bouffan, in Aix, he denigrated and ridiculed them, describing them with painful cynicism as "awkward".

Paul Cézanne
A modern Olympia
1872-1873
oil on canvas 46 x 55
Paris Musée d'Orsay

Paul Cézanne
Luncheon on the Grass
1873-1875
oil on canvas
Paris Private collection

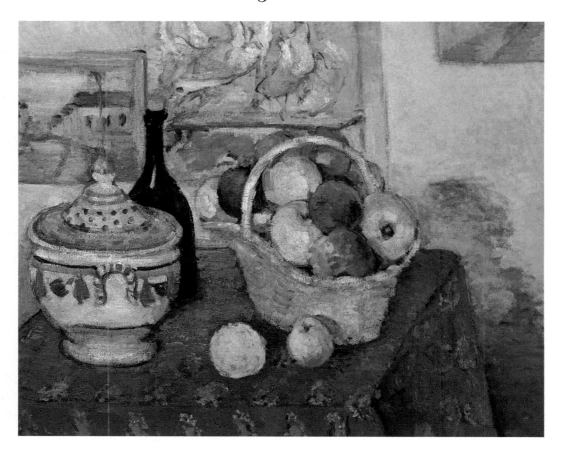

In 1872, Hortense gave birth to a son they named Paul. Although Cézanne had fathered the child he still refused to marry Hortense. His father was unaware of the liaison, and Cézanne wrongly feared that he would be disinherited if his father happened to hear about it. Pissarro, appalled by this situation, invited the couple to Pontoise. The few years these men had spent together were decisive for Cézanne. Pissarro succeeded in convincing him to lighten his palette, develop his powers of observation and give up his excessively romantic style. In 1874, it was Pissarro who included Cézanne in the proposal for an exhibition by a "Limited Company of Artists", in spite of Degas' reservations.

Doctor Gachet, with whom Cézanne went to stay in Auvers-sur-Oise, also encouraged him, initiating him into the art of print-making, and bought some of his canvases. Following the 1874 exhibition, Count Doria purchased *The Hanged Man's House*, but this was not enough to really launch Cézanne's career. In fact, Doria's gesture was regarded as mere folly. Only Victor Chocquet, a senior civil servant in the Customs and Excise Service, whom Cézanne had met through Renoir, had faith in him and for a long time was the biggest collector of his paintings. Both men shared a ardent admiration of Delacroix. After Chocquet's death, his collection was sold at the Hôtel Drouot in July 1899, and the catalogue, compiled by Théodore Duret, included no fewer than 32

Cézannes, one of which was acquired by the Berlin Museum.

Between 1874 and 1877, Cézanne returned to Paris and rented a studio at 120, Rue Vaugirard, later moving to the Quai d'Anjou, for he never stayed in the same place for long. The Salon was still refusing to accept his paintings, and the press was totally hostile to him. Cézanne's temperament, difficult at the best of times, became really unbearable. He left Hortense in Paris and returned to Aix, refusing to participate in the 1876 Exhibition. He turned into a hermit, driving away even his most faithful friends. Again, he was tormented by doubt and was incapable of facing up to his responsibilities as a family man.

I cannot accept the illegitimate judgement of colleagues whom I have not assigned the task of evaluating me (...). I wish to appeal to the public directly, and to see my works exhibited all the same (...). Therefore, let the Salon des Refusés be re-opened.

Cézanne
in a letter to Count de
Nieuwerkerke
Superintendant of Fine Arts
Paris April 19 1866

Paul Cézanne
Still-life with Soup Tureen
1883-1885 (1877?)
oil on canvas 65 x 81.5
Paris Musée d'Orsay

142

Our Cézanne is promising, and I have seen, and have at home, a remarkably forceful and striking painting.
If, as I hope, he stays for some time in Auvers where he is going to live, he will astonish the artists who were too quick to condemn him.

Pissarro
in a letter to Théodore Duret
1873

Paul Cézanne
Apples and Oranges
1895-1900
oil on canvas 74 x 93
Paris Musée d'Orsay

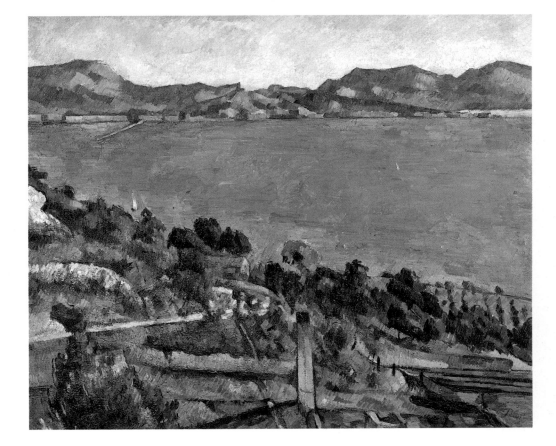

144 *The Most Disparaged Artist*

(L'Estaque is) like a playing card. Red roofs against the blue sea (...). The sun is so strong that objects look as if they were mere silhouettes.

Cézanne
in a letter to Pissarro
July 21 1876

Cézanne was soon to break with his friends. He already knew that their style was different from his own. The technique of fragmented brush-strokes did not sit well with his own interest in volume and hampered the robustness of his compositions. He made one last attempt at exhibiting in 1877 when he sent 16 canvases to the exhibition in the rue Le Pelletier, organized by Caillebotte. Although Victor Chocquet and Georges Rivière warmly defended Cézanne, his work was a favourite target for mockery. The ordeal was all the more cruel as his friends were beginning to win fame. "For the past fifteen years, M. Cézanne has been the the most disparaged and ill-treated artist by press and public alike", wrote Georges Rivière after the exhibition. "He has been systematically insulted and his works have been welcomed with bursts of laughter which have not ended yet".

From that time onwards, Cézanne gave up conquering the Parisian public and retired to Provence. While he stayed in his father's home, Jas de Bouffan, Hortense and Paul stayed in Marseilles. Although he often visited them, he only lived for painting, and these visits generally turned into working sessions. Thus, Cézanne painted several versions of the Bay of Marseilles as seen from L'Estaque, one of which is now in the Musée d'Orsay.

Cézanne's geographical distance from the other Impressionists matched his artistic distance from them. Around 1878, Cézanne's short, truly Impressionist period came to an end. "For him", wrote Gilles Plazy, "What counts is the blending of light and matter, the complex relationships between light and volume. Emotion is not enough for him, he needs to construct and compose, in other words, to mirror the unity of nature in the unity of his work". Like Degas, Cézanne believed that the air in paintings was not the air one breathes. He aimed at constructing a different reality, starting from nature, but beside and beyond it, the reality of an independent, autonomous and timeless of work of art.

Meanwhile in Paris, a couple of friends were attentively following Cézanne's progress. Disregarding the general hostility towards the painter, his friend Guillemet decided to use his right to have a painter admitted to the Salon without an official examination. Unfortunately, Cézanne's entry was presented as the work of a "pupil" of Guillemet and was badly hung. This made it seem even more obvious that his appearance among the "greats" was a trick, rather than public recognition. Anyway, no one was fooled and Cézanne only became even more bitter on realising that although his dream had finally come true it had done so under conditions that virtually subjected him to ridicule.

Paul Cézanne
L'Estaque
c. 1878-1879
oil on canvas 59.5 x 73
Paris Musée d'Orsay

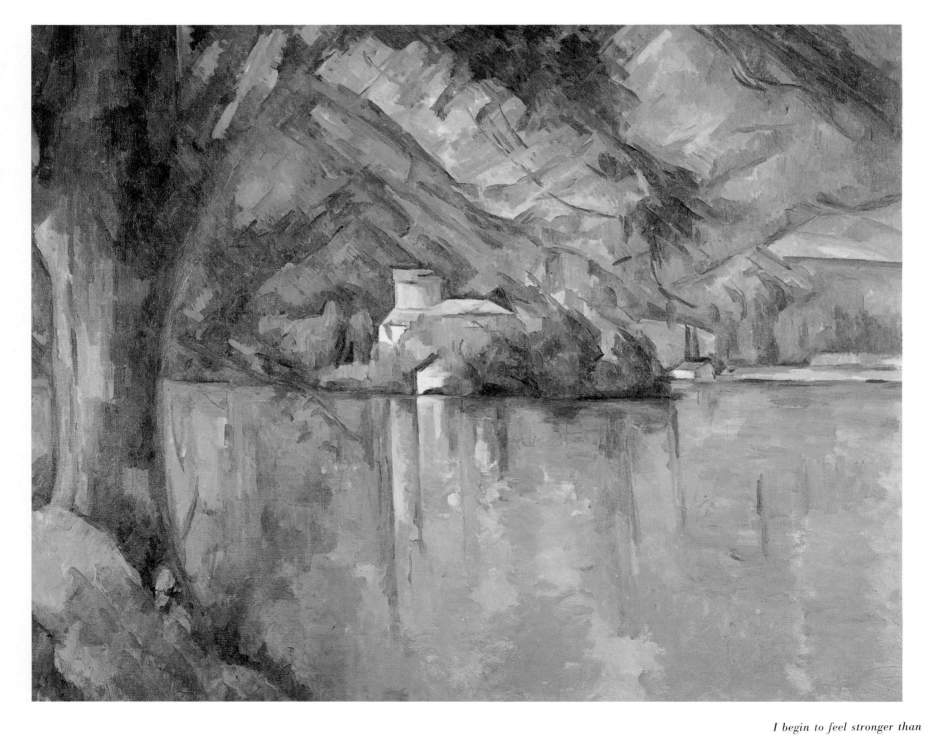

*I begin to feel stronger than
everyone around me and you
know that the high opinion
I have of myself is well-
founded.*

Cézanne
in a letter to his mother
1874

Paul Cézanne
Lac d'Annecy
oil on canvas
London Courtauld Institute

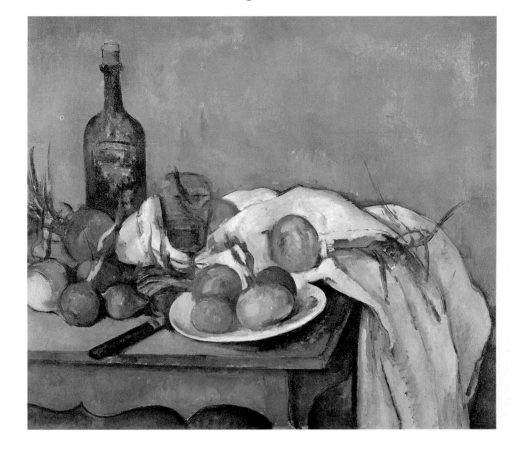

L'Œuvre, in which he claims to depict me, is only a hideous distortion, a lie for his own glorification (...). It came as a blow to me.

Cézanne
to Emile Bernard
about Zola
1904

146 *"Something Established and Long-lasting"*

You can't expect a layman to say anything sensible about painting, but, damn it, how could anyone dare claim that a painter would kill himself because he had produced a bad painting? When a painting is no good, you sling it in the fire, and begin another one.

Cézanne
to Vollard
about Zola

In 1886, Zola published *L'Œuvre*. Many people were convinced that Cézanne was the model for the main character, the painter Claude Lantier, a genius and a failure, who finally commits suicide in front of a canvas he cannot finish. Obviously, Zola borrowed a lot from the life story of his childhood friend. However, it is even more obvious that Zola did not understand Cézanne's work at all; Zola was a writer but had no eye for painting. The men did not really quarrel as a result, as has been said, they merely drifted apart. They had reached the point where their opinions differed so much that any exchange of views was fruitless, and they could no longer communicate.

That same year, Cézanne's father died, and the painter inherited two million francs. Cézanne had finally just married Hortense Fiquet, whom he probably no longer loved. Both the inheritance and the wedding looked like belated atonement. From then on, free from his everyday cares, the artist could devote himself entirely to his art.

He was still immensely ambitious. He wanted "Impressionism to become something established and long-lasting like the art in museums". He meant that it ought to be something more durable than the "minor sensation" which seemed enough to inspire his friends, but which for him was only a starting point, a sort of initial stimulus. He was not concerned with communing with nature but wanted to analyze it, so as to transfer it to the canvas after simplifying it and reducing it to geometric forms. It might be argued that Cézanne went a stage further than Monet, that he went beyond Impressionism.

Paul Cézanne
Still-life with Onions
1895-1900
oil on canvas 66 x 82
Paris Musée d'Orsay

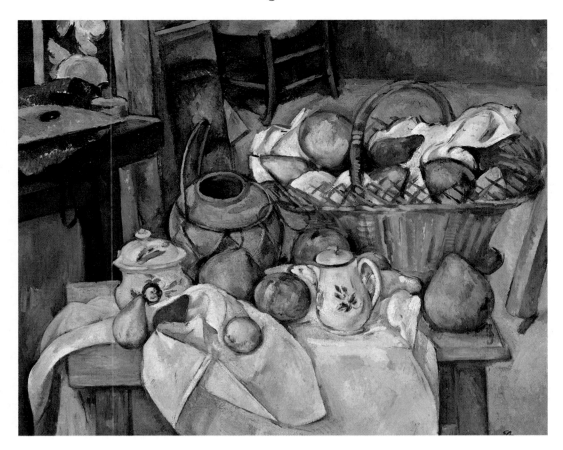

*To see God's work!
That's what I am
applying myself to.*

Cézanne

Unlike Monet, whose research culminated in his dissolving of structure into light (as in his paintings of the cathedral) Cézanne aimed at emphasizing structure by substituting "tone for modelling, in other words, by substituting the relationships of colours to light with simple chiaroscuro". This meant that, instead of creating a real illusion of space, Cézanne decided to invent an autonomous space structured by colour. "Perspective must be rendered solely through the use of colour", he wrote. Still-lifes, which could be arranged in any way the artist pleased, constituted an ideal area for experimentation, in which apples and oranges did not tell a story or display an emotion, but were objects in space, whose function was geometrical.

Cézanne's treatment of shape is summarized in his epithet made famous by the work of the Cubists who came after him, "Everything in nature is to be treated through the cylinder, sphere and cone", these shapes being suggested by the play of contrasting light and tone. "Drawing and colour are not separate", he wrote. "As one paints so one is drawing. The more harmonious colour is, the more apparent drawing becomes. When colour is at its richest, form is at its fullest."

Cézanne had come a long way from his *The Negro Scipio* to his still-lifes arranged with almost mathematical precision, but his work did not suffer a complete about-turn. His artistic development was not paradoxical, in fact, he was still working towards the same goal but by different means.

Cézanne had been a mystic in his youth and remained so. In his painting, he attempted to reflect the unity of the universe, a translation into colour of its secret rhythms. Having attempted to express them through a subjective sensitivity, Cézanne simply reverted to a more traditional direction, one which had already been taken by philosophers and scientists, from Socrates to Descartes and Newton, and by the mystics who all believed in numbers as signs from the heavens, an instrument and a manifestation of the perfection of creation.

Cézanne's choice of the apple, the fruit of Eden, a mystical fruit, thus takes on an unexpected significance, for such a coincidence cannot be due to mere chance. Yet theme and theory were always subservient to the work itself. Only painting mattered. Colour was a complete summary of the work. "Be a painter," wrote Cézanne to Emile Bernard, "Not a writer or a philosopher".

*I can see the Promised
Land (...). Why has it come
so late and so painfully?
Is Art a sacred order
which requires the chaste
to devote themselves
to it totally?*

Cézanne
to Vollard
January 9 1903

Paul Cézanne
Still-life with Basket
1888-1890
oil on canvas 65 x 81
Paris Musée d'Orsay

148

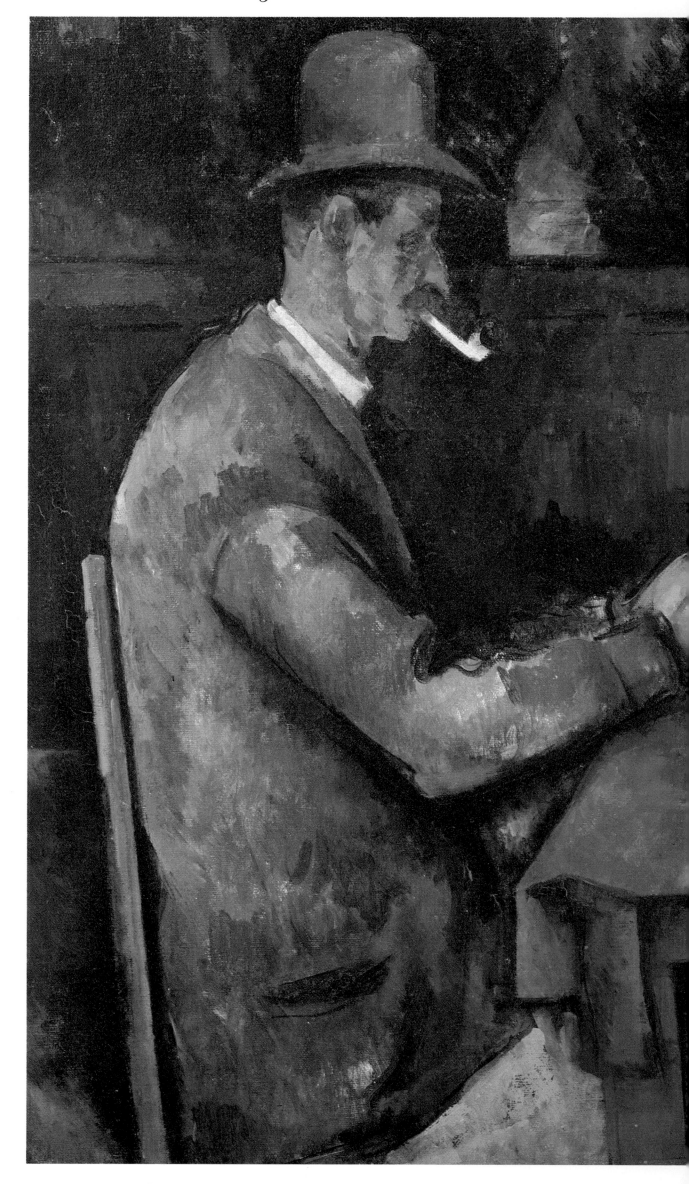

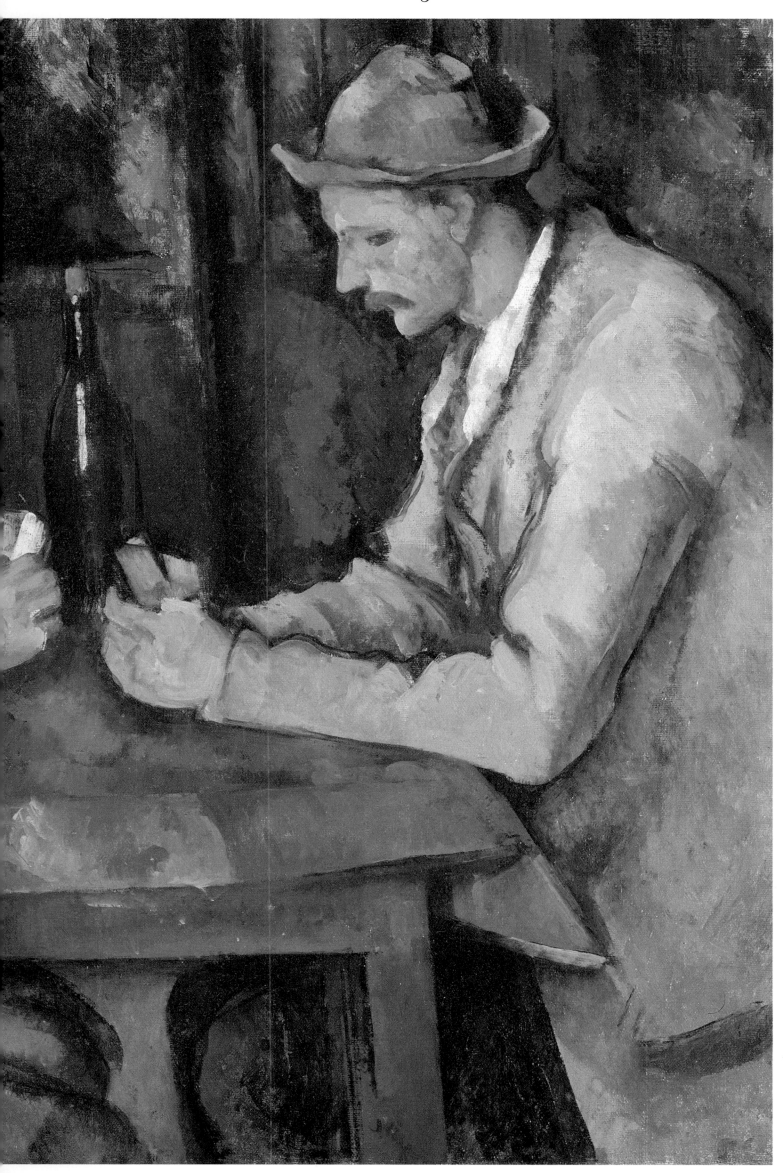

149

*At Vollard's, there is a
very complete exhibition of
Cézanne's works. Some still-
lifes with an unusual finish,
and some incomplete works
which are extraordinarily
wild and powerful.
I'm afraid they won't be
properly understood.*

Pissarro
November 13 1895

Paul Cézanne
The Card-players
1890-1905
oil on canvas 47.5 × 57
Paris Musée d'Orsay

Père Tanguy and the Younger Generation

Cézanne's still-lifes have been described as ideal landscapes, a comment which could also be applied to his portraits. However, in the latter case, the aim was not to suggest a motionless permanence and almost mineral-like quality of a still-life. The human body is a piece of living architecture, so a portrait must convey a movement fixed in that moment in time. Degas had already tackled this problem, but Cézanne found a completely different solution to it. His was neither Monet's moment of timelessness, nor Degas' special one, but rather the sum of all the moments which defined his subject, which Cézanne transposed pictorially multiplying the angles of vision, thus opening the way for modern painting to explore an autonomous pictorial space. "Cézanne does not consider he has the right to freeze the movement of the world in an instantaneous pose (...)," wrote J.-L. Daval. "He tries to give expand his shapes by constant changes of colour, by contrasting different moments so as to evoke through these contrasts this impression of permanence and continuity which are so typical of his style". In *The Bathers*, he goes a step further by trying to achieve a synthesis between landscape and the human form.

This opinionated and exhaustive search for an artistic ideal baffled the public. At fifty-five, Cézanne had never yet had a one-man show. Yet his name, which had been so discredited by those of his own generation, was beginning to be known, and it was being mentioned with increasing admiration within the restricted circle of a group of young painters, which included Gauguin, Seurat and Emile Bernard, and later, by Maurice Denis and Paul Sérusier, all of the so-called Nabis. Cézanne was assisted on his road to fame by two people. It all began in Père Tanguy's little colour-grinding shop at 14 rue Clauzel.

Tanguy was a socialist and a communard. He had been deported to Brest after the events of 1871, but allowed to return to Paris in 1873 only because Rouart pleaded in his favour. His friend, Pissarro, had introduced him to Cézanne, and from then on, Tanguy was the only exhibitor of Cézanne's paintings, though he derived little profit from it, since Cézanne's work fetched between 40 and 100 francs a painting. The younger generation of painters discovered Cézanne at Père Tanguy's. When Tanguy died in 1894, his collection was sold at the Hôtel Drouot. It was then that Vollard made his appearance.

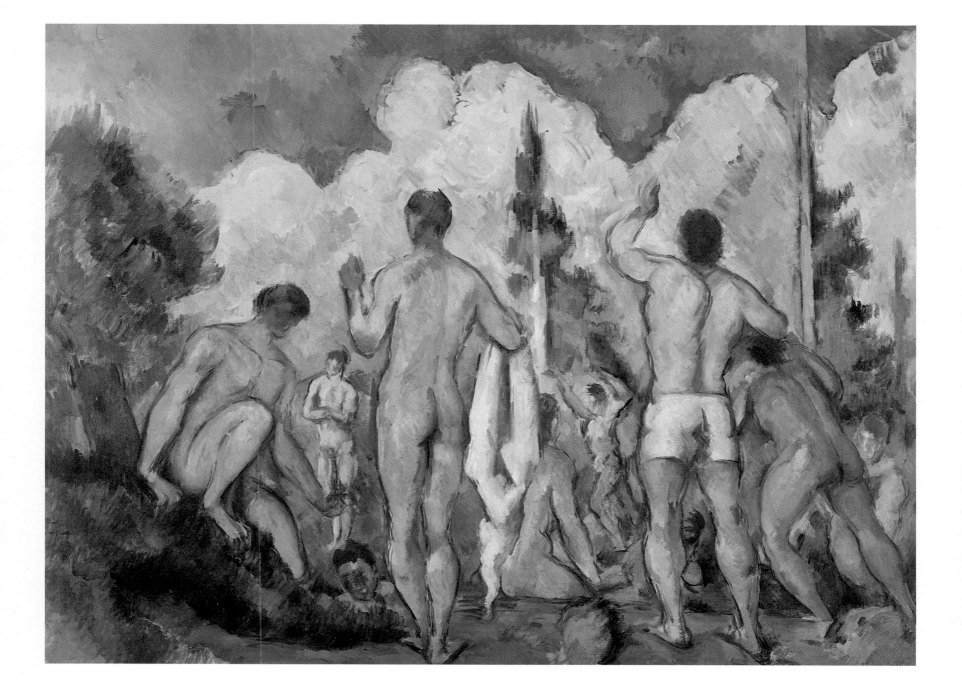

Paul Cézanne
Bathers
1890-1892
oil on canvas 60 x 82
Paris Musée d'Orsay

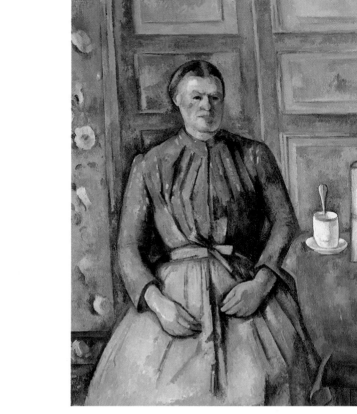

*I swore to myself that
I would die painting, instead
of sinking into the debasing
senility which threatens old
men who let themselves
be overpowered by those
passions which deaden
the senses.*

Cézanne

*Tanguy, now Pissarro's
and Cézanne's man, let
in unknown young artists
who had no other place
to go, and who were were
actually lucky to be able
to show their work at
his shop, next to painters
who had already been
granted a measure of
acceptance (...). Tanguy's
shop (...) was thus raised
to the status of an art
centre.*

Théodore Duret

Vollard was a lawyer's son who was born on the island of Reunion. He had come to Paris to expound his thesis for a law degree and had stayed for good. In 1894, he opened an art gallery at 41 rue Laffitte. Vollard was ambitious and was waiting for a big break to launch him into the art world. When Bernard and Denis made him aware of Cézanne, he knew he had found his man.

Vollard bought five out of the six Cézannes in the Tanguy sale and made contact with the artist through his son Paul, who lived in Paris. Some time later, Cézanne, whom he had never met, sent him a hundred and fifty canvases from Aix. Vollard bought the lot for 90,000 francs and exhibited them in his gallery. This was Cézane's first one-man show, in 1895.

The hostility of the press is not worth mentioning since by now it was irrelevant. The younger generation had just chosen their master. In 1900, Maurice Denis painted *Hommage to Cézanne*. The painting was bought by André Gide. At the 1904 Autumn Salon, Cézanne's work was allotted a whole room, and at the Salons of 1905 and 1906 his triumph was complete.

Was Cézanne aware of this belated recognition? He had long immersed himself in a solitary existence in Aix. His wife and son lived in Paris.

After his mother's death, Cézanne sold Jas de Bouffan and settled in Aix. Although he was ill and exhausted, he refused to work less. On the evening of October 15 1906, he was caught in a storm while painting *Jourdan's Hut* from life. Whether from cold or wet, he fainted at the roadside. He was brought home in a laundry-cart, but was up again the next day. This time, he had overdone it. Cézanne died on October 22 1906, "brush in hand," in the words of Duret, without Hortense and Paul having had the chance of seeing him alive again.

Paul Cézanne
Woman with Coffee-pot
1890-1892
oil on canvas 130 x 97
Paris Musée d'Orsay

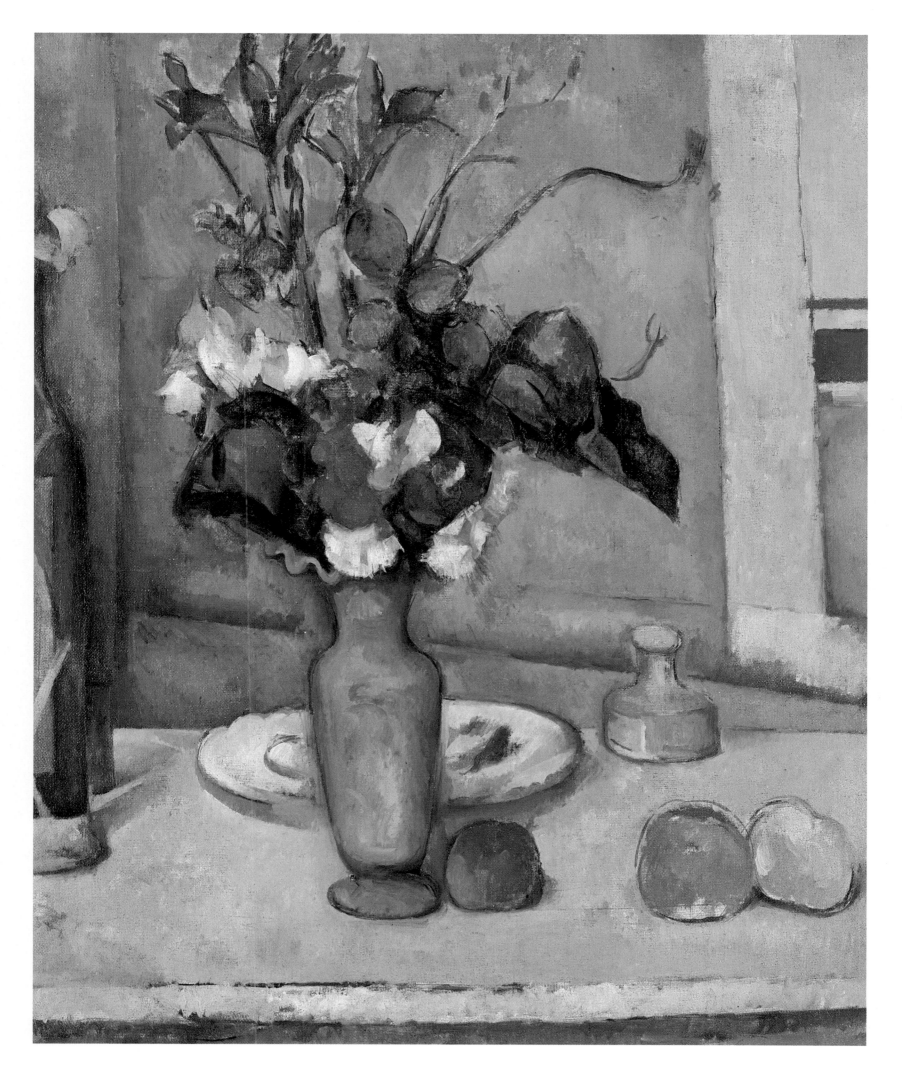

153

Paul Cézanne
The Blue Vase
1885-1887
oil on canvas 61 x 50
Paris Musée d'Orsay

Edouard Manet
On the Beach
detail
1873
oil on canvas 59.6 x 73.2
Paris Musée d'Orsay

Recognition came very late, not only for Cézanne and Sisley but for all the other Impressionists. In Sisley's case it came too late. Manet, their elegant leader, had to wait until the end of his days until he was officially recognized and honoured. *Le bon bock* had a fleeting success at the 1873 Salon, but did nothing to prevent a violent reaction from the hanging committee of the 1878 Salon. Manet had grown closer to his friends again in 1873, although he refused to exhibit with his friends at Nadar's in 1874; he even accepted Monet's advice and decided to try painting in the open air.

On the Beach was painted in 1873 while the Manets were staying at Berck-sur-Mer. Manet's wife, Suzanne, is sitting in the foreground while Eugène, Manet's brother, who was to marry Berthe Morisot the following year, is reclining on his elbow on the sand next to Suzanne; he serves as a transition between Madame Manet's grey dress and the yellow stretch of sand.

The arrangement of the two planes, forming two nested triangles, remains classical, although there is some simplication in the treatment of the fabrics and the background shows Japanese influence in the colour tones, the high horizon and the areas of flat colour. Japanese style had been fashionable in Europe since the mid-century and Manet had already acknowledged its influence in his portrait of Emile Zola. The trawlers sliding across the horizon are less important in themselves, serving merely to highlight the two figures, in that the hues of their hulls and sails reflect the colours of Suzanne's dress and of Eugène's jacket.

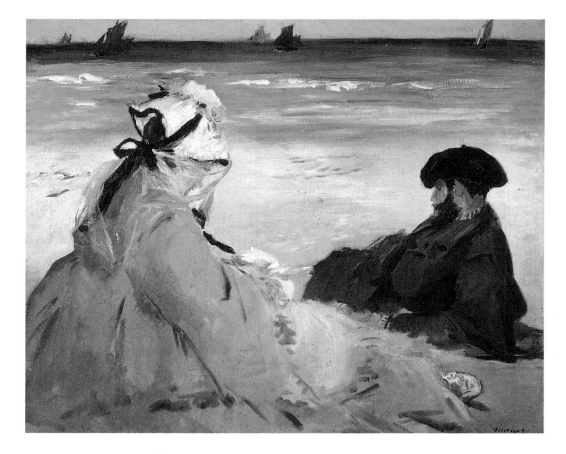

156

Ship at Sunset, which is in the Museum of Le Havre, bears a resemblance to these trawlers and may have been executed in 1873 like *On the Beach*. If that is the case, a date (1873) and a place (Berck-sur-mer) could be suggested for this study which is so different from Manet's other work. On the other hand, it may be one of the series of seascapes painted in Boulogne after 1864.

The classicist trend which lingers in *On the Beach*, as well as the fact that Manet uses black like the Dutch painter, Franz Hals, clearly underline the difference between Manet and the other Impressionists. However, this new preoccupation with the light, making it look as though it emanates from the sandy surface, has something to do with Manet's visits to Argenteuil between 1872 and 1874. It was the latter year which marked Manet's most Impressionist style, of which the best examples are *Boating* (New York) and *Boating at Argenteuil* (Tournai).

Etretat, the Boardwalk
postcard

Edouard Manet
On the Beach
1873
oil on canvas 59.6 x 73.2
Paris Musée d'Orsay

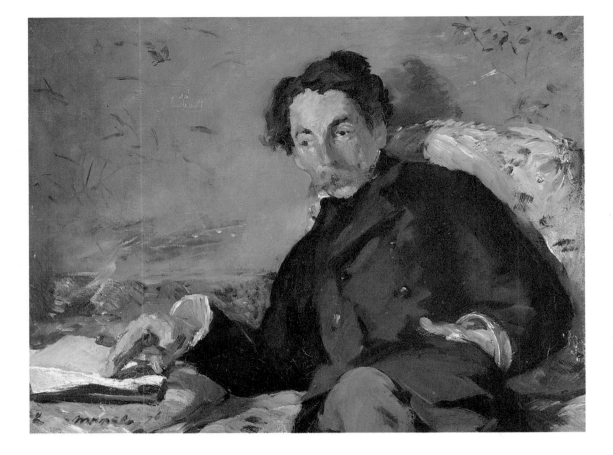

Whatever its ultimate importance in the history of art, Argenteuil was a mere episode in Manet's career, a brief visit in the summer of 1874. He was a Parisian to his very soul. He had always preferred to work in his studio and, later in life, his illness was an even greater encouragement to do so. He changed studios three times, but all were situated in the Batignolles district, two in the Rue Saint-Pétersbourg. He was in the habit of inviting his friends over after a long day's work. Thus Zola wrote that "The artist confessed that he loved fashionable society and that he was secretly enraptured by the fragrant and light-filled delights of these evenings (...) he had an innate need for refinement and elegance".

The second of these studios was a former fencing school. It was huge but not very comfortable, located on the ground floor, with windows overlooking the L'Europe Bridge and the trains entering or leaving Saint-Lazare Station, making the walls shake as they passed. With the exception of a Japanese wall-hanging, the studio was only decorated with Manet's paintings, which today would be considered the height of luxury.

It was here that fashionable painters, bankers, men of letters, and playwrights mingled with actresses and other women, who despite an often humble birth, had made their way in society, and of whom it was said – in an expression which was geographically inaccurate but very apt – that they belonged to the "demi-monde".

Edouard Manet
Portrait of Stéphane Mallarmé
1876
oil on canvas 27.5 x 36
Paris Musée d'Orsay

158 *The Three Graces*

Three such women were attractive enough to Manet for him to immortalize them on canvas. Ellen André was a young actress who features in *The Luncheon of the Boating Party*, and who, with Marcellin Desboutin, had been Degas' model for *The Absinthe Drinkers*. She posed for Manet's *At Père Lathuile's* in 1879.

Nina de Callias was only painted once. Ten years later, one year after Manet's death, Berthe Morisot described the portrait, *Lady with Fans*, in a letter to her sister, as "Mme de Callias, a woman dressed in black, lying on a sofa against a background of Japanese fans on a tinted background (...). It's a wonderful painting which will go to the Louvre." The woman's slightly mocking smile flickered beneath her mournful eyes. The pose was abandoned, in keeping with the model's way of life. She was separated from her husband, Hector de Villard, a columnist for the *Figaro* newspaper. Nina de Callias held a salon in the Rue Chaptal, where the avant-garde used to meet. Nina was an eccentric, perhaps even a nymphomaniac, who had many lovers. "She was a pretty woman", Emile Goudeau wrote of her, "Short, with very expressive dark eyes, beautiful jet-black hair and a milk-white complexion". Charles Cros and Villiers de L'Isle-Adam succumbed to her charms, as did Manet. Unfortunately, she ended her life sadly, in a home for the mentally disturbed where she was to die alone.

The last of the three Graces was Méry Laurent. She is supposed to have been Manet's last love.

Anyway, she was the acknowledged mistress of Dr Evans, a famous dental surgeon who has passed into history because he arranged the escape of the Empress Eugénie to England, after the defeat at Sedan in 1870. The good dentist proved his affection for Méry Laurent by giving her an annual allowance of fifty thousand francs. Manet, far less wealthy but no less infatuated, did even better, by immortalizing her in *The Fall*, now in the museum of Nancy, Méry Laurent's home town.

Le Bal Mabille
lithograph by Provost
1867

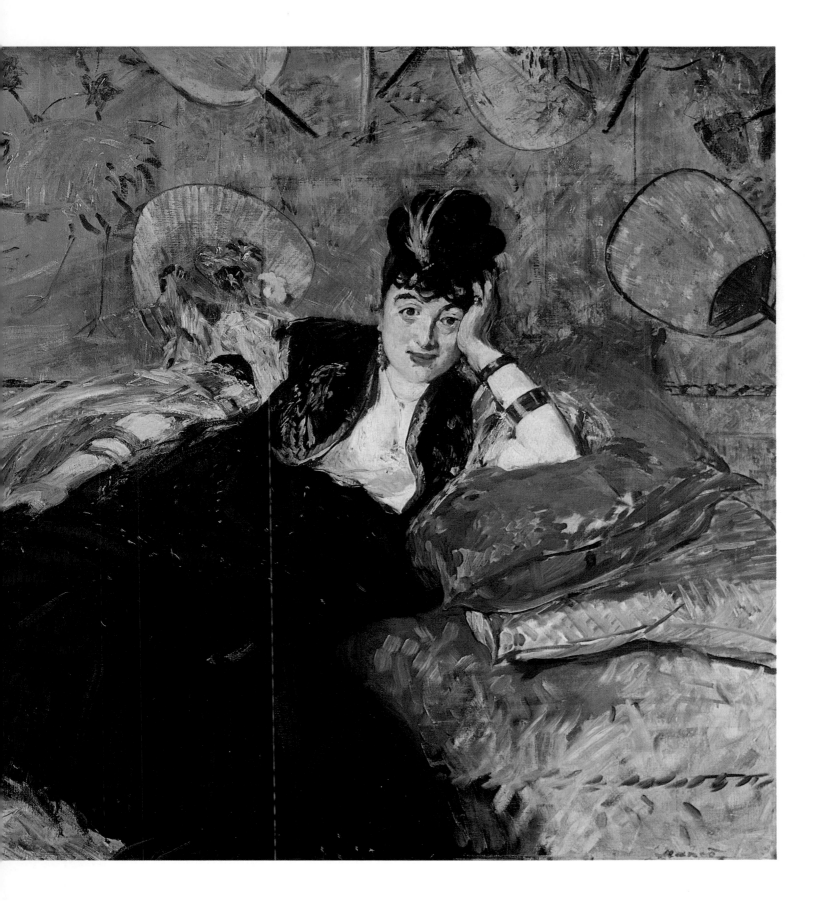

Edouard Manet
Nina de Callias
1873
oil on canvas 115 x 166
Paris Musée d'Orsay

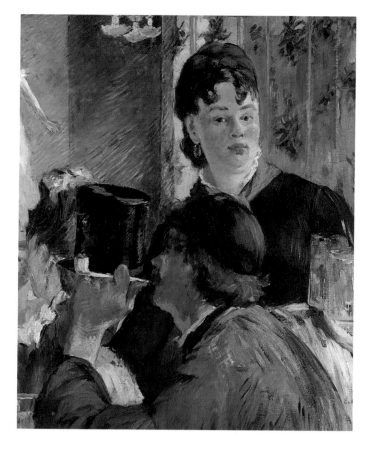

The Nouvelle-Athène

In 1878, Manet had to leave his studio in the Rue
Saint-Pétersbourg, moving to the Rue d'Amster-
dam. Did this move alter his focus of interest? Or
were the works of Renoir and Degas exerting an
influence over him? Whichever the case, for the
last five years of his life, Manet was to produce
many paintings featuring brasseries and cafés,
some of which are today considered to be among
his best work.

In fact, Manet had always been a frequent
visitor to cafés, such as the Guerbois, or later the
Nouvelle-Athène, in the Place Pigalle. It was here
that Degas painted *The Absinthe Drinkers*. George
Moore, an Irish novelist who knew the Impressio-
nists in his youth, alluded to these cafés in *Confes-
sions of a Young Man*. "I went neither to Oxford
nor Cambridge", he wrote, "but to the Nouvelle-
Athène (...). I can still see the white frontage of the
café (...), I can still remember the smell (...) of eggs
spluttering in butter (...) the perfumed aroma of
absinthe (...) steaming soup (...) and the blended
smells of tobacco, coffee and lager (...). There were
marble tables (... where) we would discuss art until
two in the morning".

Edouard Manet
The Waitress
1878-1879
oil on canvas 77.5 x 65
Paris Musée d'Orsay

The Waltz at Mabille
lithograph by Gustave Barry
Ecole Frese

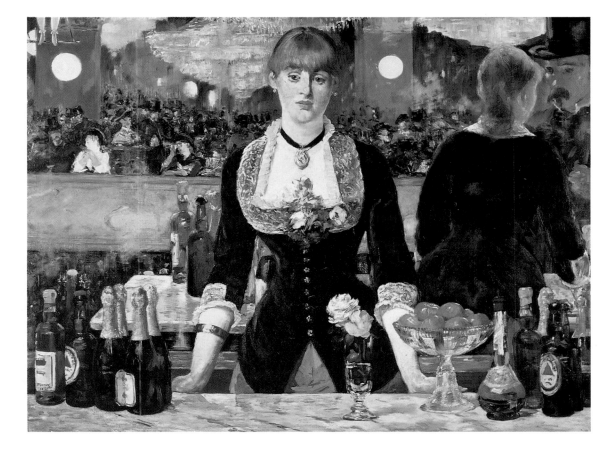

"*Masterly Simplification*" 161

Manet remained Manet and the lively scenes he depicted were never painted from life. He reconstructed and interpreted what he saw. In this respect, Georges Jeanniot has left an interesting eye-witness account of the genesis of *The Bar at the Folies-Bergère*. "When I returned to Paris in January 1882, Manet was the first person I visited. He was working on *The Bar at the Folies-Bergère*, and the model (...) was posing behind a table laden with bottles and food (..). Manet was certainly not copying life; I became aware of his masterly simplification (...) his modelling was not a mere aping of nature. Everything was simplified. Tones were lighter, colours more vivid, contrasts attenuated". A model who had been engaged in the Place Pigalle and a scene re-created in the studio. The truth of nature mattered less than the truth of the painting. As in Cézanne's case later, as for any great painter at the height of his achievement, Manet had placed art above all else. The time for theorizing was almost over.

Edouard Manet
Bar at the Folies-Bergère
1882
oil on canvas 96 x 130
London Courtauld Institute

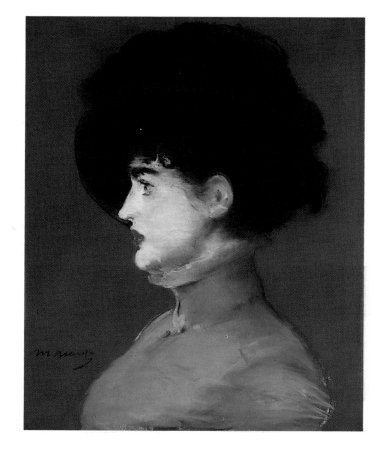

Manet's health began to deteriorate seriously in 1880. The syphillis he had contracted in Rio as a young man had continued to spread, and was now reaching the terminal phase. He suffered from locomotor ataxia and gangrene was soon to affect his left foot.

When he met Jeanniot "he needed a walking-stick and did not look steady on his legs. Nevertheless, he was cheerful and spoke of being on the way to recovery". However, he could no longer stand in front of his easel, so he left Paris and rented a house in Rueil. Here, he painted the flowers in the garden, or some portraits in pastel, a technique which was quicker and less demanding than oils, but in which he was no less proficient, as witnessed by *The Portrait of Irma Brunner*.

However, the year 1882 was to bring him some consolation. His friend and former schoolmate, Antonin Proust, had just been appointed Minister of Fine Arts in Gambetta's Cabinet. Proust suggested that Manet be awarded the Legion of Honour medal. Jules Grévy, the President of the Republic,

tried to oppose the idea, but Gambetta won and, with the support of the members of the House of Deputies, convinced the President to sign the decree. Manet was at last a Knight-companion of the Legion of Honour! But the coveted rosette, which had been extorted almost by force, did not make him as happy as expected. It had come too late. When Count de Nieuwerkerke congratulated him, Manet bitterly informed him that such a belated gesture by the state certainly could never make up for twenty years of neglect.

Manet had another satisfaction, tinged with bitterness, when he won a second place medal at the 1882 Salon for *Pertuiset, Lionhunter*. The bitterness emanated from the fact that Manet's friends, Gervex and Guillemet, had had the greatest difficulty in collecting the required 17 votes out of 33 from the hanging committee. Manet was also bitter because the medal had been awarded for this rather ridiculous figure who was unwittingly reminiscent of the comic character, Tartarin de Tarascon, and not for *A Bar at the Folies Bergère* for which the critics showed a marked lack of enthusiasm. Manet considered the latter work to be far superior, again demonstrating that despite appearances to the contrary, the painter was still not understood by his contempories.

Edouard Manet
Portrait of Irma Brunner
1882
pastel
Paris Musée d'Orsay

Manet's life ended terribly. He was confined to bed in March 1883, when his left foot turned black with necrosis. The rest of the leg became gangrenous and had to be amputated. After a few days of hesitation, the operation was performed in early April, but it was too late. On April 30 1883, Manet died after much suffering.

The painter was buried in the cemetery of Passy. One year after his death, Théodore Duret organized an important retrospective exhibition with the help of Berthe Morisot and her husband. Even now, the hostility of the establishment persisted. The exhibition was to have been held in the galleries of the Ecole des Beaux-Arts, but was almost cancelled, because the head of the school refused to show the canvases of that "revolutionary". Fortunately, Jules Ferry, the Minister of Education, forced the exhibition on this reluctant individual, a Professor Kaempfen, whose only claim to fame is this incident.

This exhibition was a success, enhancing Manet's already improving posthumous reputation. In 1889, he was honoured at the Universal Exhibition as one of the great painters of the 19th century. *Olympia*, was bought by subscription and hung in the museum of the Luxembourg Palace. When Georges Clemenceau became premier of France in 1907, he had *Olympia* hung in the Louvre. Forty-two years after the resounding scandal of the 1865 Salon, the hopes of a whole generation finally materialized. Despite all the years which had passed, and many revolutions which had stormed the art world, sweeping away received ideas, there were still some who protested and remained shocked. *Olympia*, like all great masterpieces, was ageless.

Edouard Manet
Portrait of Georges Clemenceau
1879
oil on canvas 94.5 x 74
Paris Musée d'Orsay

164 *Manet's Sister-in-law*

Manet's death marked not only the end of Impressionism as a group movement, but of its initial impetus. Thenceforward, it would be represented by individual painters who sought their own destinies and embarked on personal and solitary quests rather than the group spirit which had ceased to exist. Cézanne was living in Aix. A few days before Manet's death, Monet moved to Giverny. The following year, Pissarro went to live at Eragny. Meetings were few and far between.

Manet's death affected Berthe Morisot more than anyone else. Berthe had been Manet's pupil and model, and had initiated him into open-air painting; she became his sister-in-law in 1874 and profited from this family tie to deepen their friendship which was profond, though platonic. The fortune she had inherited in 1873, on the death of her father, had invoked the criticism that she was a woman who painted, rather than a woman-painter. This was both hypocritical and untrue. Berthe Morisot took her art seriously. From 1874 to 1886, she participated in all the Impressionist exhibitions, except in 1879, when she gave birth to her daughter, Julie. Yet the reproach was founded on a grain of truth; Berthe Morisot occupied a special place within the group due as much to her birth and wealth as to her character and personality.

Paul Valéry, who married her niece, Nini, wrote, "She was unusual and reserved to the utmost, different by her very nature; her silence was comfortable yet dangerous, unwittingly (...) imposing an inexplicable distance (...)".

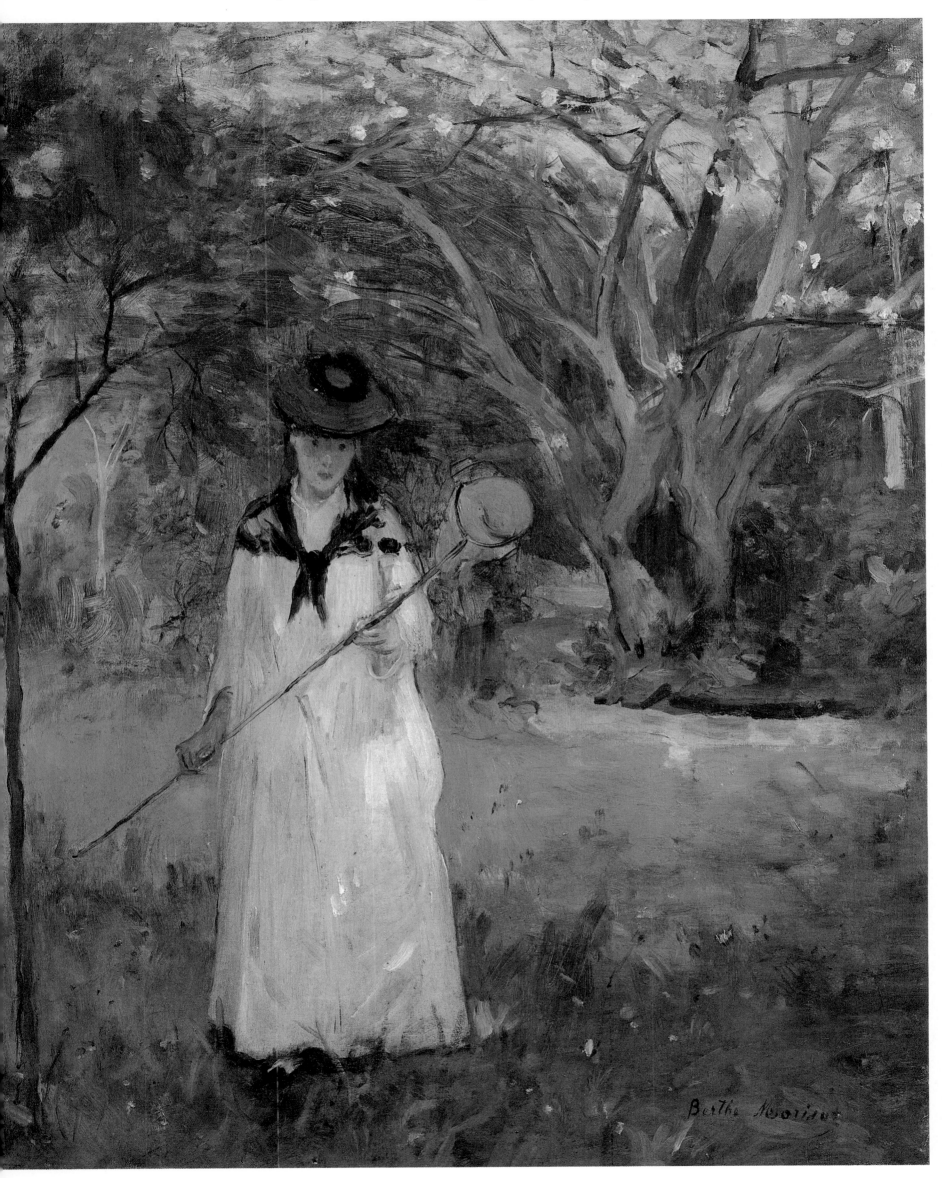

Berthe Morisot
Looking for Butterflies
1874
oil on canvas 46 x 56
Paris Musée d'Orsay

After his brother's death, Eugène Manet built a mansion in the rue de Villejust, to which he and Berthe invited many artists and writers. Mallarmé and Degas were the honoured and privileged guests of this salon which was attended by Renoir, Monet, Whistler, Caillebotte, Paul Valéry and many other famous people.

In the summertime, Eugène and his wife rented a house in Bougival, in the Rue de la Princesse, by the Seine yet well away from the noisy, vulgar riverside inns. Yet all their artist friends knew they were always welcome.

When Eugène died in 1892, Berthe settled in the Rue Weber, with her daughter, and continued to act as hostess to her many friends. Some time later, Geoffroy organized an exhibition of her paintings at Boussod and Valadon, on the Boulevard Montmartre. It was a real success. However, the artist was in poor health. Exhausted by frequent travelling and saddened by her husband's death, Berthe Morisot died on March 2 1895. On hearing the news, those Impressionists, who were still alive, felt as if they were losing a part of their own souls. Morisot's legacy was refined, delicate and spontaneous painting, of which her watercolours are the best example.

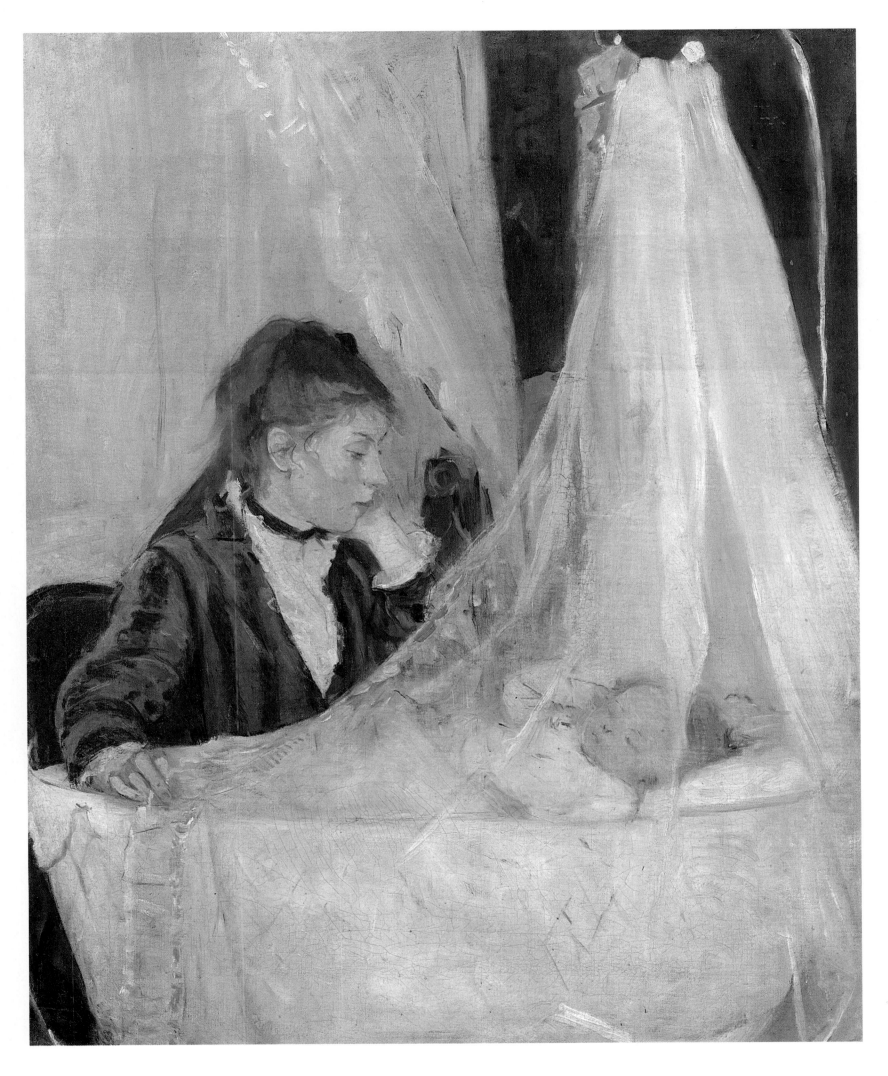

Berthe Morisot
The Cot
1873
oil on canvas 56 x 46
Paris Musée d'Orsay

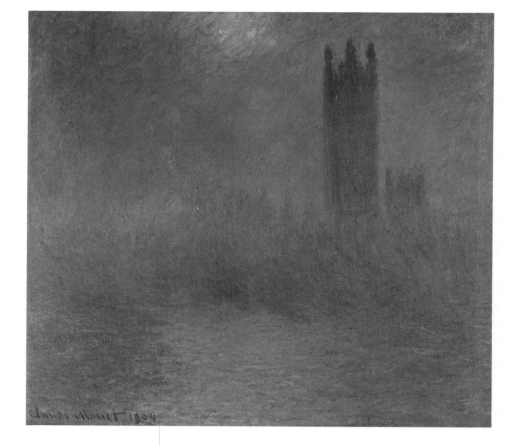

168 *Waterlilies in the Orangery*

Between 1881 and 1883, Monet made many trips to Normandy, staying at Etretat, Fécamp and Dieppe. He had also travelled abroad a lot in the 1880s, and had many exhibitions of his work. However, from April 1883, Giverny become his home base. Camille had died four years previously and Alice Hoschedé had become the painter's companion. They lived at Giverny surrounded by their children, six from Alice's previous marriage to Ernest Hoschedé, and Camille's two children. Monet and Alice bought the house in 1890 and married in 1892.

Monet was doing better. After the period of hardship from 1878 to 1880 his situation improved and eventually he found he was quite comfortably off. He seized the opportunity to landscape the garden, planting it with banks of massed flowers. The River Epte, which flowed by the house, was diverted to make a large pond in which waterlilies could flourish. Weeping willows trailed their branches in heavy clusters at its edge, and a Japanese bridge added an exotic touch to the scene.

Ever since he had painted the various views of Saint-Lazare Station, Monet had realized the benefits he could reap from creating a series of paintings on the same theme. From 1890, he systematized the process. This gave rise to the

Haystacks series, exhibited at Durand-Ruel's in 1891, then the *Poplars* in 1892, the *Rouen Cathedral*, in 1892-1893, views of the Thames in London between 1899 and 1904 and finally views of Venice in 1908.

However, the series which was to occupy the longest period of his life was the *Waterlilies*. He had conceived the idea for this series in 1899, but had been busy with other projects at that time and did nothing about it until 1905. This time he decided to devote himself to it entirely. In 1920, at the request of his friend Clemenceau, he donated this important series, begun in 1915, to the state. The paintings were hung in the Orangery in Paris, shortly before his death. The patriarch of Giverny ended his days happy and honoured, having had the rare joy of witnessing his own apotheosis.

Yet there was a dark side to this story. Monet was now history. New art had been experimenting with new directions for the past 40 years, and the creator of the *Waterlilies* appeared to the younger generation to be an old soldier lingering on the field of a battle which had already been won.

Thus Monet discreetly took leave of this world. In October 1926, he stopped working. On December 5 1926, at the age of 86, he died in Giverny, the last of the giants of 19th-century painting.

Claude Monet
The Houses of Parliament
1904
oil on canvas 81 x 92
Paris Musée d'Orsay

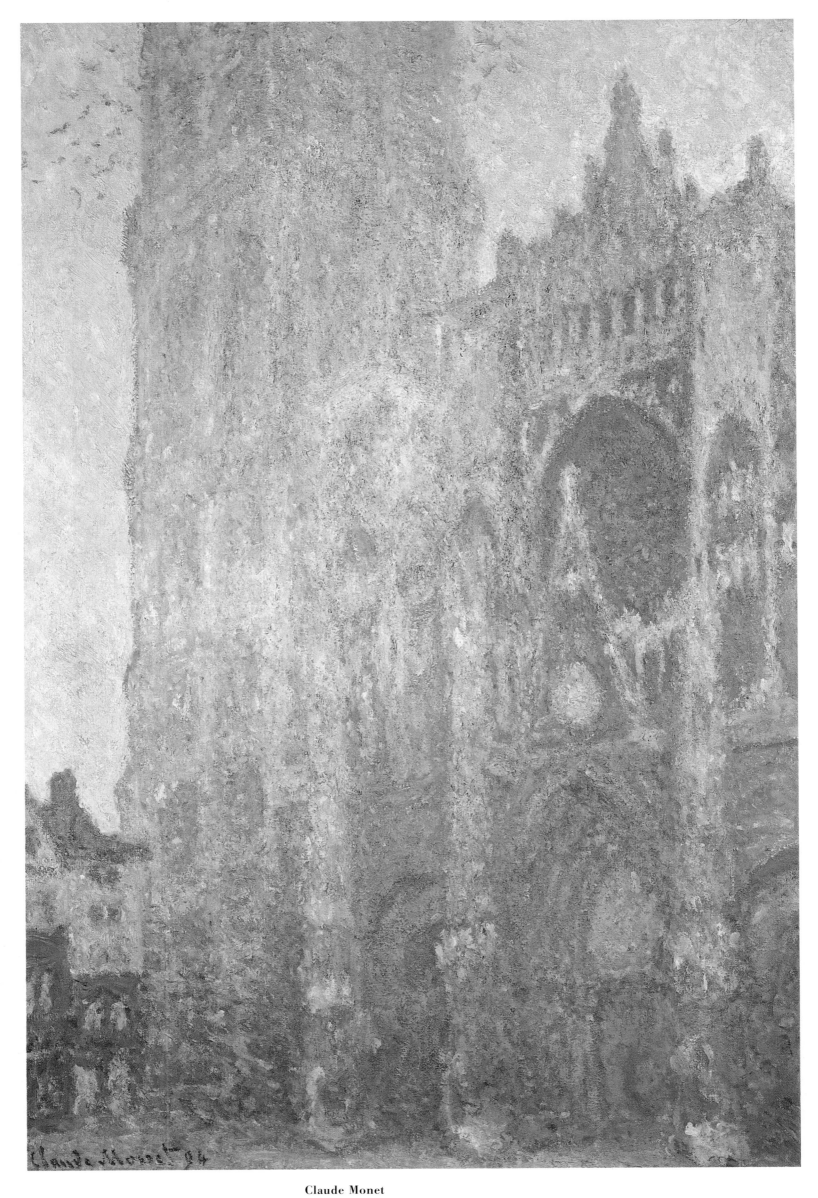

Claude Monet
Rouen Cathedral Series
1892-1893
oil on canvas 91 x 63
Paris Musée d'Orsay
The Entrance Morning Light Blue Harmony

170

Claude Monet 97

Claude Monet
Cliffs at Varengeville
1897
oil on canvas
Le Havre Musée des Beaux-Arts

172 *"It Will Drive Me Mad"*

The fate of Monet's later work is interesting. Curiously enough, until fairly recently, *Waterlilies* and the other series were treated with a measure of contempt. Many art critics considered them too systematic. They regarded them as aberrations, the result of too much theorizing which, they believed, had been prejudicial to the quality of Monet's work. Monet was deplored for having sacrificed form and for having eventually abandoned real life, which was quite surprising since they had always blamed him for being too close to it.

Obviously, like Cézanne, Renoir and Degas, Monet was concentrating more and more on painting itself. The subject-matter he had so often painted became less important to him. Does this mean that reality was now a mere pretext? Was Monet a pioneer of lyric abstraction? The idea is attractive but not plausible. Monet never was an abstract painter. Colour never was an end in itself, but a means by which to represent the subtle interplay of light and colour. Monet's work never lost its way. The goal he pursued when painting the *Waterlilies* was the same as when he painted *Women in a Garden*. The fact was that the subject-matter became progressively reduced to the bare essentials to the point where it appeared to disappear altogether, at least in the eyes of some. The painter had focused on a detail which then became the subject of one painting, then a series. It grew and multiplied, becoming gigantic and omnipresent. Real life was by no means absent. On the contrary, it was being closely embraced.

Was Monet's project a sensible one? In 1890, Monet wrote to Gustave Geoffroy, "I have once again begun working on things which are impossible to do, painting water with grass waving in the depths (...). It will drive me mad to try and do it". Eighteen years later, he added, "These views of water and reflections of light have become an obsession. It's too much for an old man like me (...). I hope that something will emerge from so much effort". He had exactly 18 more years in which to reach his goal.

Monet at Giverny
Musée Clemenceau

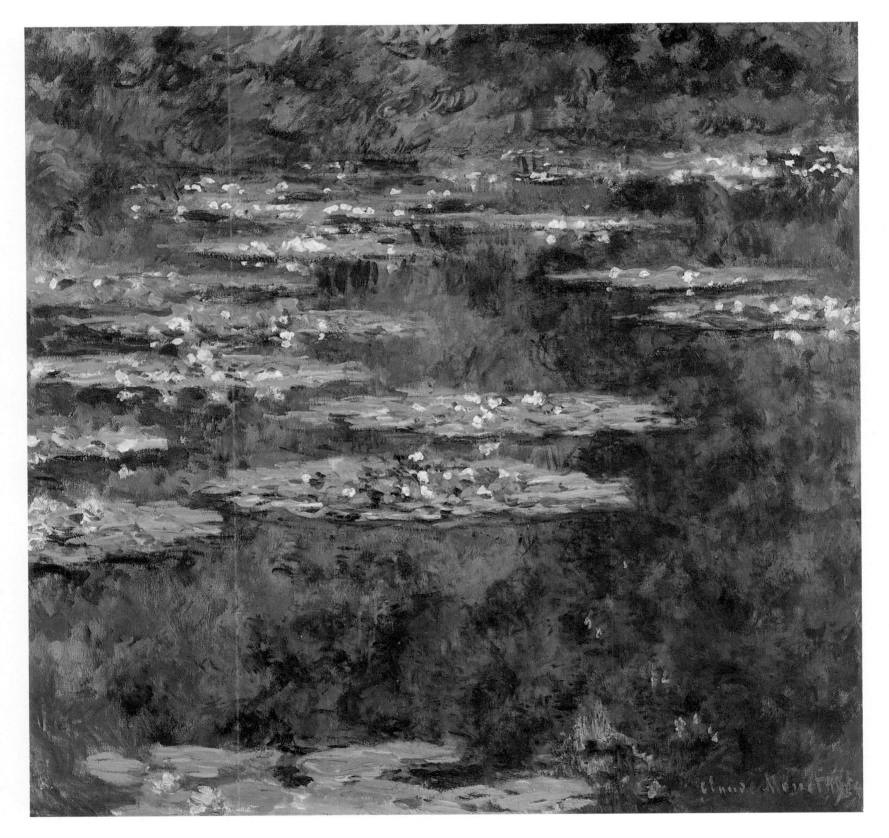

173

Claude Monet
Waterlilies
1904
oil on canvas 89 x 95
Le Havre Musée des Beaux-Arts

174

Giverny Monet's Garden, Waterlilies
c. 1908
Paris Bibliothèque des Arts décoratifs

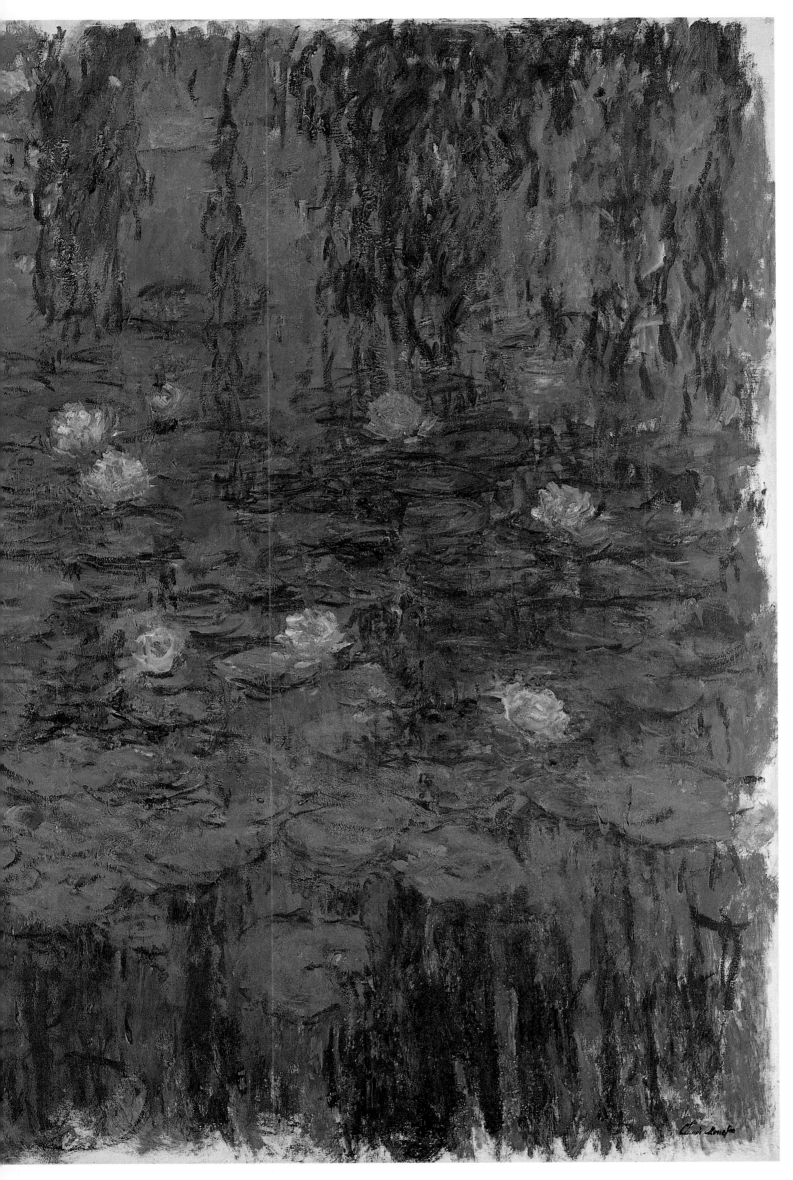

175

In depicting water, he has become the painter of the indirect, of the invisible. He concentrates on this almost invisible and spiritual surface which separates light from its reflection. The azure of the air is captured by the azure of the water.

Paul Claudel

Claude Monet
Blue Waterlilies
1916-1919
oil on canvas 200 x 200
Paris Musée d'Orsay

Georges Seurat
The Circus
detail
1890-1891
oil on canvas 185 x 150
Paris Musée d'Orsay

III

the Newcomers

Georges Seurat
Nude in profile
1887
oil on panel 25 x 16
Paris Musée d'Orsay

I t is difficult to place an exact birthdate on Impressionism. Was it 1863 or 1874? It is just as hard to define when it came to an end. Was it in 1883, with the death of Manet, or in 1886 perhaps, when the last Impressionist Salon was held? A case could even be made for December 1926, when Monet died. If the history of Impressionism as a movement is considered to be more important than the individuals who created it, it could be claimed that it ended in 1884. This was the year in which the Neo-Impressionist school was born, headed by Seurat. The name of the movement is significant; while acknowledging the debt they owed to their masters, its members nevertheless clearly expressed their intention of going beyond the initial teaching. In their view, Impressionism was already a thing of the past.

In this respect, Georges Seurat's *Bathing at Asnières* constitutes a turning-point, since it marks a break with Impressionism. Seurat was inspired by scientific theories of colour, especially Eugène Chevreul's *On the Law of Simultaneous Contrast of Colour* 1839. Under the influence of this theory, Seurat branched out into a new area which was to end in "divisionism".

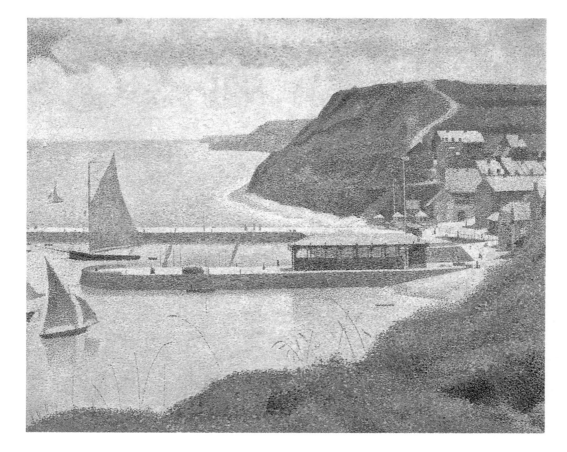

Seurat wanted to turn painting into a science. He was an extremely precise, introverted, methodical and quiet person. His father, a country bailiff, had married a Parisian woman and had moved to La Villette. Seurat did his military service in Brest, returning to Paris in 1882 where he rented a flat at 19 Rue de Chabrol. The artist was still searching for his own style. He sketched a lot, copied old masters and read every available new theory about colour.

In 1883, the portrait of his friend Arman-Jean was accepted by the Salon. However, the painter had begun to assert his originality. By concentrating on his drawing, his technique became more individual. The subject-matter he chose was undoubtedly still that of the Impressionists, but his simplification and geometrization of shapes had gone beyond that of his masters. After 1883, Seurat's work was no longer accepted by the Salon.

Yet Seurat thought that he had found the key to modern painting. Like Zola, who aspired to writing scientific novels, Seurat believed that he was creating a science of painting. He was trying to bring to art the exactitude of mathematical equations.

The novelty of the work of Seurat and his friends caused many raised eyebrows, even in the Impressionist camp. Degas supported the younger painters on principle. Monet, on the other hand, grumbled and criticized these "daubers," although he did not name anyone in particular. Sisley insisted on preserving the original authenticity of the movement. Only Pissarro, the most generous and open-minded of them, openly defended Seurat and Signac. This caused Renoir, Sisley and Caillebotte to refuse to participate in the eighth and last exhibition of the movement in 1886. Furthermore, it was decided to simply call the event "The Eighth Exhibition of Painting".

For their part, the younger painters gathered around Odilon Redon and founded the Society of Independent Artists, which held its first Salon in 1884. Seurat exhibited his *Bathing at Asnières* – over the refreshment bar! These artists intended to shock people as much as their predecessors had done in 1874, ten years earlier. They created less of a sensation but the success of their enterprise was more durable and more assured. After a decade dominated by the Post-Impressionists, of which Seurat's retrospective in 1892 was the climax, the Salon provided an opportunity for the Fauves and the Cubists to make their debut. For thirty years, until 1914, the Salon was a major event, equal in importance with to the Autumn Salon.

Georges Seurat
Part-en-Bessin The Harbour High Tide
1888
oil on canvas 67 x 82
Paris Musée d'Orsay

Camille Pissarro
Woman in a Close Springtime at Eragny
1887
oil on canvas 54.5 x 65
Paris Musée d'Orsay

184 *Pissarro's Enthusiasm*

To seek modern synthesis through means based on science, which are based on the theory of colour discovered by Monsieur Chevreul, based on Maxwell's experiments on N.O. Rood's measurements.

Pissarro
in a letter to Durand-Ruel
November 6 1886

Not only did Pissarro support the newcomers, he even followed in their footsteps. When Seurat exhibited *A Sunday Afternoon on the Isle of the Grande Jatte* in 1886, Pissarro was absolutely enraptured by it. A few months later, he wrote to Durand-Ruel, "Monsieur Seurat, a very talented artist, was the first painter to have the idea of thoroughly studying scientific theories and applying them to painting. I merely follow in his wake". For in the meantime, Pissarro had adopted the divisionist technique, and was ready to start again from scratch at the age of fifty-six. It was so typical of him.

This episode lasted for five years. Then, in 1891, Pissarro, the unrepentant dreamer, was forced to admit that he could no longer work in that direction without thwarting his natural inclinations. He returned to his early loves, writing to Georges Lecomte, "One must follow one's artistic instinct – one must humble oneself before nature (...and not) lose intimate and direct contact with it (...) reason and science are liable to cool the emotions".

This is an almost naive conclusion drawn by a man who had not hesitated for a second, in the name of this new struggle, to quarrel with Gauguin and most of the friends of his youth, merely to defend the younger generation. Fortunately, Pissarro was later reconciled to them and by the time he died, in 1903, he was considered as a great artist by art-collectors, being rightly hailed as one of the fathers of Impressionism.

Camille Pissarro
The Seine and the Louvre
1903
oil on canvas 46 x 55
Paris Musée d'Orsay

With that of Pissarro, another name is linked to Neo-Impressionism, that of Félix Fénéon. In 1884, while almost everyone was condemning the young Seurat's work, Félix Fénéon was one of the few to be able to detect its promise. Fénéon had just taken over editorship of *La Revue Indépendante*. The title of this magazine was no accident. Its aim was to defend the work of the painters who had just founded the Salon of the Independents. Fénéon was only twenty-three.

This tall, lean man had an agile and logical mind, though he was by no means lacking in inspiration and verve. He was good at explaining without boring the readership and at persuading without tiring it. He probably owed much to Seurat, with whom he was associated from the beginning, but without Fénéon, the fates would never have dealt so kindly with Neo-Impressionism.

Fénéon also contributed to other art magazines, such as *L'Art moderne* and *La Revue Blanche*. He was thus able to organize a famous retrospective exhibition of Seurat's works on the premises of *La Revue Blanche*, in 1900. After 1914, he ran the Galerie Bernheim-jeune.

His deep and great friendship with Seurat did not prevent him from admiring other painters. He passionately admired the work of Toulouse-Lautrec, who could not resist sketching his friend's unusual and almost ridiculous silhouette in the *Danse des Almées*, destined to decorate La Goulue's booth at the Foire du Trône. This drawing is true to life, portraying as it does a perspicacious and amused observer of his times.

Henri de Toulouse-Lautrec
Moorish Dance
1895
285 x 307.5
Paris Musée d'Orsay

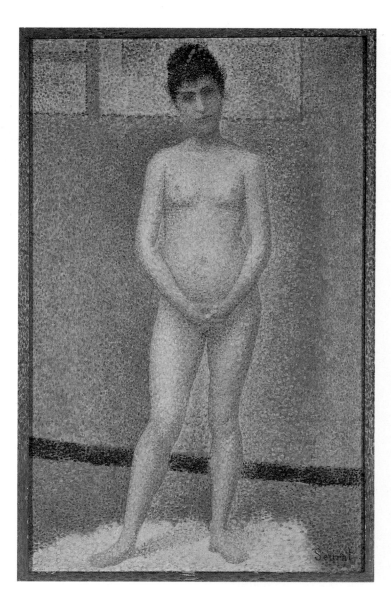

186 *After Degas*

After ›886, the Divisionist technique, which consisted in applying dabs of unmixed colour to the canvas, was fully mastered by Seurat in the series *Les poseuses*. Three of these elaborated studies are now in the Musée d'Orsay in Paris. The finished paintings which resulted from them have been acquired by the Barnes Foundation, near Philadelphia.

Although line is absent from these works, their composition is extremely carefully planned. The challenge which Seurat had set himself, since he could draw beautifully, was to render line purely through colour. These studies were produced shortly after Degas' exhibition of his series of paintings of women, and show some resemblance to Degas' work. As an admirer of Degas' work, Seurat probably wanted to try his hand at the same subject-matter, which would bring out the full originality of the technique he had just perfected.

Georges Seurat
Nude woman
1887
oil on panel 26 x 17
Paris Musée d'Orsay

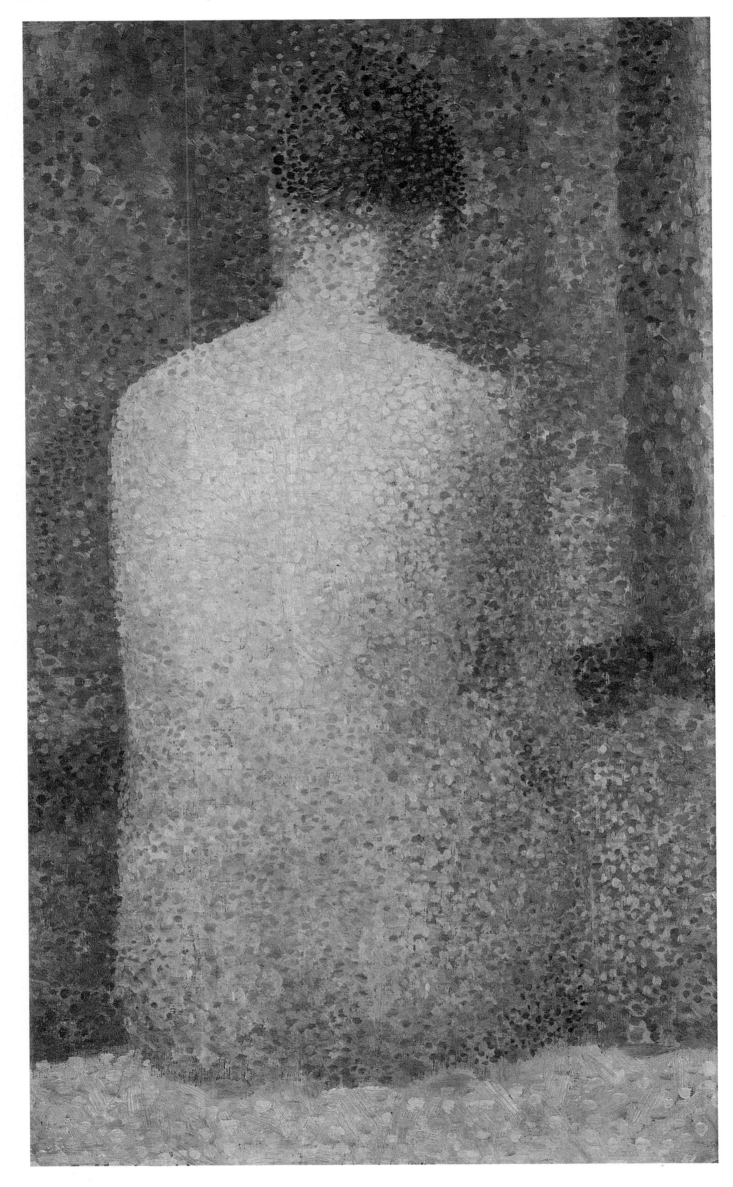

Georges Seurat
Nude Woman's Back
1887
oil on panel 24 x 15
Paris Musée d'Orsay

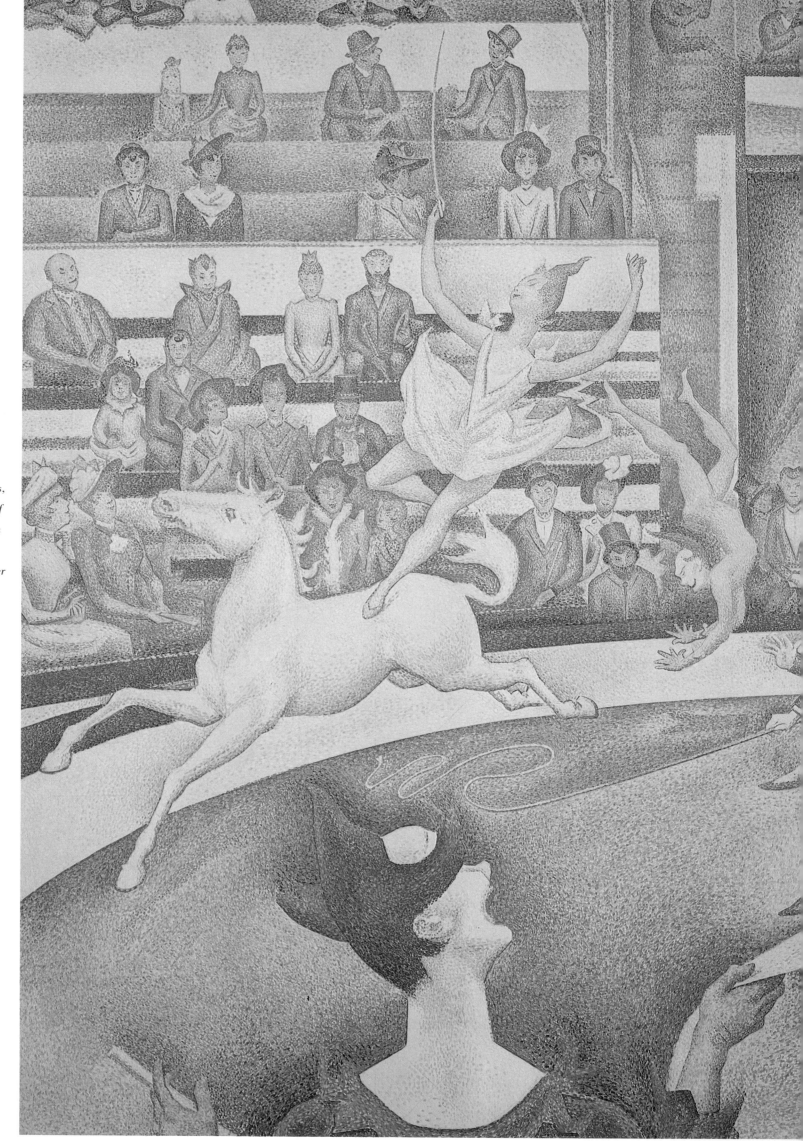

188

Seurat observes, compares, squints at the interplay of light and shade, perceives contrasts, discerns reflections, muses at length over the lid of the box he uses for a palette, fighting with matter as he does with nature (...). From observation to execution, from brush-stroke to brush-stroke, the panel is covered.

Paul Signac

Georges Seurat
The Circus
1890-1891
oil on canvas 185 x 150
Paris Musée d'Orsay

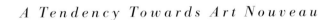

A Tendency Towards Art Nouveau 189

In 1888, Seurat spent a few days at Port-en-Bessin, near Caen. The following year, he went to Le Crotoy and in 1890 to Gravelines. In all these places, he painted austere seascapes which perfectly convey the rugged atmosphere and scenery of France's Channel coastline.

Seurat returned to Paris for the winter of 1891 and embarked on an ambitious painting on the theme of the circus. It was supposed to be a hymn to gaiety, but unfortunately, death prevented its completion. On March 29 1891, Seurat died of dyphtheria; he was barely thirty-two years old. His fourteen-month-old son was to die soon after.

This last painting contains curves and swirls which may herald a possible relationship with Art Nouveau, which was all the rage in Paris between 1890 and 1905.

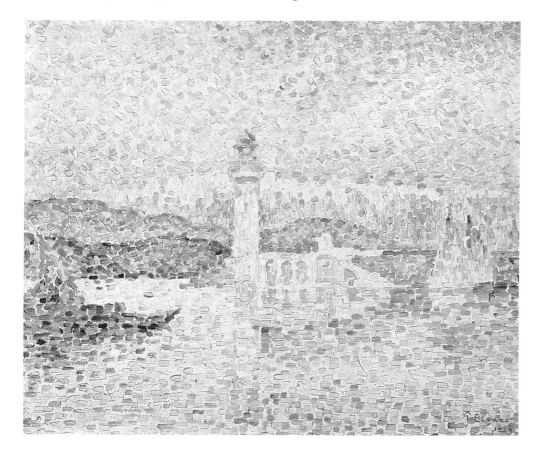

Seurat's Greatest Friend

Paul Signac was one of the first painters to rally to the Neo-Impressionist cause. Although, like Seurat, he was a painter, he also had a gift for writing and loved sailing. He was lucky enough to live forty years longer than his friend.

Paul Signac was born in 1863, the year in which the first Salon des Refusés was held. In fact, he appears to have known nothing about painting until 1880. In that year, an exhibition of Monet's works was a revelation to him. He was later to befriend Monet, and he met Seurat in 1884, both of whom became his mentors. Seurat had a decisive influence upon Signac. Thenceforward, Signac, the journalist, joined Félix Fénéon in being one of the most fervent advocates of the "pointilliste" technique. Signac's manifesto *From Eugène Delacroix to Neo-Impressionism*, published in 1899, is a landmark in the history of art.

Paul Signac
The Lighthouse at Antibes
1909
oil on canvas 45 x 55
Nantes Musée des Beaux-Arts

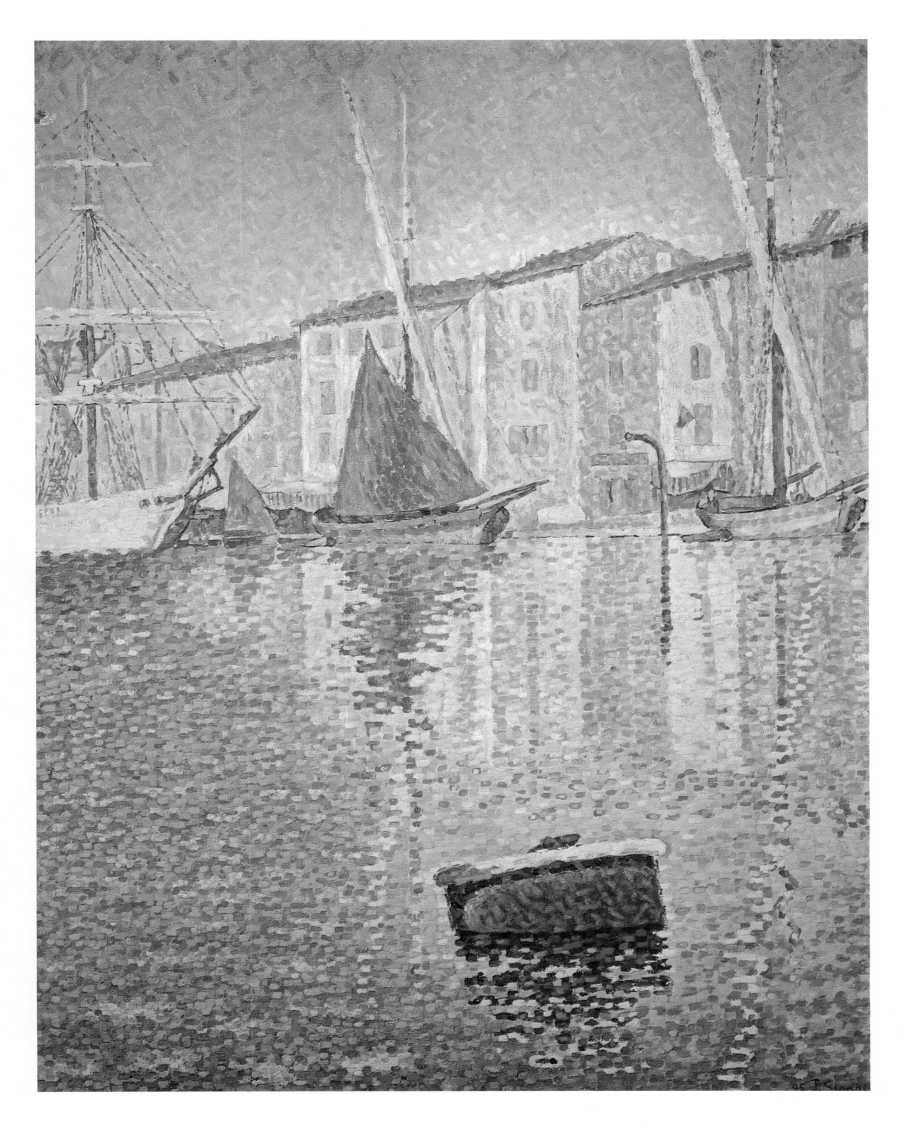

Paul Signac
Red Buoy
1895
oil on canvas 81 x 65
Paris Musée d'Orsay

192 *A Lover of the Sea*

Signac's enthusiasm for the new school of painting did not make him forget his greatest passion – the sea. Practically all his works reflect this love for harbours and ships. It was through Signac that Seurat visited Port-en-Bessin. After his friend's death, Signac discovered Saint-Tropez. This little village, which has become so famous since then, became his home port. Matisse was one of his visitors there in 1904.

In the course of time, Signac's technique developed. He painted with freer, larger brushstrokes, but right up until his death in 1935, he remained faithful to his early concept of painting.

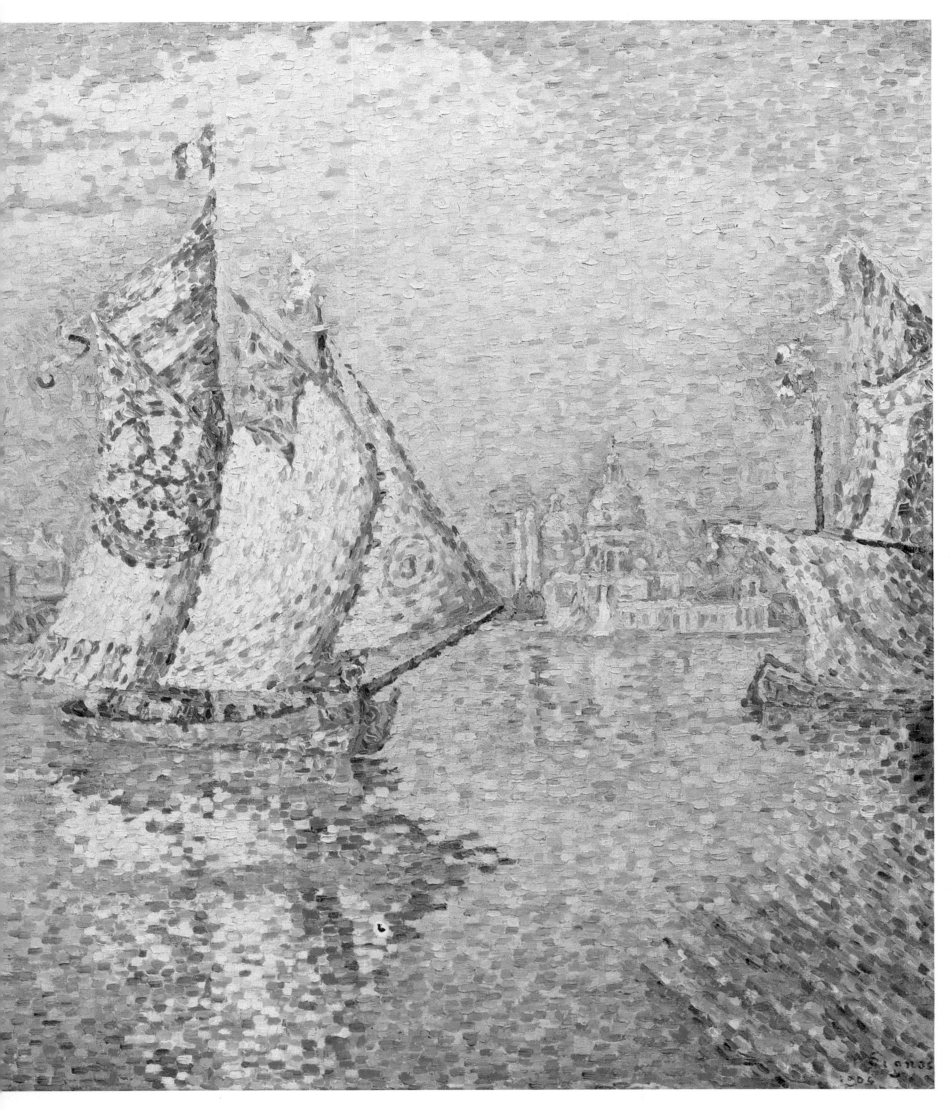

Paul Signac
Yellow Sail
1904
oil on canvas 72 × 91
Besançon Musée des Beaux-Arts

194

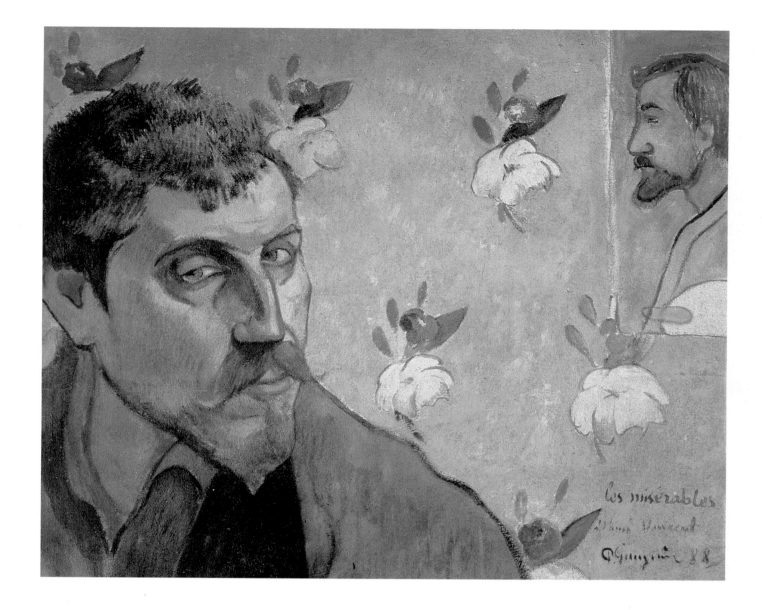

Paul Gauguin
Self-portrait
called *"Les Misérables, for Friend Vincent"*
1888
oil on canvas 45 × 55
Van Gogh Museum Amsterdam

Paul Gauguin, founder of the school of Pont-Aven, was another successor to the Impressionists. After an eventful childhood, partly spent in Peru, he embarked on a naval career, but gave it up to become a stockbroker in Paris. He worked at it most conscientiously from 1873 to 1883. A married man with children, he was appreciated and respected, his career seemed to be mapped out in advance. Yet, in January 1883, he suddenly resigned from his job and announced to his family that from now on he would devote himself entirely to painting. The news horrified his wife, who decided to pack her bags and go home to Copenhagen, taking the children with her.

In truth, the model employee had never really forgotten the voyages of his youth. Moreover he had already produced several paintings which he exibited at the Impressionist Salons from 1879 onwards, thanks to an invitation from Degas and Pissarro. This was, no doubt, enough to convince him to break away from his former way of life without notice.

196

Paul Gauguin
The family of the painter in a garden
rue Carcel, Paris
1882
oil on canvas 87 x 114
Copenhagen Carlsberg Glyptoteck

198 *The Life of a Tramp*

The period which ensued was very difficult for Gauguin. Enthusiastic but penniless, he was reduced almost to living the life of a tramp. He stayed with Pissarro in Rouen for a while, but they quarrelled over Pointillism and Gauguin left. His wanderings brought him to Pont-Aven, in Brittany. The wild landscape and inhabitants attracted him. Yet only a year later, he left for Panama, moving on to Martinique, where he made friends with Daniel de Monfreid. Here, Gauguin thought he had finally discovered the landscapes he had always dreamt of, in a country where life was both primitive and exotic. Unfortunately, short of money as always, he was forced to return to France in 1887.

For the next two years, he continued to live like a tramp, wandering from Pont-Aven, with his friend Emile Bernard, to Arles, where he joined Vincent Van Gogh. Returning to Paris, he taught at the Vitti Academy, in Montparnasse. Finally in April 1891, his request being favourably received by the Minister of Education and Fine Arts, he embarked at Marseilles for Tahiti. Two months earlier, with this journey in mind, he had successfully sold thirty paintings at an auction at the Hôtel Drouot.

A photograph of Paul Gauguin
c. 1886

Paul Gauguin
Sketch in a Letter to Vincent Van Gogh
1889

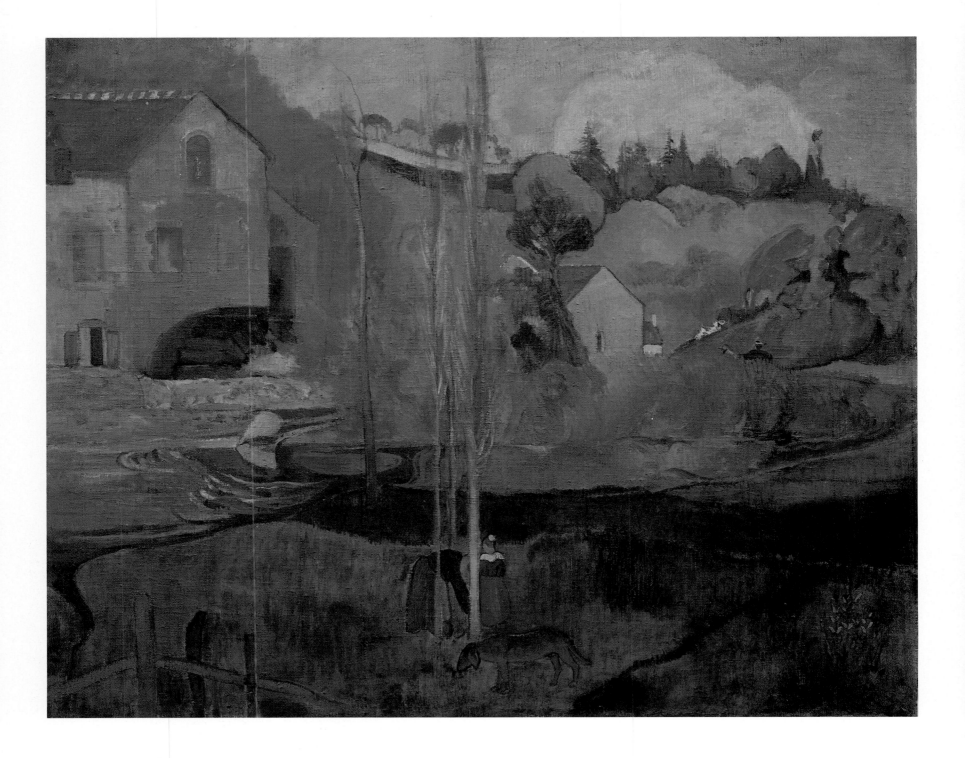

Paul Gauguin
Landscape in Brittany
1894
oil on canvas 73 x 92
Paris Musée d'Orsay

200

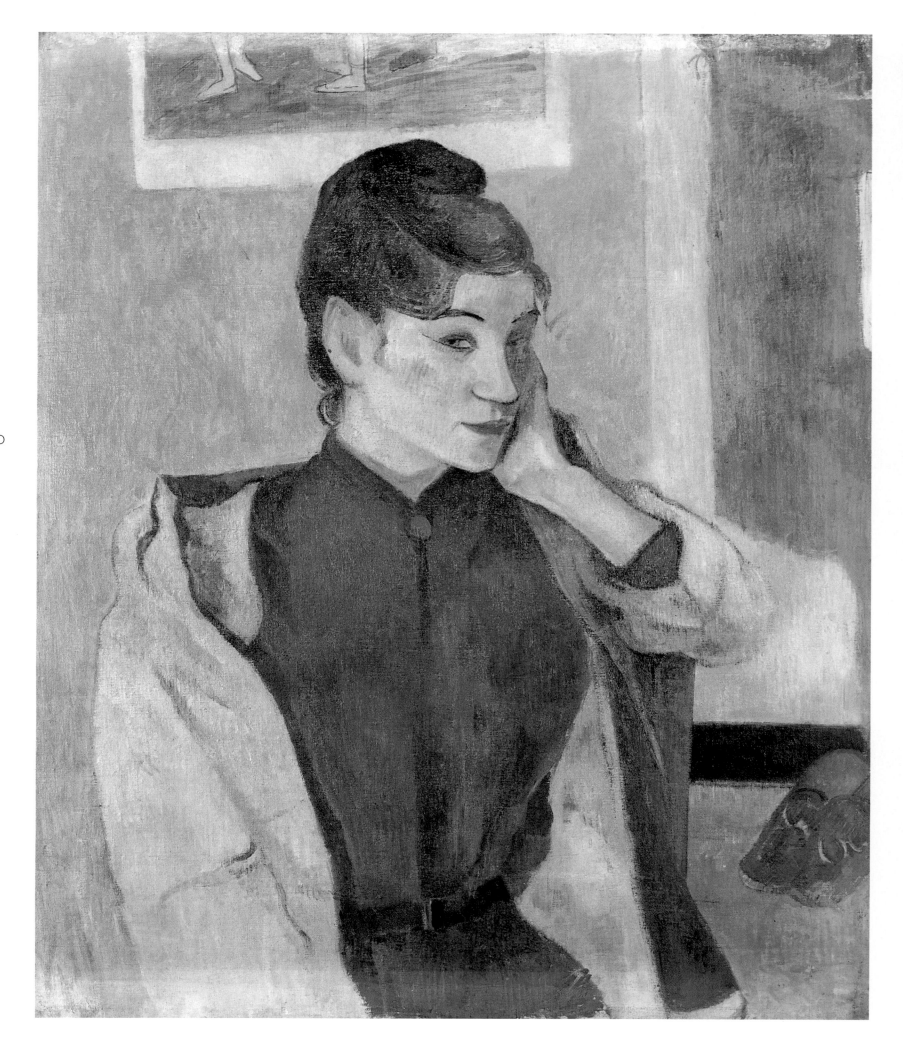

Paul Gauguin
Portrait of Madeleine Bernard
1888
oil on canvas 72 x 58
Grenoble Musée des Beaux-Arts

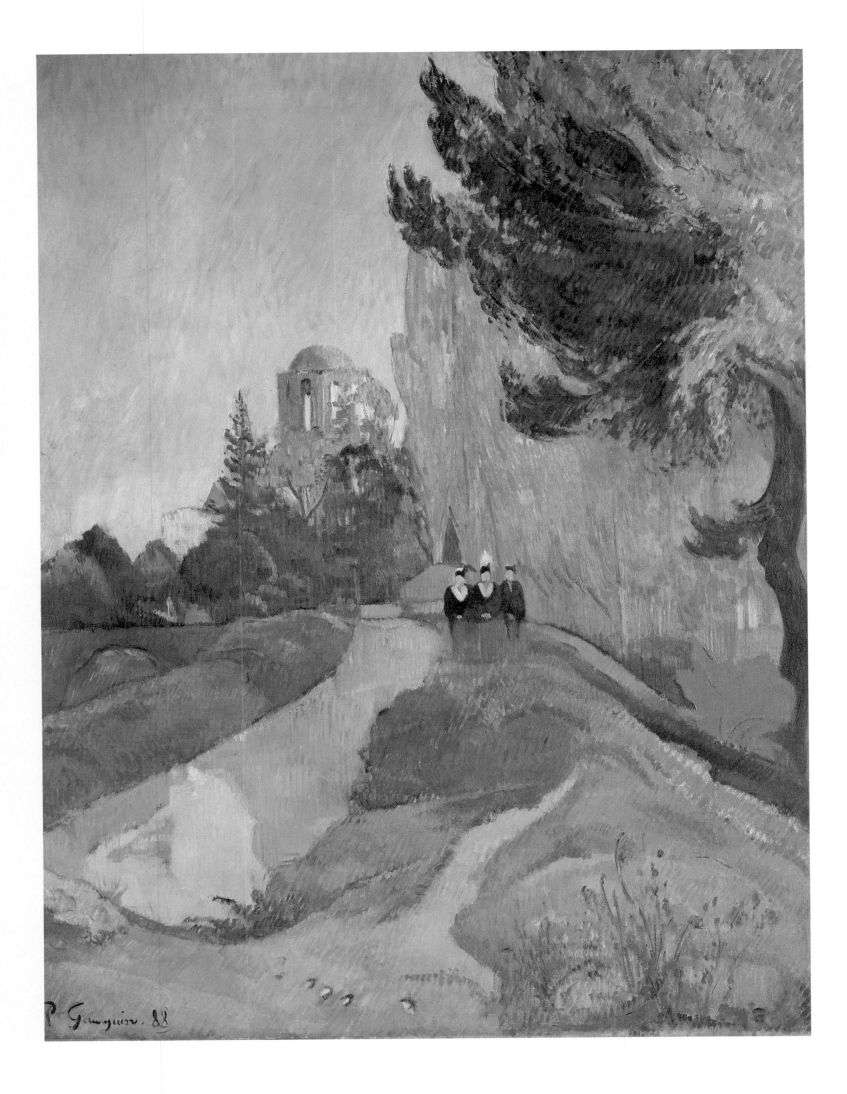

Paul Gauguin
The Aliscamps
1888
oil on canvas 92 × 73
Paris Musée d'Orsay

202 *Deceptive Dreams*

His first visit to Tahiti was a mixture of the marvellous and the sordid. He soon became disgusted by the attitudes and stupidity of the whites in Papeete, so he decided adopt the Tahitian way of life and lived among natives in a straw hut. He threw himself into his work, with the excitement provided by a feeling of discovery (*Arearea* and *On the Beach* are examples of such paintings). His subject-matter was idealized everyday life, as depicted in the Polynesian tales which he heard or read.

However, Gauguin was running out of money. He requested funds from France, but they were not forthcoming and he decided to return to France in 1893. He found out that he had inherited some money, but as soon as he had possession of it he frittered it away. He was seen at Pont-Aven, Le Pouldu, and in Paris. He threw lavish parties in his studio and lived as though his wealth came from a bottomless pit. He then had to face a rude awakening.

Paul Gauguin :
The Smile, plate III

Pont-Aven
Entrance to the Bois d'Amour

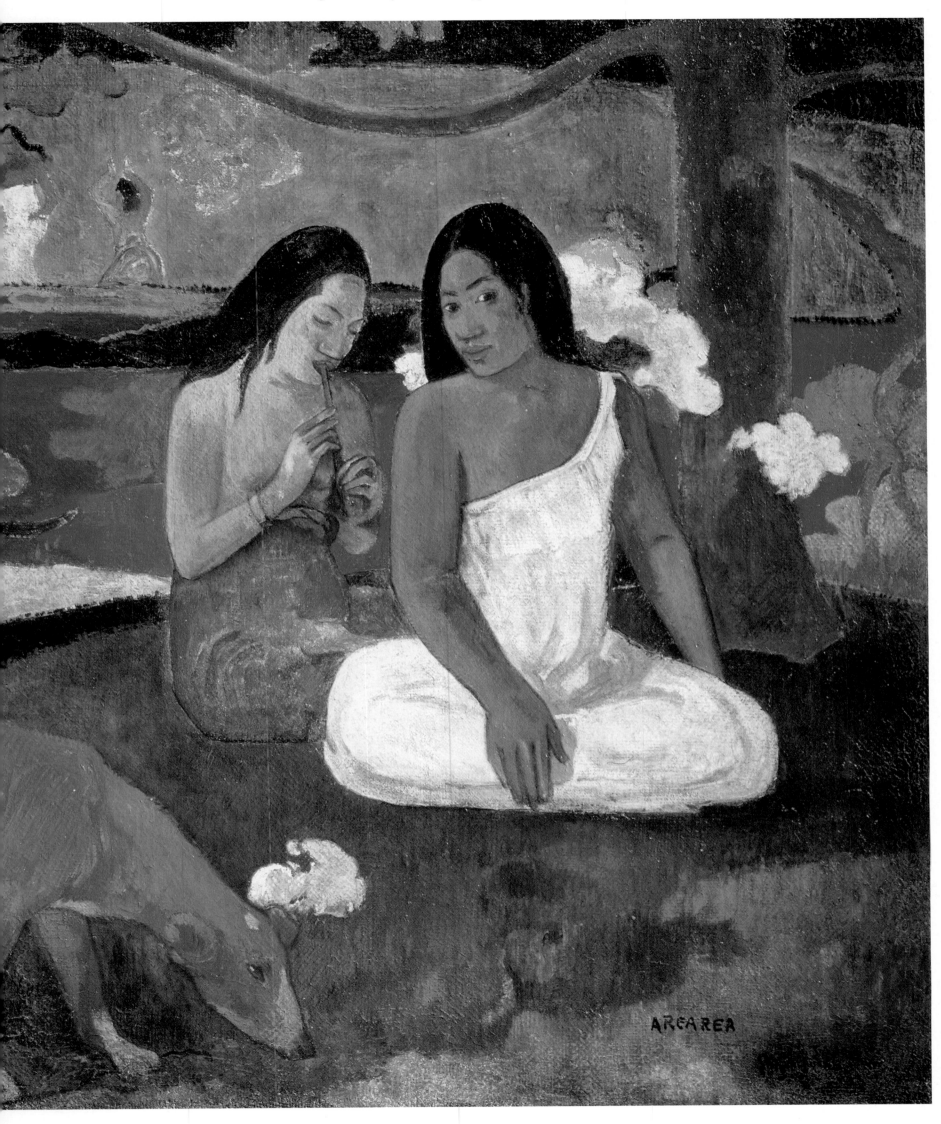

Paul Gauguin
Arearea
1892
oil on canvas 53 x 75
Paris Musée d'Orsay

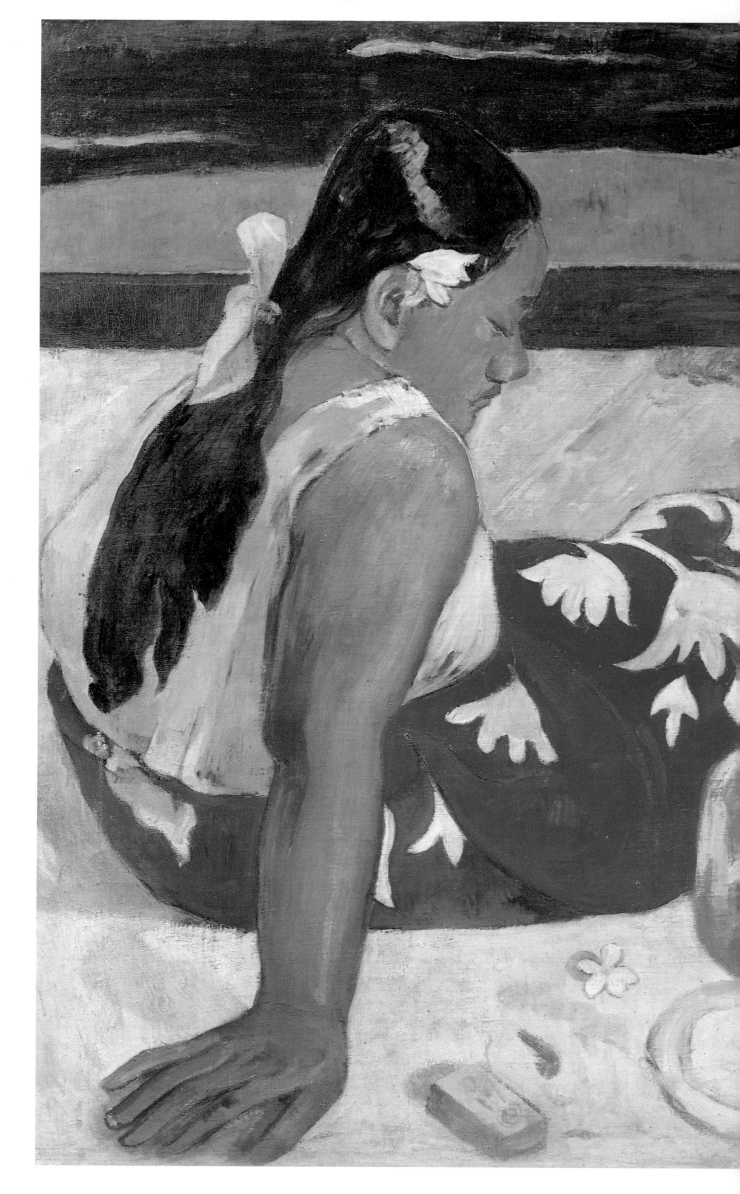

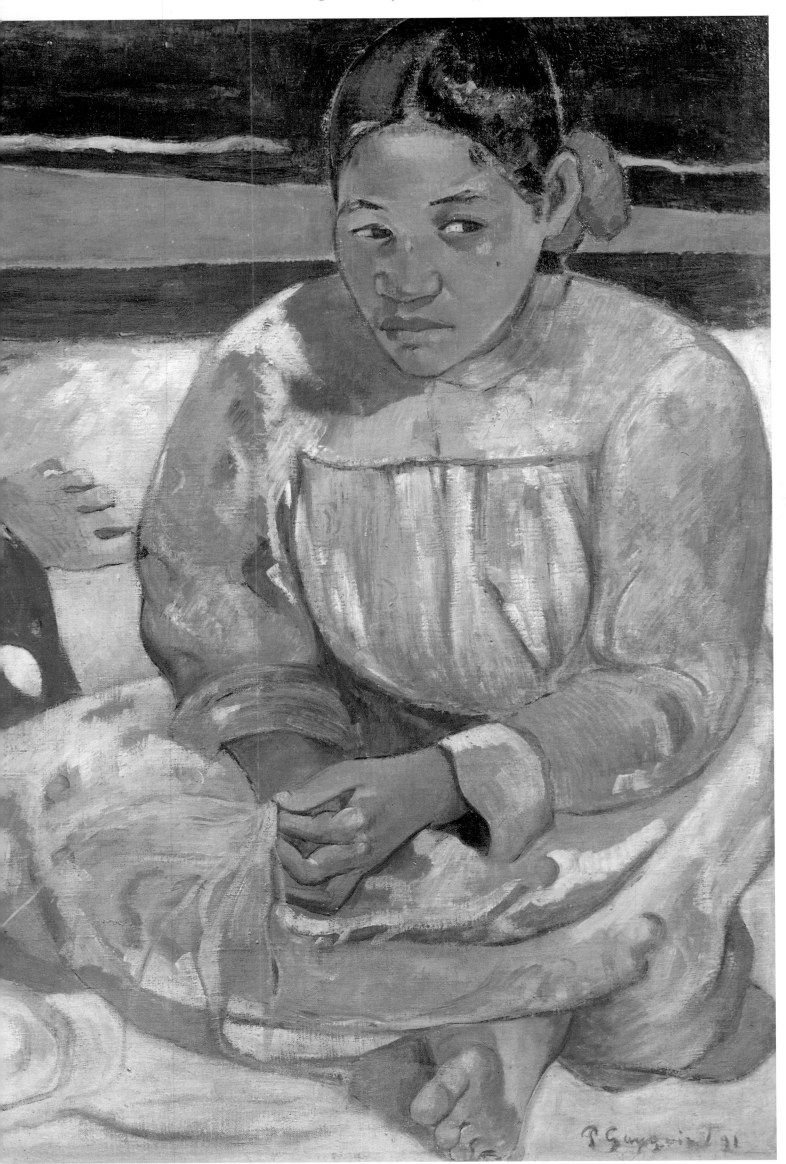

Paul Gauguin
Tahitian Woman or *On the Beach*
1891
oil on canvas 69 x 91,5
Paris Museé d'Orsay

206 *A Break with the Old World*

Degas conceived the idea of exhibiting Gauguin's Tahitian work at Durand-Ruel's. The show was held in 1893; it was a total failure. The fact that Gauguin had been away from France for two years, and nobody knew exactly how this eccentric rebel's work would develop, made collectors wary. So Gauguin went to Copenhagen to see his wife and children. This was another fiasco. These people had nothing left in common. Gauguin returned to Paris alone, and penniless again. The crowning disaster was that his mistress, Annah, had stolen everything from his flat and left without leaving her address. Gauguin decided to return to Tahiti. A sale was arranged at Drouot to finance his trip, as it had done in 1891. But this one was a disaster. Nevertheless, he left from Marseilles in July 1895. He never saw France again.

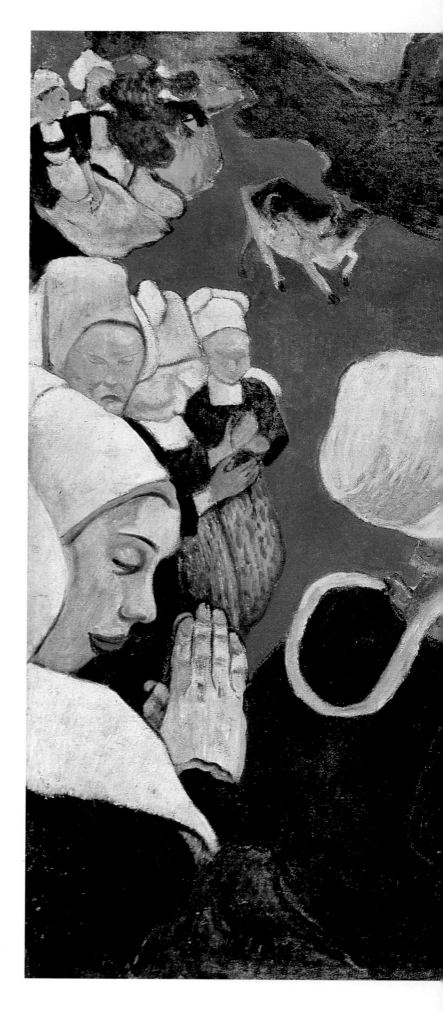

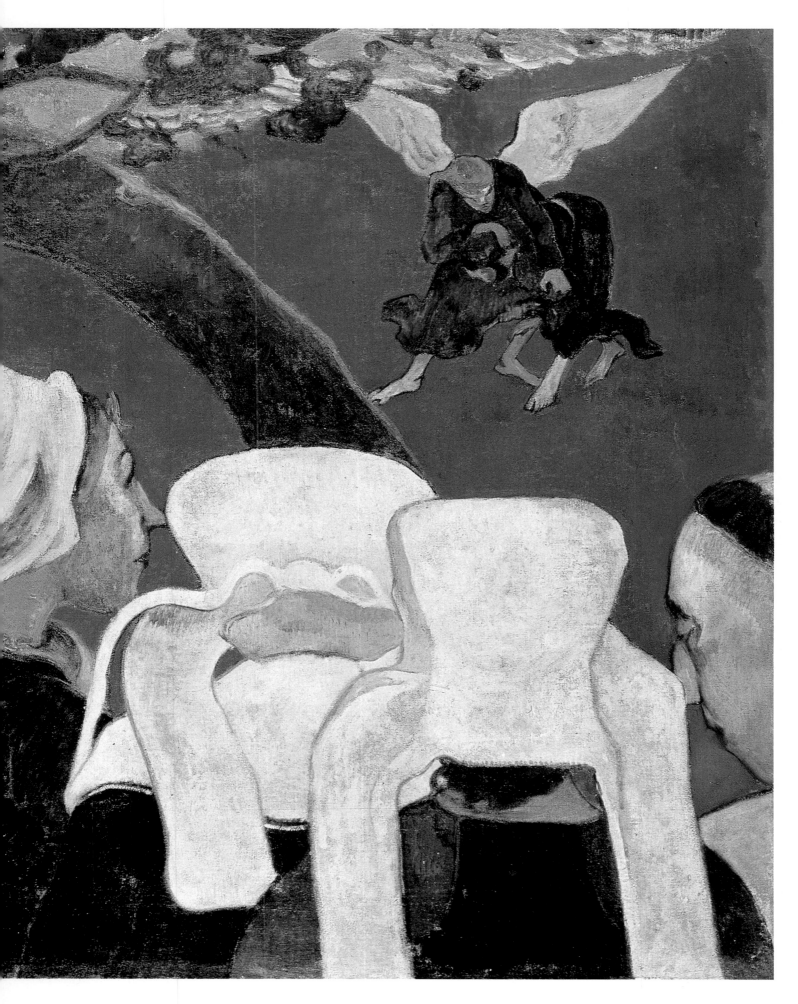

207

*Paul Gauguin, with his
outstanding qualities which
undoubtedly enable him
to rank among the greatest
painters, delved back into
the remotest origins of
mankind in order to discover
the divine purity of art.*

Guillaume Apollinaire
La vie artistique
11 May 1910

Paul Gauguin
Vision after the sermon
1888
oil on canvas 73 x 92
Edinburgh National Gallery of Scotland

208

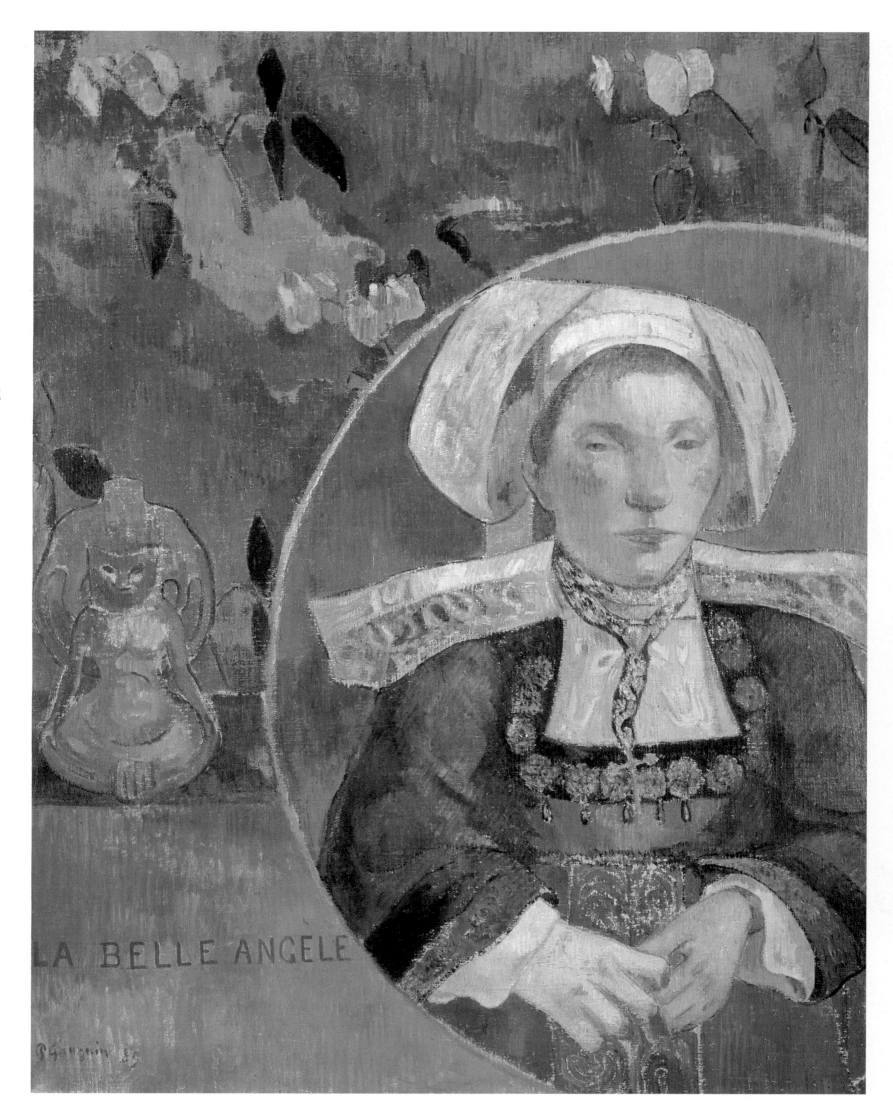

Paul Gauguin
La Belle Angèle
1889
oil on canvas 92 x 73
Paris Musée d'Orsay

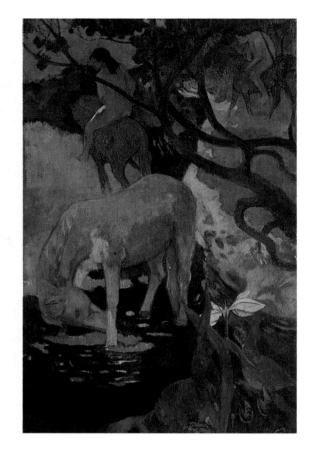

Gauguin The Anti-Colonialist 209

Gauguin abandoned Papeete for the northern end of the island. He gave drawing lessons. The first two years of his stay there were extremely hard. Gauguin had caught syphilis and was hospitalized in 1897. He also heard that his daughter had died back in Europe. His wife then stopped writing to him. He had burned his bridges completely.

Nevertheless, he was working at a frantic pace, producing dozens of paintings and sculptures, and hundreds of woodcuts. In 1898, his situation improved. Back in France, Ambroise Vollard had taken over from Durand-Ruel, and was trying to convince art-collectors of Gauguin's talent, helped by Daniel de Monfreid. In Tahiti, Gauguin took a job in the land registry office. In 1899, he began writing for *Guêpes*, (Wasps) a Papeete satirical newssheet. His attacks on the Governor became more virulent and Gauguin ran into trouble. In August 1901, he left Tahiti for Dominica (Atouana) in the Marquesas Islands, where he was warmly welcomed by the natives because of his anti-colonialism. Gauguin continued to paint while continuing his political struggle. It cost him three years in jail, but did not deter him from continuing his calls for rebellion. However, early in 1903, his encroaching illness forced him to give up painting. He devoted the last months of his life to compiling his memoirs, in the book called *Before and After (Avant et après)*. Gauguin died on May 8 1903.

(...) We have fallen into the hideous error of naturalism. Naturalism began with the Greeks, under Pericles. Since then, there have been lesser or greater artists than those who have reacted to a lesser or greater extent against this error (...). Truth lies in purely intellectual art, in primitive art – Egyptian art is the most erudite of all. That is the fundamental principle.

Paul Gauguin

Paul Gauguin
The White Horse
1898
oil on canvas 141 x 91
Paris Musée d'Orsay

A Modern Painter *The Nabis*

Gauguin's later work is permeated with mysticism. He continued the world of the Impressionists but in a diametrically opposite direction to that of Seurat. While Seurat had chosen science and civilization, Gauguin wanted to go back to the origins and to magic. His style, which has been called "cloisonnisme" is the absolute opposite of Seurat's pointillism. Gauguin worked in large flat areas of colour. He was trying to rediscover man's pre-scientific purity and simplicity, before the emergence of science. His deliberately naïve art is full of symbolism. Gauguin's rediscovery of primitive art opened the way to the revolutionary movements in art in the 20th century.

"What matters to me," he wrote, "(...) is what is going to open the march into the 20th century".

For such a solitary individual, Gaugin left a particularly rich legacy of followers. He can claim to have founded at least two movements in art, the school of Pont-Aven and the Nabis.

Gauguin had met Emile Bernard in Pont-Aven and together, they perfected the technique of cloisonnisme. Other artists came to Pont-Aven, attracted by the low cost of living and by Gauguin's fame. Paul Sérusier was one of these artists. He was born in 1863, like Signac. His meeting with Gauguin was at the origin of the Nabi movement (Nabi means "prophet" in Hebrew). One October day in 1888, when he was painting in the Bois d'Amour, Gauguin asked him, "How do you see that tree? Is it green? Then use green (...). And that shadow? Wouldn't you say that it's blue? Don't be afraid to paint it as blue as possible".

Paul Sérusier called this painting, *The Talisman*. When he brought it back to Paris, his friends Denis, Vuillard and Bonnard were struck by the effects of the colour in it. Maurice Denis put their thoughts into words in the famous phrase, "A painting is essentially a flat surface covered with colours assembled in a certain order".

Stylization and synthesis were henceforward to become the key-words.

Emile Bernard
and his Sister Madeleine

Paul Serusier
The Talisman
1888
oil on panel 27 x 22
Paris Musée d'Orsay

Pierre Bonnard
The Game of Croquet
1892
oil on canvas 130 x 162
Paris Musée d'Orsay

Paul Gauguin
Their Golden Bodies
1901
67 x 76
Paris Musée d'Orsay

Vincent Van Gogh
The Potato-eaters
1885
oil
Amsterdam Van Gogh Museum

Vincent Van Gogh's life and career can be divided into two unequal periods, consisting of before and after he met the Neo-Impressionists and the Pont-Aven painters.

Van Gogh was a tortured individual, whose torment is apparent in his work. Like Jongkind, he was the son of a Dutch Protestant minister. He first embarked on a career, at the age of 16, as a salesman in Goupil's art gallery in The Hague, until 1869, when he worked for the same gallery in Brussels, in London and, in 1875, in Paris. Yet he was not happy in his job. Van Gogh felt deeply for the poor and dreamed of being able to alleviate their distress. In 1876, he left the gallery and went to England where became a preacher among the miners of the Black Country. The miners however almost openly rejected him; he was forced to leave and had no choice but to return to Etten where his parents lived.

Vincent Van Gogh
The Loom
1884
oil on canvas 61 x 85
Otterlo Rijksmuseum Kröller-Müller

Salvation Through Art

Van Gogh believed he had found his true path in life, he would enter the priesthood. He studied for about a year in Amsterdam, to prepare himself for the entrance examination to theological college. He failed the exam so his father sent him to the Evangelical School in Brussels. Here again, he failed. Van Gogh then decided to preach to the miners of Borinage in Belgium. At first he surprised these rough miners then worried them, so they got rid of him. In 1879, at the age of twenty-six, Van Gogh had failed at everything he had tried. In his despair, he suddenly turned to painting. Undoubtedly, he assigned to art the mission which religion had been unable to fulfill for him – his salvation. He was setting himself an impossible task.

From 1880 to 1883, Van Gogh devoted himself to painting, helped and advised by his cousin, the painter Mauve. But they soon quarrelled. Van Gogh's mental equilibrium was always rather precarious. A recurring theme emerges from his art, linking the preacher and the painter, that of the poor, the artisans, peasants and journeymen, who were always his favourite subjects. Van Gogh was a realist painter, but he painted in a dark, heavy impasto, the colours of mud and sweat, like those of his subjects. There was nothing to indicate that his later work would be any different.

Vincent Van Gogh
Paysanne près de l'âtre
1885
oil on canvas 29 x 40
Paris Musée d'Orsay

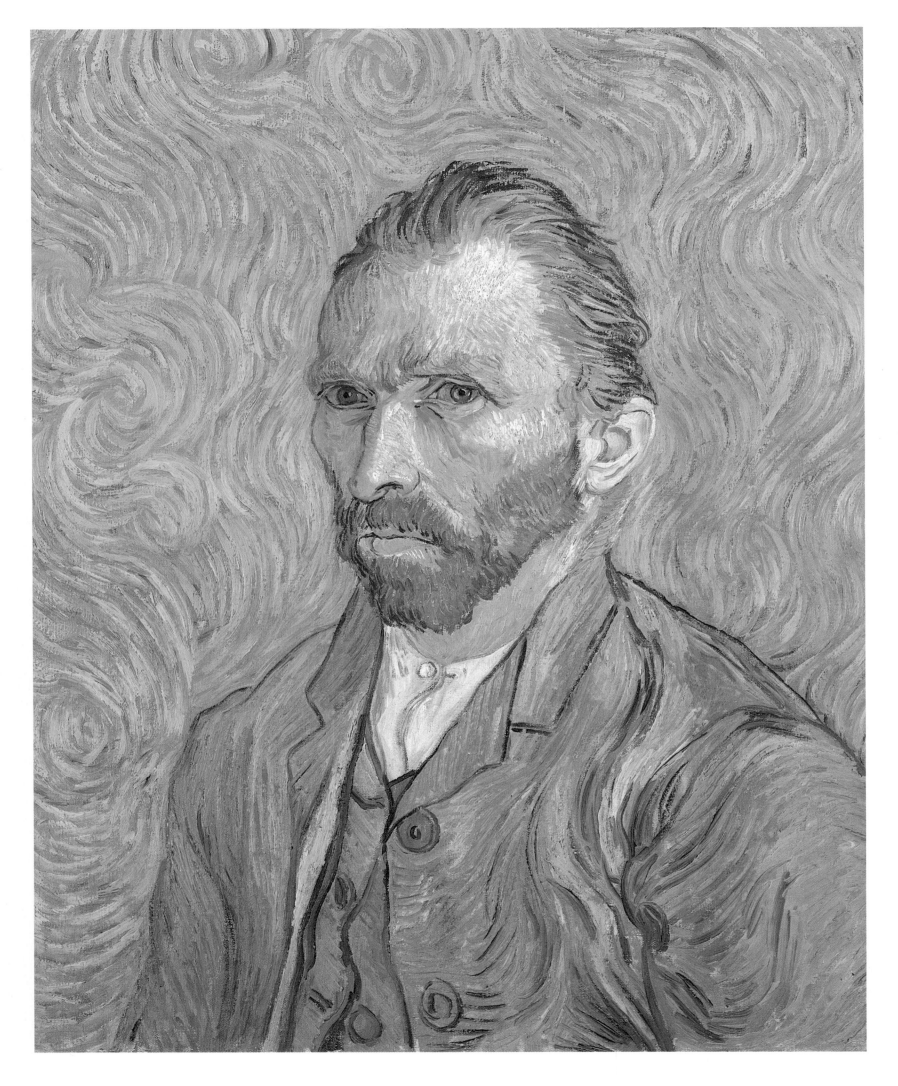

Vincent Van Gogh
Portrait of the Artist
1889
oil on canvas 65 x 54.5
Paris Musée d'Orsay

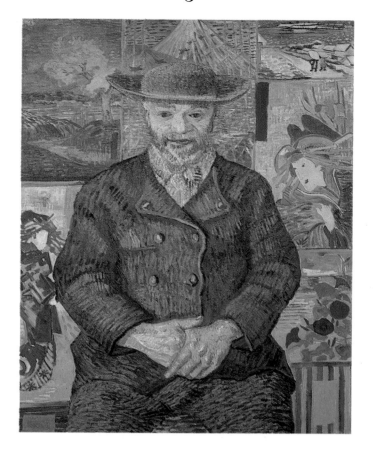

220 *The Lights of Paris*

In 1886, Van Gogh was thirty-three and living in Antwerp; he had entered the Academy of Fine Arts the year before. His father had just died. Van Gogh had discovered Rubens and was beginning to drift away from Millet's influence. Colour had errupted into his painting, and with it, modernism. He came to the conclusion that he ought to go to Paris, then the art capital of the world. In Paris, he was welcomed by his brother Theo, who was working at Goupil's gallery. Van Gogh discovered the Impressionists. He entered Cormon's studio, made frequent visits to the Louvre, met Toulouse-Lautrec and Père Tanguy, Pissarro, Degas, Seurat, Signac, and Gauguin. He still had much to learn about technique and style. For a while, Emile Bernard, who was working at Asnières, won him over to Pointillism. Later, Bernard's influence was supplanted by that of Gauguin as an example to the Dutchman. Van Gogh worked extremely hard in Paris. He produced 200 paintings, using a brighter palette, some of which were exhibited at Tanguy's, next to the Monet canvases.

Unfortunately, the return of the grey Parisian winter brought on Van Gogh's depression and torment. He was losing his appetite for work. Van Gogh needed light. Toulouse-Lautrec, who had been born in Albi, advised him to go to Arles. Van Gogh left Paris on February 21 1888.

Vincent Van Gogh
Portrait of Père Tanguy
1887
oil on canvas 92 x 73
Paris Musée Rodin

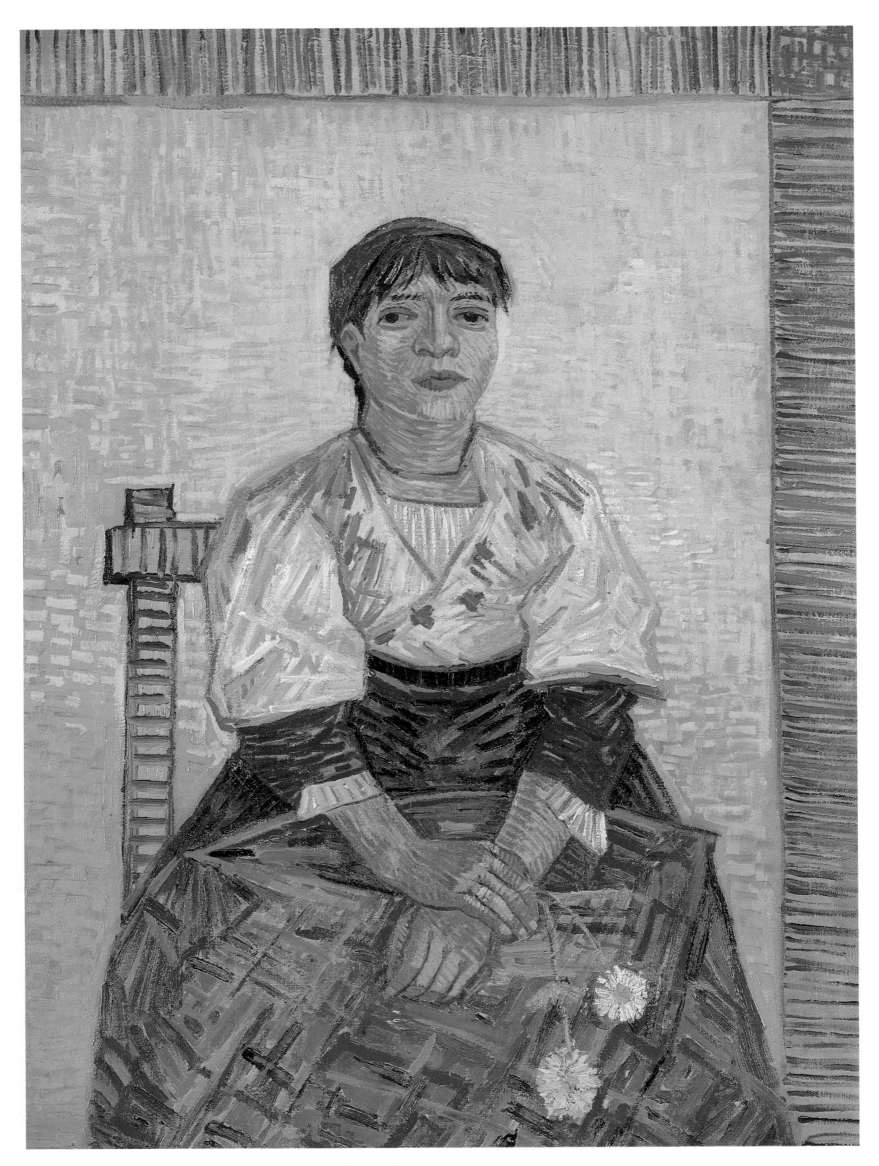

221

Vincent Van Gogh
Italian Woman
1887
oil on canvas 81 x 60
Paris Musée d'Orsay

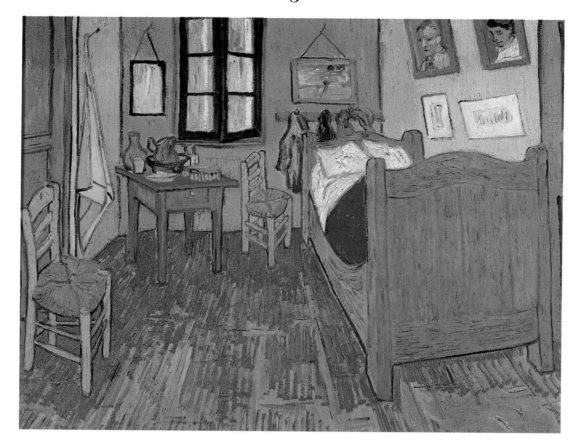

222 *The Severed Ear*

*I know that writing
is a great strain on you,
so I am not expecting
a letter (though I am
always delighted to hear
from you). Bernard's
military service has been
postponed on medical
grounds.*

Paul Gauguin
in a letter to Vincent Van Gogh

In the sunshine of Arles, Van Gogh felt as happy as a child. He was clear-headed once more. He created his own style, which was neither Impressionist nor Pointilliste, but simply Van Gogh. He used unmixed colour and a strong outline, emphasized in heavy impasto. A new period was beginning, which gave rise to two hundred new paintings.

However, the mental illness, which had tormented him since childhood was still troubling him. The precarious existence he led only increased his feelings of insecurity. Van Gogh was convinced he was dying, and that he must work as fast as possible before expiring. His loneliness was also troubling him. Gauguin, with whom he was in correspondence, decided to visit him in the autumn of 1888 and he received a joyous welcome. Unfortunately, their relationship soon deteriorated. Van Gogh could not tolerate anything or anyone for long. Although he dreamed of love, stability and mutual support he lived like a hermit and quarreled with everyone.

On Christmas Eve, 1888 a quarrel broke out between Gaugin and himself. Van Gogh, having exhausted his arguments, threw his glass in Gauguin's face. The evening ended thus. Yet, Van Gogh had not calmed down the next day and was seized with a fit of madness. He went out into the street with a razor in his hand until he saw Gaugin and approached him. However, Gaugin's presence of mind in the circumstances suddenly made him aware of what he had been about to do. Van Gogh rushed back to his room and locked himself in, and as he was still holding the razor, in a gesture of self-punishment, he used it on himself and cut off his own ear. Shortly afterwards, he offered this macabre relic to a prostitute.

Vincent Van Gogh's house in Arles
the Yellow House, before it was pulled down

Vincent Van Gogh
Van Gogh's room in Arles
1889
oil on canvas 57.5 x 74
Paris Musée d'Orsay

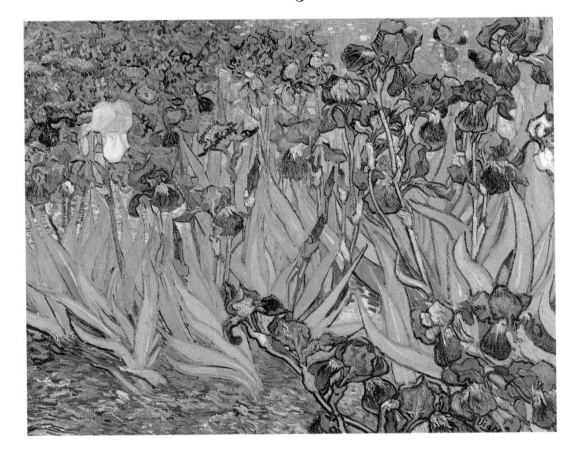

Saint-Rémy Hospital 223

People in Arles were nervous of the presence of this madman. After this self-mutilation, Van Gogh spent two weeks in hospital. His neighbours forced him to return there. Theo, who had always felt responsible for his brother, asked Signac to visit him. Van Gogh was aware of his mental state. In May, 1889 he asked to be admitted as a voluntary patient to the Saint-Rémy Hospital. His voluntary status gave him a measure of freedom within the hospital. He had a special routine, discharging himself and returning whenever he felt a new fit coming on. During this third period of his life, he painted some 150 canvases, an indication of the enormous creativity of this artist. However, as his condition worsened, he reverted to the use of browns and sombre shades, a more tortured line, twisting in obsessive vortices in his depictions of oppressive, stifling, landscapes. Van Gogh was painting his own vertigo. He was gnawed by doubt, dreading the fact that he might be merely a bad painter and a ridiculous failure.

Vincent Van Gogh
Iris
oil on canvas
private collection

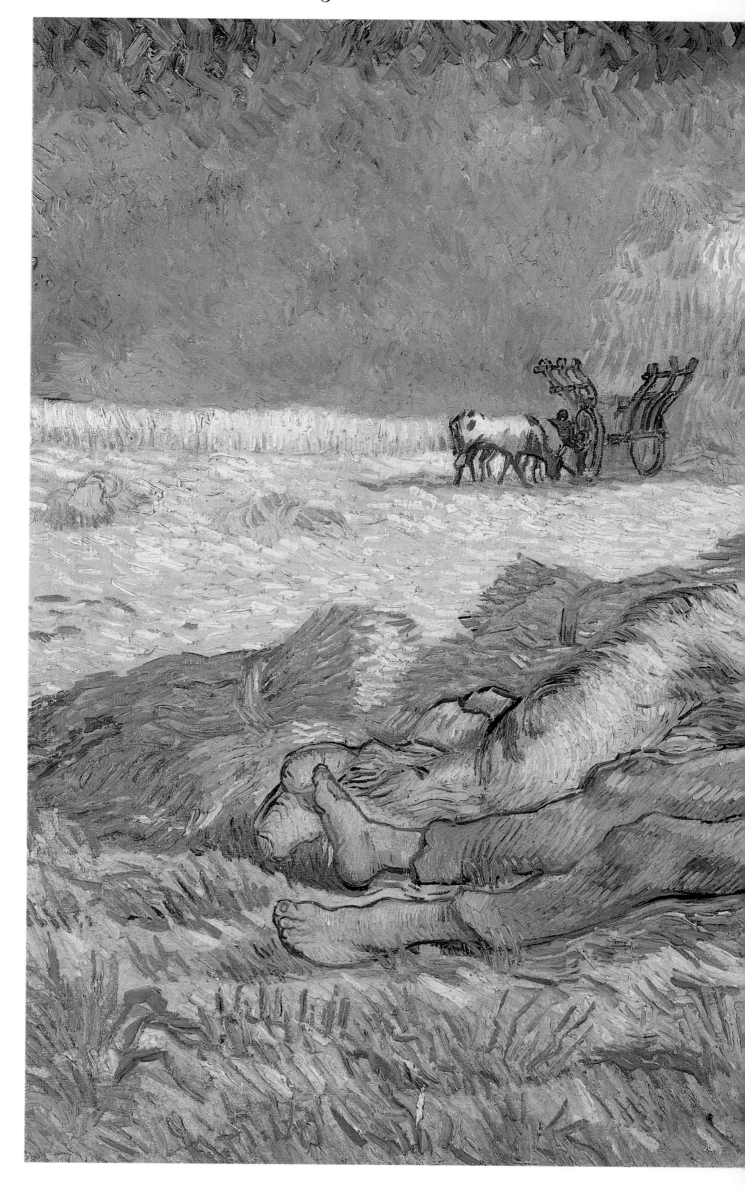

224

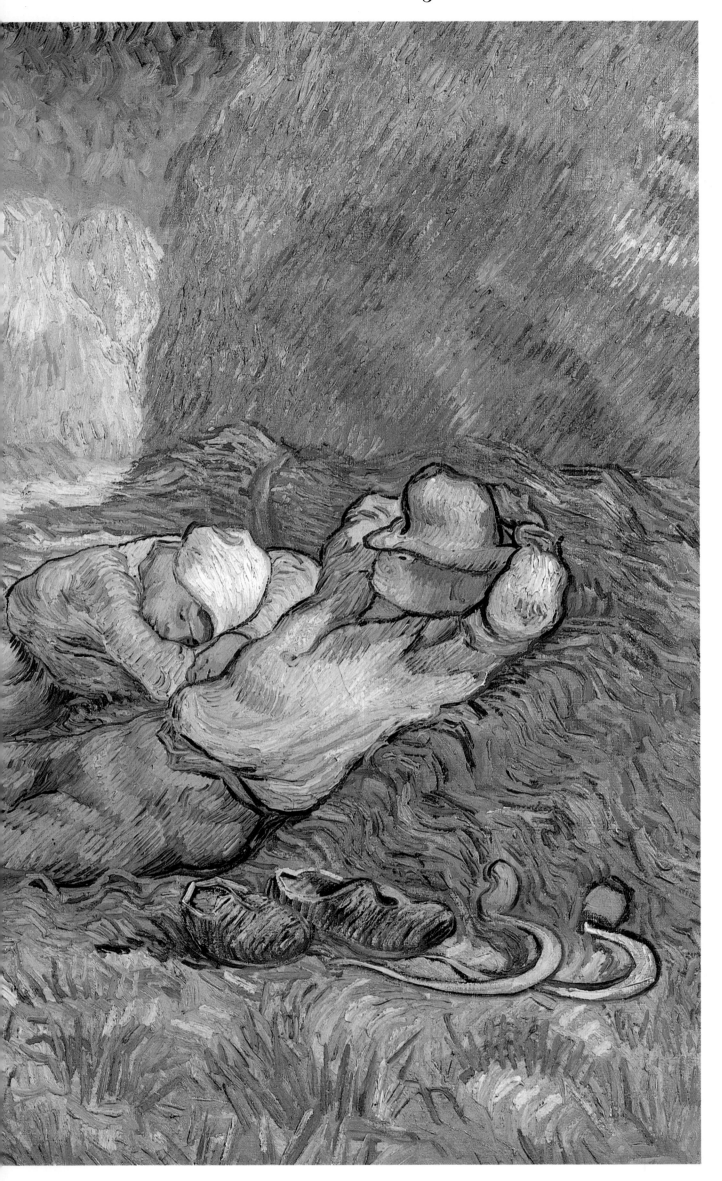

225

*You must know that I am
deep in complex calculation,
which soon results in one
canvas after the other of
rapidly executed paintings,
which have been carefully
planned in advance.
So, when it is said that my
work is done too quickly,
you can reply that it has
been looked at too quickly.*

Vincent Van Gogh
in a letter to his brother Theo
Summer 1888

Vincent Van Gogh
The Nap or *the Siesta*
1889-1890
oil on canvas 73 x 90
Paris Musée d'Orsay

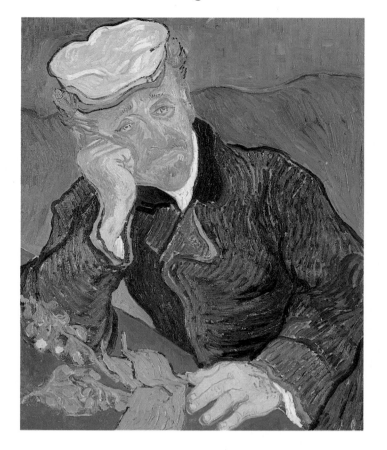

226 *A Sunday in July*

Yet in Paris, interest in his work was mounting. Was it too late? Early in 1890, Theo asked Dr. Gachet to look after his brother in Auvers-sur-Oise. Obviously, Theo feared the worst. His brother agreed to the plan and went to Auvers in May. His fits of violence had been replaced by a permanent melancholy. June passed without incident. Nobody believed he was cured, but it was hoped that he was having a remission. Only Van Gogh had lost hope. Weary of suffering, he chose to put an end to his torment. One day when Dr. Gachet was out, he walked out into the country, entered a deserted farmyard, took his gun and shot himself in the chest.

He did not die instantly. His death-throes lasted for two days in the boarding-house to which he had been brought severely wounded. Theo and Dr. Gachet stayed with him until the end. In committing suicide, Van Gogh had joined the long list of tortured artists of the 19th century of whom the archetype is the character of Claude Lantier, created four years earlier by Zola in L'Œuvre.

Vincent Van Gogh
Dr. Paul Gachet
1890
oil on canvas 68 x 57
Paris Musée d'Orsay

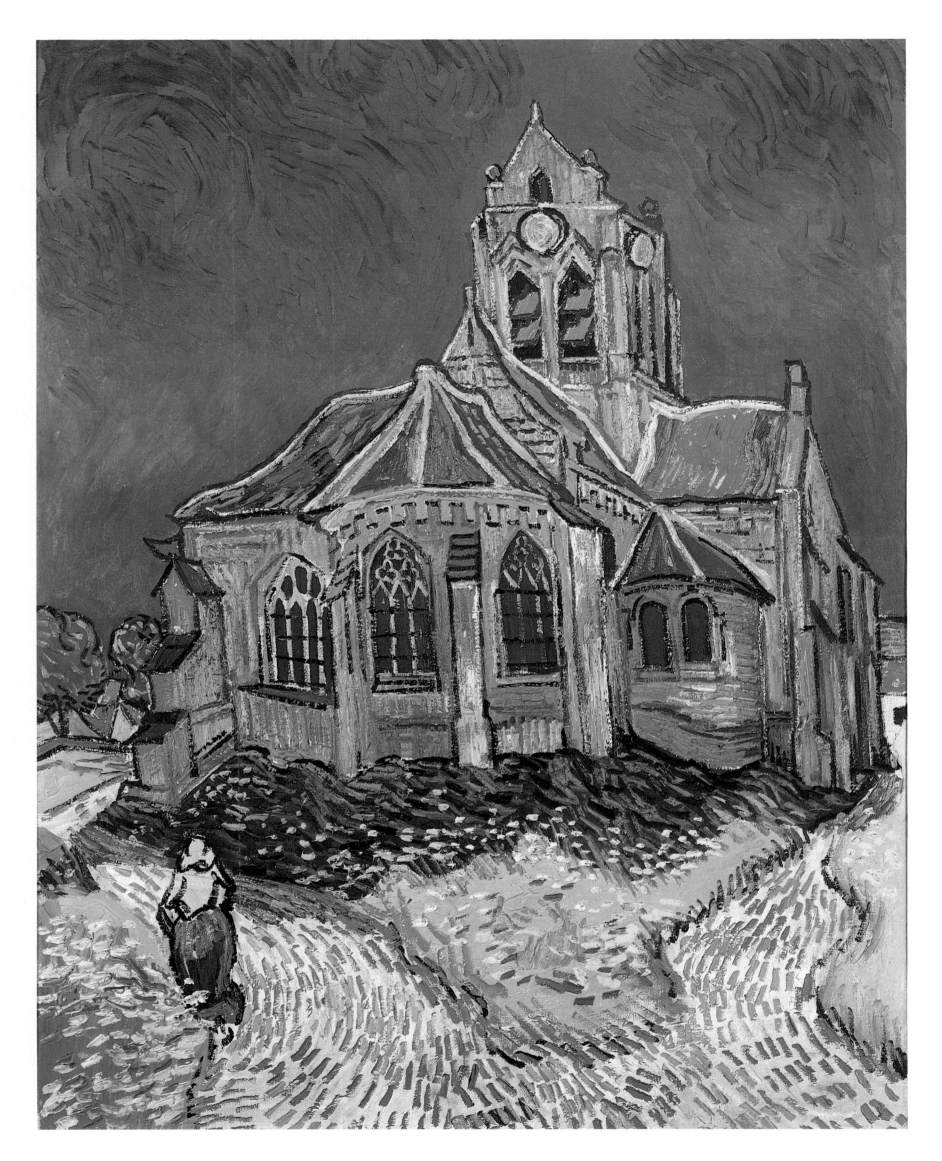

Vincent Van Gogh
The Church at Auvers-sur-Oise
4-8 June 1890
oil on canvas 94 x 74·5
Paris Musée d'Orsay

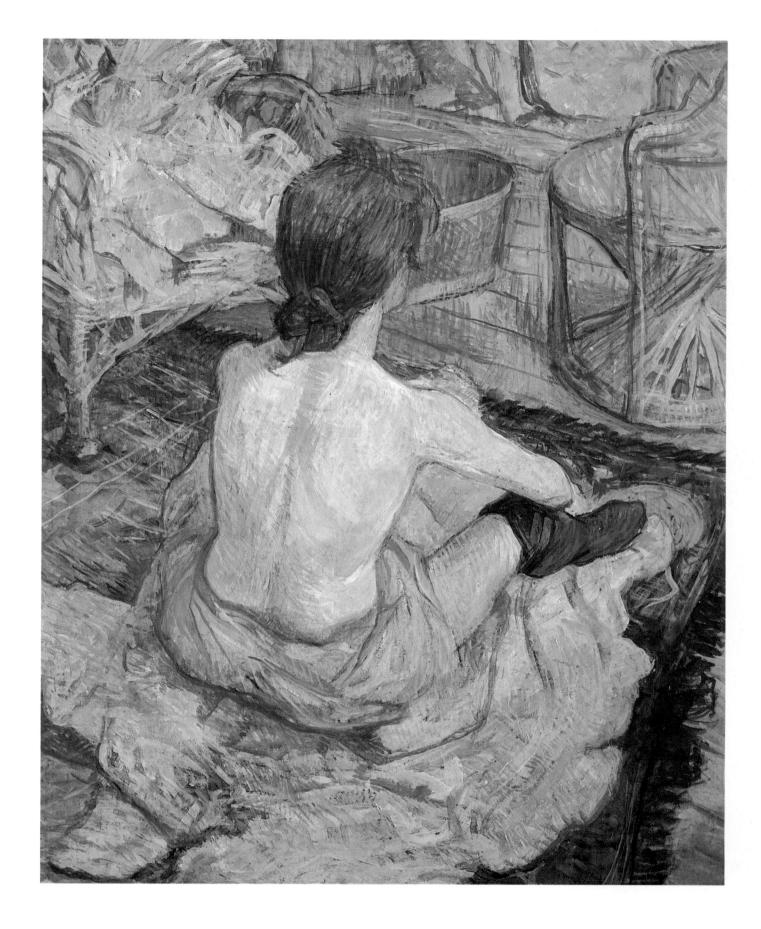

Henri de Toulouse-Lautrec
Toilet Scene
1896
oil on hardboard 67 x 54
Paris Musée d'Orsay

Henri de Toulouse-Lautrec died in 1901, at the age of thirty-seven, two years before Gauguin. Thus, by an accident of history, the four leading painters of the younger generation died before their elders, Monet, Renoir, Degas, and Cézanne. Toulouse-Lautrec's frantic race against time pervades his work to a greater extent than any other painter. His work consists largely of swift sketches which skilfully portray figures in characteristic poses in a few strokes, yet say more about them than a painstakingly-produced oil painting. Toulouse-Lautrec used turpentine-based paint, a technique which enabled him to get the maximum from transparent effects, cluttered and empty spaces, thus conveying the uncertainty of life through a deliberately unfinished look. If his unusual style is to be categorized, it can be said to be subject to two influences, his interest in the psychology of his human subjects and the influence of Japanese prints. In this respect, Toulouse-Lautrec demonstrated how much he owed to Degas. Like him, he preferred anonymous subjects (such as his study of an English barmaid at "The Star" in Le Havre) to celebrities, and intimate scenes or a movement captured from life to a studied, frigid pose. In short, he preferred life, however vulgar, to genteel refinement.

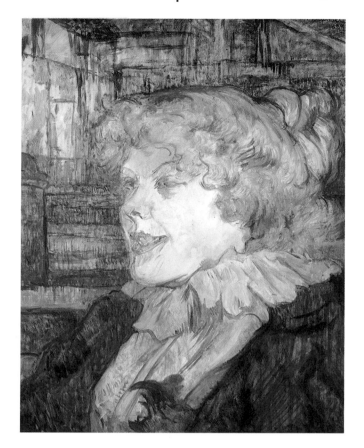

230 *A Personal Misfortune*

However, Toulouse-Lautrec was by no means a man of the people. He was descended from the Counts of Toulouse, a family which had once been as powerful as the kings of France. He was born in Albi in 1864, and grew up in the provinces, except for a short spell studying at the Lycée Fontanes (now called Lycée Condorcet) in Paris. His mother then took charge of his education privately and her affectionate tutoring allowed him to develop his gifts for drawing in all the margins of his copybooks. Unlike the middle classes, the aristocracy did not object to leisure. It was actually one of their privileges. In this context, drawing was a valued pastime, so far from trying to dissuade him from this preoccupation they positively encouraged it. René Princeteau, a friend of his father's and a painter of animals, gave him much advice, as did another artist, John Lewis-Brown. Toulouse-Lautrec signed his first canvases at the age of fifteen.

His precociousness was due to a personal misfortune. In 1878, as a boy, he had fallen and broken his left leg. The bone did not knit together properly. The following year, he fell again, this time breaking his right leg. The two accidents left him a cripple. His tragically peculiar body, with its atrophied legs topped by the trunk of an adult, was later to make him famous. Since he could not rely on his body to live life to the full, he transferred his appetite for life to his imagination.

At eighteen, he studied in Bonnat's studio. This true "pompier" painter found it difficult to bear the talent of a young man who was so passionately fond of the Impressionists. Thus, Bonnat did not hesitate to tell one of the most brilliant draughtsmen of the 19th century, "You draw atrociously". Toulouse-Lautrec left and entered Cormon's studio, where he remained until 1887. It was here that he met Van Gogh and Emile Bernard. In 1887, he considered that his training was complete and settled down to work in his own studio, in the rue Caulaincourt, in Montmartre, near Goupil's gallery.

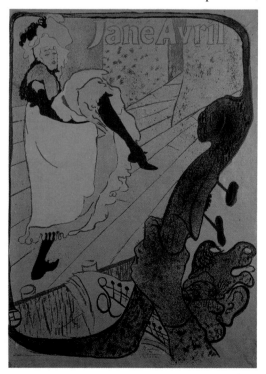

Henri de Toulouse-Lautrec
Jardin de Paris Jane Avril
1893
poster 130 x 95
Albi Musée Toulouse-Lautrec

Henri de Toulouse-Lautrec
The Englishwoman at the "Star"
in Le Havre
1899
oil on panel 41 x 32.7
Albi Musée Toulouse-Lautrec

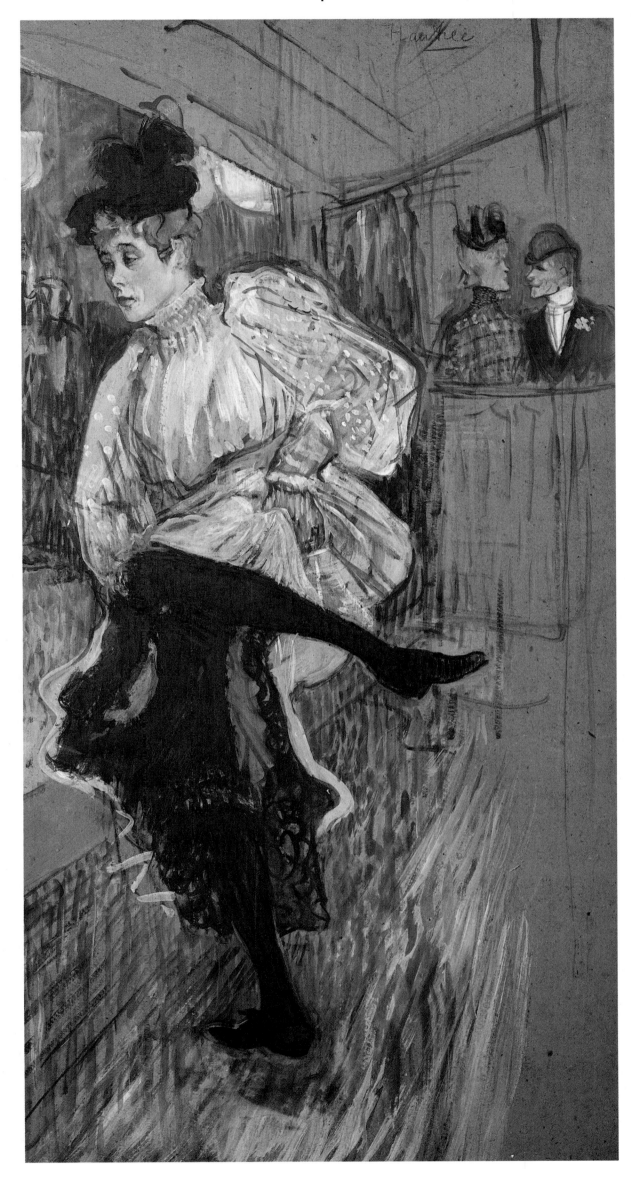

Henri de Toulouse-Lautrec
Jane Avril Dancing
c. 1892
oil on hardboard 85.5 x 45
Paris Musée d'Orsay

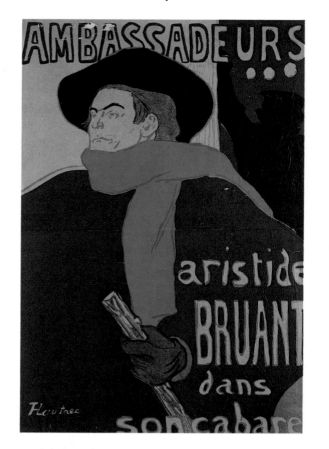

"These Women Are Real"

Instead of concealing his deformity, Toulouse-Lautrec chose to display it. He loved Parisian nightlife too much to hide away in the studio. For about ten years, he was seen at the theatre, the circus or at race-meetings. Brush in hand, he was the chronicler of late-19th century Parisian life. Yet his Paris was not that of high society. He preferred the night-clubs, the booths of the Foire du Trône, the music-halls and the brothels. He thought that real life was to be found in this sort of place. Referring to Jane Avril, La Goulue and Yvette Guilbert, he once said, "A professional model looks like a dummy, these women are real".

In order to catch these creatures from life, he had to work fast. His technique was the opposite of Cézanne's. He would transfer a dancer's body to the page with a few strokes. He only needed a few hours' sitting to produce a portrait. When one examines his work closely, one can easily imagine the agitated movements of the artist at work. In some of his paintings, the fragmented brushstrokes show the influence of his friend Van Gogh, another painter who felt an urge to work fast.

Henri de Toulouse-Lautrec
Aristide Bruant dans son Cabaret
1893
poster
Albi Musée Toulouse-Lautrec

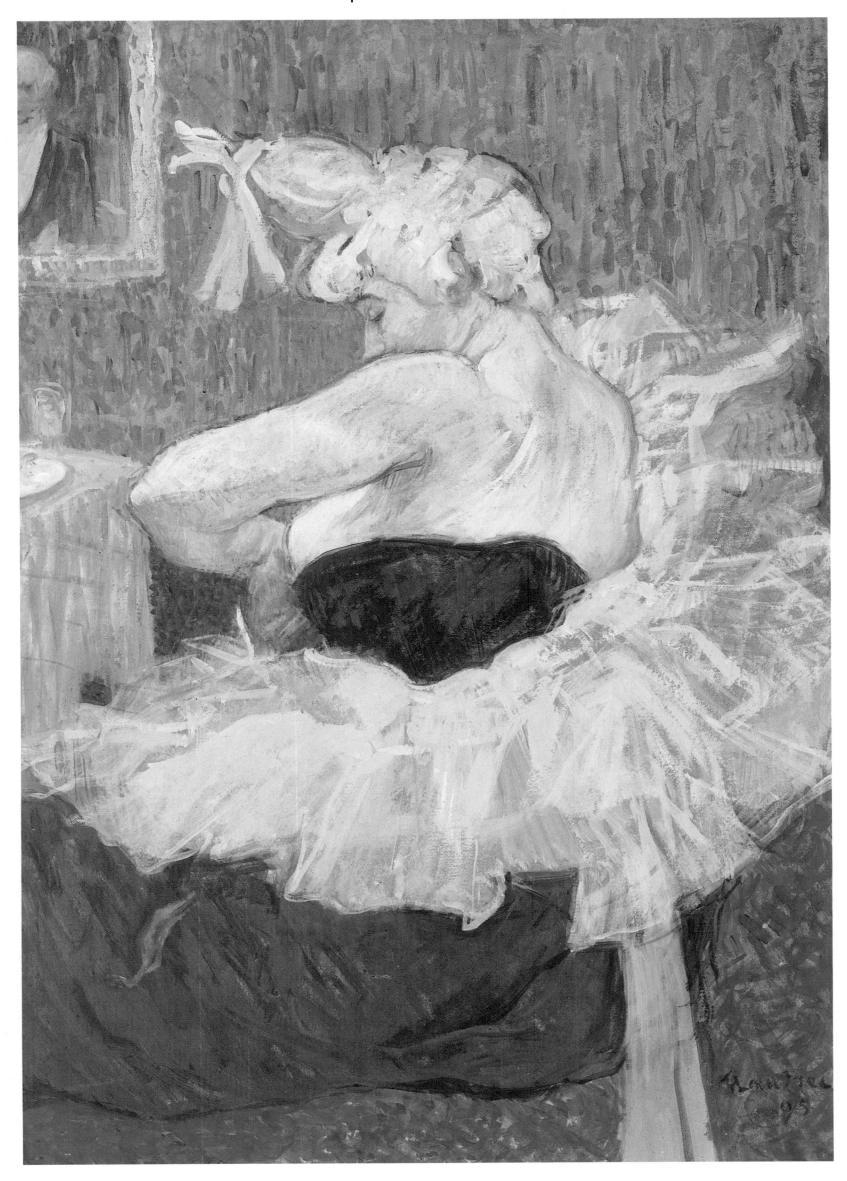

Henri de Toulouse-Lautrec
La Clownesse Cha-U-Kao
1895
hardboard 64 x 49
Paris Musée d'Orsay

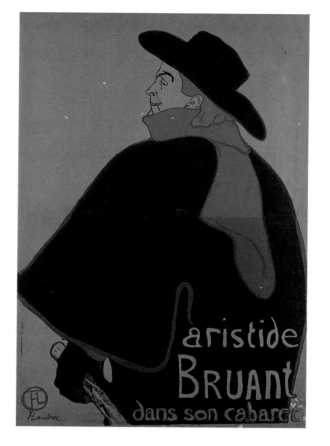

234 *Drink*

Toulouse-Lautrec's method of working propelled him towards a style consisting largely of suggestion and synthesis. From 1891 to 1900, he went even further in this process of simplification, in a series of thirty posters for the theatre, including the famous ones featuring Aristide Bruant. In this, he was breaking away from Impressionism, which had influenced his early style, only retaining the same freedom in his use of colour. His drawing was stylized with the contours carefully emphasized, enclosing flat areas of colour. His masterly simplifications fascinated the next generation of painters, that of Matisse and Picasso.

Yet art could never completely cure Toulouse-Lautrec's deformity. He needed a stronger remedy, and he found it in drink. In 1898, his health began to deteriorate seriously as a result of his heavy drinking. He tried to dry out but was unsuccessful. In 1901, he died in the Château de Malromé, near Bordeaux.

Most of Henri de Toulouse-Lautrec's works are now on show in his home town of Albi, in the museum named after him, which was opened in 1922 in part of the Palais de la Berbie.

Henri de Toulouse-Lautrec
Aristide Bruant at "Les Ambassadeurs"
1892
tracing paper on canvas 148 x 117
Albi Musée Toulouse-Lautrec

Henri de Toulouse-Lautrec

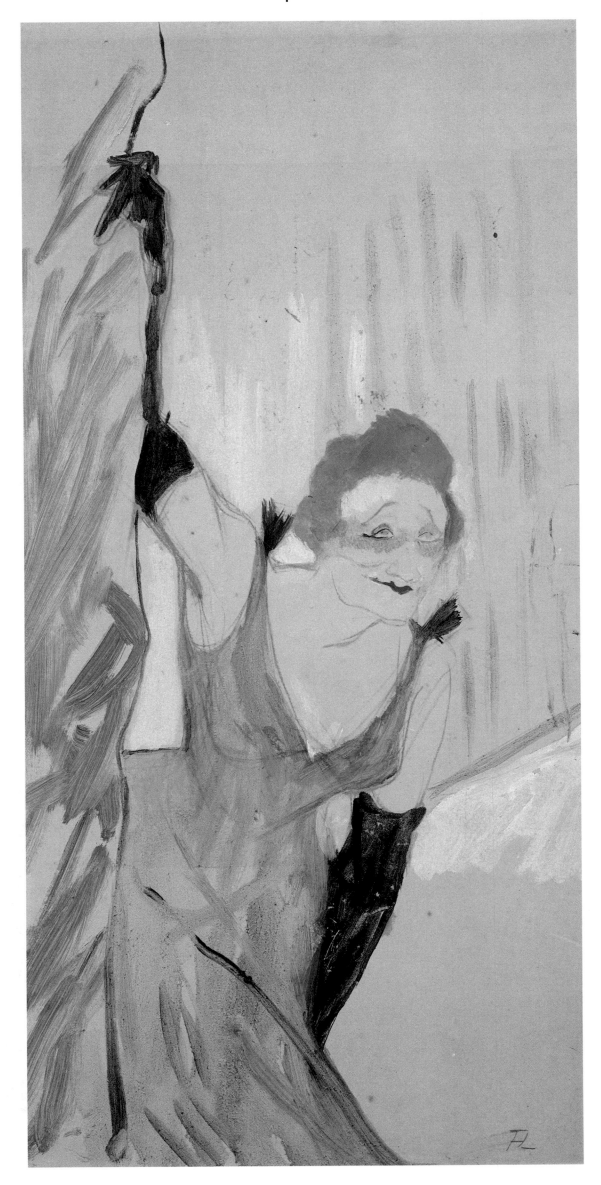

Henri de Toulouse-Lautrec
Yvette Guilbert Bowing to the Public
1894
hand-coloured print 48 x 25
Albi Musée Toulouse-Lautrec

236